THE PRICE OF
CHILDREN

The Price of Children

Stolen Lives in a Land Without Choice

Maria Laurino

OPEN ROAD

INTEGRATED MEDIA
NEW YORK

Originally published in Italian as *Il Prezzo Degli Innocenti* by Longanesi & C. S.R.L., Milan 2023. © 2023 by Maria Laurino. First US publication by Open Road Integrated Media, © 2024 by Maria Laurino.

Cover photo by Russell Campitelli

ISBN: 978-1-5040-9923-3

This edition published in 2024 by Open Road Integrated Media, Inc.
180 Maiden Lane
New York, NY 10038
www.openroadmedia.com

For Tony and Michael, who help guide the way.

Contents

THE PRICE OF CHILDREN

We think we tell stories, but stories often tell us, tell us to love or to hate,
to see or to be blind. Often, too often, stories saddle us, ride us,
whip us onward, tell us what to do, and we do it without questioning.
The task of learning to be free requires learning to hear them,
to question them, to pause and hear silence, to name them,
and then to become the storyteller.

—Rebecca Solnit, *The Faraway Nearby*

In every modern story, a mythical element is always present, implicit,
as if lying in ambush, ready to step forward and take over the story itself.
—Edoardo Albinati, *The Catholic School*

Where is she? What have you done with her? . . .
She's in good hands, they said. With people who are fit.
You are unfit, but you want the best for her. Don't you?
—Margaret Atwood, *The Handmaid's Tale*

Part One
Baby Shoes Never Worn

- 1 -

Turin, 1963

The handsome city that greeted Francesca from the train station, with its elegant arched porticoes and wide boulevards humming with prosperity, should have awakened something within the pretty, dark-haired twenty-three-year-old arriving from a small provincial town in Southern Italy. At another moment in Francesca's life, the Po River would have beckoned her to wander along its edge as it glittered golden in the midday sun. In another time, Francesca would have entered one of the city's famous centuries-old cafés replete with gilded mirrors and marble floors, inhaling the experience in the joyful fashion of the discovering young, with long breaths and beating heart. But when Francesca arrived in Turin that spring, the season of her disappearance had begun.

The previous fall Francesca had worked as an olive picker in Puglia, one of a long line of peasant farmers who for centuries harvested this local crop to be pressed into oil. She gently shook the branches of the small trees, coaxing the plump ripe olives onto the tarp beneath her feet. It was tedious work, the days long and hot, but one night she earned a small reward. Her boss,

whom she had a crush on, offered her a ride home. Francesca was delighted but hadn't anticipated the route her boss would take, down to the azure sea, stopping at a thatched *trullo*, the traditional dried stone hut of the region. This particular *trullo*, run as a bar and inn, had its own tradition among the local men.

At first, she tried to hide from her mother her slowly changing body, denial the only strategy for what had happened that night. By four months, however, their small house, bulging and swelling with shouts and recriminations, felt ready to burst. Francesca listened but no longer heard, cocooned in her own thoughts and desires. One thing was clear: she had no choice but to leave their village.

The train ride to Turin was excruciating, over fifteen hours in a stuffy carriage clamoring north. In the tight space of the enclosed cabin, Francesca sat opposite her older brother, a *carabiniere* stationed north who had traveled back home determined to bleach out the stain now saturating the family. She stared out the window at the arid land, endless swaths of honey and brown that became a misty blur as her brother unleashed his fury. *Disgraziata*! His demeaning reproaches, declared in the name of moral authority and fraternal duty, hung in the air with a heavy nauseating sweetness, like a cheap cigar. *You are the ruin of our family.*

The *carabiniere* took Francesca to the home of their sister who had moved to Turin. Francesca argued with them both. She was determined to keep the baby she carried. She did not want to disappear. But they sent her to a home for unwed mothers run by nuns, where she earned her keep cleaning the premises and met others like her. Women who had been raped or seduced and abandoned or naïvely ignorant about sex and pregnancy or who were the mistresses of men skilled in the art of moral legerdemain, women who lived in a home made possible by the

charitable contributions of Turin's upper class, including the wife of a famous FIAT executive. Women from Italy's north and south, isolated women made to suffer for their sins while the men remained enviably free from responsibility.

The day began by saying the rosary five times, and the evening concluded with the same susurrant repetition, each bead marking the one hundred and fifty times the prayer seeking the Virgin's grace is repeated. If Francesca escaped, temporarily at least, her family's daily condemnations, she now sought absolution from a far more eternal wrath. The days spent in this convent-home were like waking up in a gossamer world, a veil of shame clouding even the hand of the body that betrayed her.

During the languorous wait for the body to ripen for labor, the nuns prepared the women for their soon-to-be childless world by teaching them domestic skills. Once clumsy fingers learned to pull silky threads and coil pastel yarns around knitting needles, producing handmade wares that the nuns took to a small shop downtown, the proceeds helping to support the home. In one of life's crueler lessons, the nuns taught Francesca how to knit baby shoes.

The season turned to fall when Francesca was sent to Turin's maternity hospital in a special section reserved for sinful women. The woman who carried her baby for nine months, who bore through torturous labor a son Piero, a name she had chosen months before, who nursed him for a precious few days, and who desperately wanted to keep him, was about to be erased. On the floor of the maternity ward, she had a name and a child, but four days later she possessed neither. In the days and years ahead, she would need to find another chamber in her heart, one devoid of the unbearable grief of relinquishing her first-born son. Her son's Italian birth certificate, sealed from prying eyes for the next century—preventing mother from

ever learning about son and ensuring that son could never find mother—read, *nato di donna che non consente di essere nominata,* born of a woman who does not consent to be named.

It made no difference that Francesca remained in Turin for three more years to be near her baby, working as a nanny for a wealthy couple and imagining Piero in the face of the little boy she nurtured. It made no difference that Francesca repeatedly returned to the gates of the foundling home seeking to take back her child. "Make peace, woman," the mother superior finally told her, determined to put an end to her visits. "Your child has been sent to America. He is with a *good* family."

It didn't matter that the nun's words were false—that Piero had been earmarked for a particular American couple and would remain in a sterile room lined with cribs of crying babies for another two years before paperwork was completed and visa acquired to allow for the international adoption. Nothing mattered because Francesca was now a ghost. In the eyes of the Church, nameless and childless, she had officially disappeared.

Francesca came of age during a time when the Roman Catholic Church determined not only the calendar of seasons but the rhythms of women's lives. A time, not so long ago, when young women, naïve women, untested by life's complexities and contradictions, found themselves forced into bad situations or forced to pay for a moment's bad decision, the type that's been made, and will continue to be made, for countless times in human history. A tableau of women bunched like sunflowers in fields extending beyond where the eye can gaze, heads bowed in silent shame.

Their lives appear as numerical digits in a country's statistics: tens of thousands of Italian women who surrendered their children, over two hundred thousand of these children on public

assistance by the late 1950s; those who escaped childhood in institutions adopted by Italian couples; nearly four thousand more, like Francesca's son, sent on commercial airline flights to America. Numbers so large they lose meaning, columns on sheets that cannot tally the costs of each wrenching decision made, cannot measure wounds that resist suture. What happened to Francesca, and all the others like her, is a story that any woman could relate to, and privately fear: the nightmare of living in a society where a powerful religion and acquiescent government dictate the fabric of your life.

I discovered this startling story by way of a chance phone call late one Saturday morning. It was a bright day in May, the sunlight bounced off the white brick of the neighboring apartment building, filtering through the sheer parted curtains to glaze our parquet floor a golden honey. I was taking my last sips of coffee and spoonfuls of yogurt, prolonging a routine trip to the gym, preferring to relax in this brief slant of sun when my cellphone rang.

"*Buon giorno, cugina!*"

I immediately recognized my cousin's voice. Raised in Ohio and settling in South Florida he, like every member of our family, doesn't speak Italian, and delivered his greeting in an exaggerated accent and the flat vowel sounds of the American Midwest.

My cousin was seeking travel advice, trying to navigate the labyrinthine twin airports of New York City, where I live, to get to Milan. His original flight had been canceled and he was desperate to arrange an alternative route. For months he had been meticulously planning a solo bike ride through Italy, measuring bags and weighing gear for his two-thousand-mile journey, and he didn't want to lose a single day. My cousin seeks a return to Italian soil in the same way that water guides light, unable to escape its dense refractive hold.

He was born in Italy, perhaps the reason for this magnetic pull that also feeds his occasional fantasies to move back to the motherland, adopted by my father's niece and her husband, a nurse and doctor in a small Ohio town. My cousin arrived in America on April 16, 1959, at nine months old, and coincidentally, one week before I was born. Families didn't discuss details about adoptions back then, and my parents assumed an arrangement had been made with an Italian doctor, a professional courtesy connecting a child in Italy who needed a home to a doctor and nurse in America who could provide a good one. In the tribal ways of most families, my cousin's heritage was a welcomed addition that complemented our roots; both sets of my grandparents had arrived on America's shores from Avellino and Basilicata in the early twentieth century, making my cousin a truer Italian than any of us.

During that Saturday call, as my husband checked his phone for traffic patterns to determine if a flight to LaGuardia, a domestic hub, left enough time for a taxi to Kennedy airport to make the evening flight to Milan, my cousin shared an intriguing aside. He recently had joined a closed Facebook group composed of hundreds of members, now mostly middle aged, all of whom were born in Italy and had been adopted by American couples through the same Catholic Church program.

"I spoke to the guy who runs it and he told me some amazing information—he knew the flight that I came in on as a baby!" My cousin, who is an enthusiast, talked fast, as he was pressed for time. He had also spoken with other members of the group, one who grew up in the same small Ohio town, and he rattled off a stream of disturbing stories he'd heard about the treatment of birth mothers and their children back then. I was processing this information, trying to make sense of it all, but

soon paragraphs compressed to sentences to clusters of word clouds floating in my head: Roman Catholic Church. Secrets. Priests. Thousands. Falsified documents. Dead babies. Nuns. Forced Adoptions. Lies.

"Can you believe it? My birth mother could be alive and not even know I exist."

Was this internet gossip accompanied by a game of telephone among adoptees in which facts whispered into ears mutate into outrageous tales, or were these stories part of a larger puzzle needing to be solved? Were some young women told, to smooth the adoption process, that their baby had died, the story behind my cousin's outburst that his birth mother could be alive and not even know that he existed?

"I think he has time to make the flight," my husband announced, rousing me from my stupor, providing a needed landing spot.

"Take the connecting flight to LaGuardia, then grab a cab to Kennedy."

"Great, that's what I was hoping. I already found someone to share a cab with me. Okay, thanks . . ."

"Wait! How do I learn more about this story?" I demanded, surprised by the force of my words and rising adrenaline. After a childhood spent in Sunday school, weekly mass, and the dark confessional, I knew the power of Catholicism in shaping a girl's body and soul.

"The guy who runs the group is named John Campitelli. I can try to put you in touch with him. He lives in Italy and told me about the orphanage in Turin. He even offered to take me there. Hey, I really gotta go."

My cousin arrived in Milan the next day; it was 2017 and he began his month-long solo bike ride through the country. He declined John Campitelli's offer to see Turin's now shuttered

brefotrofio, the name for Italy's institutions for illegitimate children, the word coined in the nineteenth century from the Greek, meaning to raise and nourish newborns. From the start my cousin was wary of opening a door through which he ultimately decided only to peek. But I would pry, and what I learned was much worse than what I had imagined that day, the voices of mothers and children, of generational pain, always surpassing the emotional detachment of compiled facts and numbers.

As my cousin promised, he wrote to John Campitelli and soon we connected, beginning a series of lengthy phone conversations and exchange of emails and texts.

John offered a wealth of information he had collected and catalogued. I learned about how the Roman Catholic Church repackaged those thousands of children sent to America first as "war orphans," and then as "orphans," placing them in the open arms of childless couples, whose primary parenting requirement was a devout practice of the Catholic faith. I learned about his singular determination, which began with a boyhood search for his birth mother and has persisted with a patience and tenacity spanning the decades.

John gave me an essential clue to unlocking the program's secrets: many of the archival documents sat in boxes in New York City, a few miles from where I lived. I couldn't believe the geographic luck and spent that summer reading and photographing reams of correspondence between two American priests, Monsignor Andrew P. Landi, who ran the program out of Rome, and Monsignor Emil N. Komora, who from his New York office found placements for the children throughout the country. I learned that Monsignor Landi reported to the Vatican's Monsignor Ferdinando Baldelli, a close associate of Pope Pius XII, and key to this program's long reach, from his influence with clergy to government ministers. Amid these files,

I even found a memo about the scheduled arrival of my cousin (Case #21048) to the United States.

The documents revealed how the Church carried out this program even though it violated Italian law, a fact that government ministries pointed out to a Vatican official on numerous occasions. Yet the program continued. The children obtained visas to America due to a special clause added in 1950 to the United States' Displaced Persons Act, intended as an act of generosity to find homes for children who had lost their parents during World War II, but which in truth supplied a steady stream of "illegitimate" children for adoption, beginning in 1951 and lasting well until the end of the 1960s.

My next step was to meet John Pierre Battersby Campitelli and travel to where this story begins. An American couple from upstate New York, Russell Campitelli and Barbara Battersby Campitelli, adopted and named him John, after he spent almost two years in the Turin *brefotrofio*. Barbara and Russell also adopted three other children, identical twin boys, John's older brothers, and a girl, his younger sister, all from the same Turin institution.

Today John lives outside of Milan with his Italian wife, Simona, and their two daughters. One year after my cousin's unexpected phone call, I boarded a plane to meet John Campitelli. Or more precisely, ten months later, a gestation between learning about this story and beginning the arduous labor of trying to make sense of its strange details and twisted logic.

- 2 -

It was a cold foggy Sunday when I threaded my way through the curved streets in the old part of the city searching for a metro station. Sunken clouds in menacing shades of gray stretched the sky, a typical cusp-of-spring day in Milan. I double-checked the color-coded lines, mentally marked the transfer spot, before boarding one train then another to its penultimate stop. All smooth until I exited by mistake into a giant underground parking garage and hurriedly circled my way up from dark to dim to drizzling rain.

It's strange to finally meet someone, I thought, catching my breath and spotting a bus shelter to avoid the rain, whose family narrative you have been slowly piecing together. I had been making my own concentric rings around John Campitelli's life, gathering information from phone conversations, photos, documents dug up in archives, newspaper clippings, and even airline passenger records, working from the edges before arriving that Sunday afternoon at its center.

Two months earlier, in northern California, I visited his mother Barbara, who lives by herself in a small apartment in a senior housing complex about thirty minutes outside of San Francisco. During a family vacation in Matera the prior August,

in the middle of a heat wave nicknamed Lucifer, I made an hour's detour to sip espresso at the dining room table of John's paternal half-sister Laura, flanked by her husband and son who guarded her like sentinels as a ceiling fan slowly turned. At my side of the table sat a translator whom I had met at our hotel the evening before, having overheard her tell a couple about her work, a serendipitous find as my college Italian would never suffice beyond the rudimentary. Because of their love for John, strangers welcomed me into their homes, putting up with questions about the most intimate matters.

After ten minutes had passed, a car pulled up near the bus shelter. I recognized John from photos: the first one I saw had been taken during a family vacation in Greece and formed an impression. John sent it to introduce himself, responding to my cousin's contact, letting me know that he'd get back to me as soon as he returned to Italy. In the photo, John's graying hair looks more salt than pepper, he has a square face, arched eyebrows that punctuate large brown eyes and long lashes peering through frameless glasses. Gentle features, avuncular not angular, that reminded me of a priest.

As he stepped out of the car, I saw that John is tall—"Barbara and Russell always joked that I must be a northerner," he says. John apologized for being late, having lost track of time working all morning on the adjacent apartment that he and Simona had purchased to expand the cramped living space they share with their eleven- and twelve-year-old daughters. Conversation flowed easily as we drove along wide boulevards, past the boxy buildings and rectangular warehouses that mark a city's outskirts to their apartment complex. His manner remained the same as the first time we spoke, calm, yet indefatigable, a man possessed by a singular determination.

"I had always thought that other than my brothers and sister

I was the only crazy kid who had been adopted from Italy by American parents," he explained. John's resolve to unveil the past is what Barbara Campitelli, from the perch of her California apartment, described as "his mission": reconnecting thousands of American orphans to their Italian birthland, exposing the secrets of the Church's orphan program, and reforming Italy's adoption laws to open long-sealed records. Perhaps it's this aspect of John's personality—the zealousness of the true believer on a road to justice that also led to my priest comparison. But I resist sharing this observation because I doubt that he'd take it as a compliment.

Soon we reach their complex, a cluster of five-story buildings of contrasting off-white and sandy yellow facades. Several flights of concrete stairs lead to their apartment that opens into a living room packed with furniture and family belongings. Against a mustard-colored wall, I recognize Barbara's handiwork, a pair of brown and beige macramé wall hangings she crafted that similarly decorate her apartment. A Hello Kitty pillow accentuates one of several couches, and assorted pieces of John's tech paraphernalia charge in outlets. John and Simona both work at IBM, whose headquarters, about thirty minutes from central Milan, is located not far from here.

Simona tells me to not to be surprised by the rabbit in a cage on the bathroom floor. As she pulls out a freshly baked cake from the oven and the tweens squeal with laughter from an upstairs bedroom, the warmth of this family comforts me. I head up the staircase with John to peek in and wave hello to the girls. Bookcases line the narrow corridor leading to the bedrooms and I notice that assorted phonebooks fill the bottom shelves. Two catch my eye: one from Turin in 1963, which has a honey-colored binding and steel blue letters, and another from Turin in 1964, with the colors transposed, a steel blue binding and honey letters.

"I collect old phone books, that's one of my passions," John says, noticing my stare. "You can find out so much about a person just through a phone book."

"What do you learn from a page in an old phone book?" I ask, considering these books detritus of decades past.

"It's a picture in time, it's freezing time. People here are not as mobile as they are in the States." John switches easily from his Italian to American side, fluent in the language and culture of each. "In Italy, once you've got an apartment you pass it down to your children and they pass it down to their children and it's very easy to find out who was living in that apartment in the 1960s," John explains. From there, for someone like John, who has been sleuthing the past for most of his life, you can learn a lot about someone and the places they went—the local school, the bar where they munched on a morning brioche and downed an espresso, the town doctor.

For John, who is the son of Francesca, those two Turin phone books form the Holy Grail of his collection. They mark the years, 1963 signifying his birth in the city, which he'd like to repossess. Like a reverse form of cryogenics in which life's beginnings are frozen, a desire perhaps more common among adoptees, he continues to piece together a family narrative from which he'd been erased. John will always wonder what his life would have been like if society had played by a different set of rules, one in which a single pregnant woman would not have been shamed and forced to surrender her child. The baby shoes that the nuns at the home for unwed mothers taught his mother to knit, and her illegitimate son could never wear, dangle and taunt, conjuring an alternate universe absent his primal loss. It was impossible for me to think about that image—a twenty-three-year-old pregnant women knitting baby shoes for an infant boy she will be forced to surrender,

the tiny booties then sold in a Turin shop—without recalling a famous, perhaps apocryphal, tale about Ernest Hemingway winning a bet to write a six-word short story. He scribbled on a piece of paper, FOR SALE: BABIES SHOES NEVER WORN, the brevity of the line contrasting the bottomless well of the words' despair.

In John's parallel world, he would have remained in Francesca's arms, not become a number in a facility. He would have nursed from his mother's breasts, not fended alone, an infant seeking the nipple of a bottle wrapped in a cloth napkin propped upon his pillow because of too many babies for too few staff; he would have crawled then stumbled to his first steps in reach of his mother's hand, not spent his formative early years waking up in an institution and being forced, again for lack of staff, to sit for hours in a chair.

John longed for his birth mother in the way that the clumsy left hand seeks the steadier grip of the right, an inclination that didn't arise from disharmony at home—he described growing up in a warm and artistic household that Russell and Barbara created for him and his three siblings—but rather from a deeply innate desire to understand where his life story began, the once upon a time that sounds in every child's ears. John's pain was singular and private, the only one of the four Campitelli children who experienced this pressing need. His older brothers, identical twins Paul and David, had other pressing, dangerous needs, and the youngest, Sara, dreamily painted her own private world. Only many years later, after John had found the key to opening his lost world, did Paul and Sara ask for help in finding theirs.

John had a huge advantage over the thousands of other American adoptees whose Italian family origins still remain an unsolvable mystery despite years of digging for answers. When

John was five years old, Russell and Barbara decided to move the family from a rural town near Poughkeepsie in upstate New York to the blush-tone bricks of Assisi, the following year to the sea town of Forte dei Marmi with its backdrop of Alps streaked white from Carrara marble, and finally to Florence, settling in the city for nine years. At the time, twins Paul and David were eleven and Sara was four.

Russell, a painter, and Barbara, a weaver who longed to be an architect, had met as students at the Parsons School of Design in Greenwich Village in the 1950s. After they married, Russell taught commercial art at New York University, and they shared a restless bohemian spirit and deep love for children. Both were trained in the teaching method of Maria Montessori by her son Mario (also a member of Italy's subset of abandoned illegitimate children, recognized by his mother when he became a teen-ager). The couple considered opening their own school decades before the Montessori method became fashionable in the United States, but they dropped this plan to begin a more intimate one. Barbara learned in her early thirties that she needed a hysterectomy. "God has other plans for us," Russell responded to their shared grief, and they sought to adopt, turning to their local Catholic agency.

Russell, whose parents had emigrated from Southern Italy, fell in love with the country during a dark and desperate time, stationed as an American soldier in World War II. In 1960, he returned with his new wife, one of the few American couples to personally visit the Turin Institute and meet the beautiful dark-eyed identical twins whom they would adopt when the boys were three. This unusual relationship with the Institute—only the rare adoptive couple traveled to Italy since typically the thousands of children in the orphan program flown from Rome would meet their new parents in America—enabled

them to later adopt John and Sara. The couple had made a generous contribution to the institution and the mother superior earmarked the boy and girl for Russell and Barbara after their birth mothers surrendered them as infants.

The couple's decision to temporarily transplant the family to Italy seemed a perfect choice. Russell could pursue his fantasy of painting in the Umbrian and Tuscan countryside, and the children would return to the land of their birth, steeped in its culture and learning the mother tongue first heard in the *brefotrofio*. They chose Assisi because of a friendship Russell formed in Greenwich Village with Abstract Expressionist painter William Congdon, who at the height of his American fame moved to Venice where Peggy Guggenheim became a primary collector. A restless Congdon moved again to Assisi, converting to the Roman Catholic faith, guided by the ascetic lifestyle of the first Franciscan. Russell, who shared his friend's affection for St. Francis and the spiritual landscape of Assisi, decided to follow, but the painter's abstemious choices proved infeasible for the Campitelli family. After living through a winter's deep freeze on isolated farmland in an unweatherized cabin, they packed their bags the next year for more comfortable lodging in Tuscany.

The couple started several small businesses to support the family. Russell painted Christmas cards, watercolors of Rome and Venice for upscale hotels; he carved wooden tree ornaments for export; they opened a shop that sold majolica ceramics from local artists, and the combined ventures financed the eleven years the family spent in Italy. By the time John was eleven, he had mastered a perfect Florentine accent, but to his friends, he was always "the American."

"*Tu sei Americano ma tu sei nato in Italia,*" ("You are American but you were born in Italy") the local boys teased. An American, but a funny one.

John and I are back downstairs, having left his bookcase collection and the twins to play, settled into the cream-colored couch discussing these formative years. Simona brings over the cake and coffee she has prepared and grabs a chair to join us. She has a pixie haircut and wry sense of humor, and like all good spouses, remains an attentive listener, occasionally adding details to stories she's no doubt heard many times before. Stories, however, which I am eager to hear. I want to learn the roots of John's fascination with phone books that led him at age eleven to set out to find his birth mother.

- 3 -

Russell rented a beautiful home for his family in Florence. Having learned some Italian, his accent more proficient than his grammar, and helped by Barbara, with grammar more proficient than accent, he made a deal with a hotelier who owned a stately nineteenth-century apartment building on the same street. In a neighborhood once popular with the British who flocked to Florence, they lived in the coveted *piano nobile* for one hundred thousand lire a month, a handsome sum in 1970. To the children, the apartment, a ten-minute walk from the Santa Maria Novella train station, was heavenly, with sky-high ceilings, two massive living rooms, a large back terrace, and shared courtyard garden where apricot, magnolia, and sequoia trees grew, the magnolia's soft pink petals poking into their bathroom window with the first blush of spring.

The apartment's marble floors seemed to stretch forever, and the children treated the living room like their personal ballroom, grand and always available for strapping on roller skates to glide from one end to the other. Barbara rang a bell to collect the family for dinner or risk going unheard and the food getting cold. It was a place so magical that John and Sara still dream about it in their middle age.

Around the corner from the apartment was the Piazza Indipendenza, and John and Sara, a tag-team just one year apart, strolled through every afternoon on their way home from primary school. On one end stood a private maternity hospital catering to the city's wealthiest families. A handsome brass structure at its entrance announced the day's births, large blue pastel bows wrapped on one side of the gleaming bars, pinks tied to the other. One of Sara's favorite rituals was to check out who had been welcomed to the world while the children were at their desks that morning penciling in math equations and learning the rules of grammar. "Oh boy, another one is born!" Sara would announce, treating the elegant ribbon twisted into a perfect bow as a gift for both of them.

On the southern half of the tree-lined piazza, closer to the Campitelli apartment, those soft pastels morphed into darker hues, the political realities of the 1970s, the Anni di Piombo. The Piazza Indipendenza housed, on opposing sides of the square, the headquarters of the neo-Fascist Movimento Sociale Italiano and the Casa dello Studente, where leftist students battled their political neighbors, turning the peaceful grounds into a center of protests, strikes, and sizeable militarized police presence. The Campitellis' building shared the courtyard garden with the Casa dello Studente and in the warm weather the air filled with songs, shouts, and sometimes tear gas as both parties lobbed grenades at the other. John and Sara remember running home on several occasions to escape the chaos and fumes. The children became experts in leaving open a crack in the windows to stuff rolled wet towels.

It was out of this environment of sheer delight and dangerous uncertainties, of relearning the mellifluous notes of a language first heard by tiny ears, of pastel bows celebrating babies as presents for parents, of clashing visions and righteous beliefs,

of being an American transplant on soil where family ties were as intertwined as the garden's sturdy branches, from which a young John Campitelli began to wonder more and more about the story of his birth. Barbara and Russell had always been open about the adoption of their four children. But for as long as John could remember, he had lingering questions.

Eleven is a tender age, particularly for sensitive children whose family stories don't cohere to a larger societal narrative—the "only crazy kid" beside his siblings adopted from Italy by American parents. In the quiet of his bedroom John wondered, who is the woman who gave birth to me and why did she give me up? Is she alive, and if she is, wouldn't she want to see me? Do I look like her, share her demeanor; can I see her face in mine?

John's Italian birth certificate, which Russell and Barbara had let him see, revealed that he was born Piero Davi, a fact that fed the boy's imagination. Barbara had a strict no-television rule for the family, adhering to her motto that everything you want to know about the world could be found in books. Unlike most American children of that era glued to the television set, John turned to the mysteries of Sherlock Holmes and the swashbuckling adventures of Robinson Crusoe, supplying a fantasy life as supple as his roller skates gliding across polished floors. What more perfect mystery to solve, the young detective reasoned, than your own?

The day he took those first steps must have felt like quite the adventure. He made an excuse to leave the house and zigzagged through the narrow streets, soft hands brushing the coarse grain of Florentine stone. Heading to the Santa Maria Novella train station, John skipped the commercial route along the Via Nazionale, avoiding the hellos of the local baker who made his favorite cookies and the merchant who sold his parents wine

in curvaceous bottles wrapped in straw baskets. He could shave a few minutes of precious time taking back streets, Via di Barbano to Via della Fortezza to Via del Pratello, to Via Faenza to Via Bernardo Cennini that led to the rear of the busy station. Innocence and determination can be a heartbreaking duo and with the turn of each corner John believed he was getting closer to a solution.

He wasn't planning anything slapdash like hopping on the next train; the boy, like the man, has always been methodical. John knew that the major train stations housed the local offices of the SIP, where he could find phone books for every city in the country, though he wanted just one—the city of Turin. Those bound pages contained the index to his life's first volume, a book so treasured a version rests on his shelves today. John wandered into the SIP office as if it were the most natural place for a child to spend the afternoon. Grabbing the coveted phone book, he settled into a private booth where you could place operated-assisted calls and pay a clerk later, eliminating the cumbersome *gettone*. Flipping a finger's width of pages to the letter "D," he copied into a notebook everyone with the surname on his birth certificate, Davi, about thirty-five people, along with their telephone numbers and addresses.

"So I figured, I'll start making some calls," John tells me, seeming to relish the memory of this plucky eleven-year-old. He dialed the rotary phone possessing the wish that the person who answered could connect his untraceable line.

Pronto.

Now what? With a pause to summon courage he asked, "Do you know anything about a boy named Piero Davi who was born in Turin on September 23, 1963?"

Ma chi sei?, But who are you?, the Turinese typically responded, confused by the odd question and small voice. John tried more

names until he ran out of money and time, knowing his parents would be looking for him. For several weeks, he repeated this ritual, saving lira and sneaking back to the train station, not even telling his siblings. Some responses were kind, the majority curt, but regardless of the sympathy or indifference in each inflection, thirty-five times he heard the same answer: No. Not one of these people named Davi knew of a Piero born on that day.

John had no choice but to admit defeat, a huge dent in his plan. His failure to find a clue about Piero's origins, however, caused his thoughts to darken. Could he really not be related to any Davi in Turin? Alone in his room, he entered the private dizzying world of the precocious child battling the most basic demons of self—who am I, and how did I get here?

"My parents gave me my birth certificate and it says Piero Davi on it. It's got to be me unless it's a fake birth certificate. I read around, I heard stories of children who were abducted and given fake birth certificates and I thought, well, maybe I'm one of those."

"Abducted?"

"Yes, I thought maybe my parents were trying to hide something."

At first, the path of his childhood thoughts startled me. But then I considered, if deep down a young boy believes that his mother would never give him up, the idea that he might have been forcibly removed from her is as logical a route to take as winding your way to the train station to call everyone with the last name Davi. And, of course on another level, considering how you interpret the meaning of the word consent, the boy may have been onto something.

The book that now alighted John's imagination was not Sherlock Holmes but his favorite fictional castaway. "I felt like I was Robinson Crusoe on this island. I came from somewhere

and then I got stranded and there was no one else on this island. I felt like I was that kid, and then I thought, I need to find my Friday because maybe my Friday will help me."

That's when he started talking to Sara and to Paul and David, finding comfort in having three siblings who could potentially fill the role of Friday, the famous companion whose footprints the hero discovers in the sand after years of his isolation. After all, they had been stranded on the same island, the *brefotrofio* known as the Turin Institute. But the twins, then seventeen, weren't interested in looking for their birth mother and neither was ten-year-old Sara, who adored her one-year-older brother, and kept asking John why, if they already had a loving mom and dad, did he need to find another? John reassured Sara of his love for their parents but explained that he wanted answers to a story that he felt wasn't adding up.

"I'm going to get to the bottom of this. I can solve this mystery," he promised.

When I later met Sara, a painter and teacher living outside of Florence, I asked about her memories of this time. She recalled one afternoon during siesta when their parents were napping and John quietly brought her to their art studio and office on the other end of the apartment. John climbed to reach a cabinet where Barbara stored keys to files that contained important papers. He opened a small metal box and brought it to Sara, sitting on the floor amazed at her brother's antics. Inside were papers related to the children's adoption and naturalization that included tiny photos of each of them.

"He was so proud, saying, 'Look, look, look at this!' That was the first time I remember distinctly the effect of seeing these pictures. When you're a kid, it was strange to be looking at pictures of us, and John saying, 'You see, my mom is not the same as your mom.'

"That's the way it was," Sara says, laughing at the situation and their opposing temperaments. "He always had a detective mind, even as a child."

Talking to his siblings helped John feel a little less alone, but his essential dilemma—that all the clues he had so carefully amassed led to a dead end, and neither the twins nor Sara were interested in solving this mystery—couldn't be resolved. John knew he'd need to put his efforts on the back burner, which meant remaining stranded on an island of his own for a very long time.

The seasons changed with by now their familiar rituals. The long cold winters, when neither charcoal furnace nor portable heaters could warm the huge living space and the family laughed as Russell wore more clothes at night than day, bowed to spring's arrival with birds chirping in the courtyard like feverish violins and the magnolias once again perfuming rooms, shedding soft pink petals onto the children's tiled bathroom floor. Summer's favorite antics faded as John and Sara grew too old for their silly childhood pranks, like dangling a wallet attached to invisible fishing line from a bedroom window, waiting for the curious reach of an even more innocent passerby; fall brought busier school days and complicated social lives. John was becoming a *ragazzo*, playing soccer with pals, tinkering with motorcycles and cars, and now decidedly more Italian than American.

Sara, too, was growing up, absorbed in studying art history and delighted to live in the only city that, in her mind, could properly feed this passion. But the twins had fallen into a darker period. Russell and Barbara struggled with Paul and David's developmental issues from the time the couple had brought them home from Turin, but when the boys reached puberty

their difficulties escalated. The rigorous high school curriculum overwhelmed them and after repeating their sophomore year twice they refused to go back. Despite all of Barbara and Russell's painstaking efforts through the years, teaching the young boys using the tactile touch and subtle bell tones of the Montessori method, enrolling them in private school in America—the identical twins would never receive a high school diploma. Paul and David, who lived most of their lives in a symbiotic dance, a pattern often found with identical twins, replaced those school days with seasonal work, selling leather goods in an outdoor market. Now, in their early twenties, both had found year-round jobs in the indoor central market selling fish.

The nine years the Campitelli family spent in Florence had also turned bleak for Russell and Barbara, whose businesses were failing. They'd been naïve about the baroque methods necessary for running a local shop and conducting a small business in a foreign land. They hadn't thought about copyrights or patents for Russell's craftwork, or fully considered the consequences of economic forces outside their control. Despite their deep love for the country, Russell and Barbara both possessed an American frame of mind, lacking the native's sense of *pelo e contropelo*, that intrinsic skill of knowing how to brush the fur both ways, nor did they have the fatalist's instinct for all that could go wrong. A decade in, they found themselves blindsided.

Sales for Russell's watercolor Christmas cards plummeted after postal rates tripled; American companies sought cheap plastic tree ornaments rather than Russell's handcrafted ones; and Italian firms copied some of Russell's designs—all their business ventures miserably failed. Russell, forced to take a job in a factory that made lenses for airplanes, was exhausted and defeated. The couple knew, despite how hard this would be for their children, deeply attached to Florentine life, that it was

time to head back to the States. Paul and David refused, saying their friends and life were in Italy. Russell and Barbara tried to convince them to return with the family, but recognizing they were young adults, and still unaware of the depths of their problems, ultimately agreed and found them an affordable place to live.

So, in 1979, just four Campitellis, saddened by their shrunken composition and separation from a culture that had nurtured them, packed up their belongings and returned to America, this time moving to the city of Ithaca in central New York State. John was fifteen, Sara fourteen, and college was on everyone's mind, along with its high tuition costs. Russell and Barbara, always thoughtful about their children's education, researched options and chose Ithaca, discovering that Cornell University, located there, had a special reduced tuition program to which local residents could apply. The couple thought that John and Sara might have a shot at getting into the prestigious Ivy League school, and this was one of their bets that turned out, on both counts, to be correct.

- 4 -

The move back to the States only reinforced John's dueling identity. In the isolated region of Ithaca, he was now the Italian boy in America, entering high school with a weakened command of English grammar and slight accent. The school tried to help by placing him in the Italian club. John wasn't the only one struggling to adapt.

Barbara and Russell were experiencing their own culture shock, returning expats looking for work, worried about Paul and David, and missing the daily routines of Florentine life. Sara remained brokenhearted about studying art history thousands of miles from where history's brushstrokes, those luminous temperas of Giotto and Botticelli, covered walls and canvases in churches and museums that had become her second home. For Sara, this feeling of loss, year after year, did not abate and at a certain point Russell and Barbara agreed she could take a lengthy leave from Cornell to enroll in art school in Italy. She would earn a degree from the Accademia di Belle Arti before returning to Ithaca to finish her studies.

By the time John entered college he had become more comfortable in America and university life boosted his confidence and sense of self. Dark haired with large sympathetic brown eyes,

he towered over the diminutive Russell, still convinced that his son must have northern roots. John immersed himself in civil engineering and computer science courses, subject areas that suited well how his mind worked, particularly the latter where in the mid-1980s rapid changes were underway. ARPAnet, the precursor to the Internet, had been created by the U.S. Department of Defense, and Cornell was among a select group of five American universities funded by the government to house a supercomputer center that served as a traffic highway for this shared data.

The system linked to major universities throughout the world and John's internal homing led him back to Italy, rekindling his hope to find his birth mother. Through the ARPAnet he could communicate with students at the Normale in Pisa and Cineca in Bologna, and when this American boy who spoke and wrote in flawless Italian explained his circumstances, the intrigued students offered to help if they could. Cornell taught John that the ARPAnet (and years later the Internet) could be an invaluable tool in creating a network of people to solve a story that he always felt didn't add up.

With a heavy course load, however, John had neither the time to conduct the nuts-and-bolts paper trail nor the emotional stamina necessary for any adoption search. He resumed these efforts after his graduation, sending letters requesting information about his origins to agencies in Italy and America but receiving only scant non-identifying information. A major turning point occurred in 1989. John, three years out of college and working for a computer firm in Chicago, planned to attend the annual conference of the American Adoption Congress, an umbrella organization of adoption reform groups, that was being held in Anaheim, California that year. He recently had connected with a fellow adoptee named Diana Smithson. A

woman advising each of them about how to conduct an adoption search recognized that both were born in Italy, Diana in Rome, three years before John. The two spoke on the phone and decided to meet at the conference, John flying from Chicago, Diana driving from her home in Albuquerque, New Mexico.

Diana was twenty-eight, and having married her high school sweetheart, already the mother of three small children. The weekend away would be a rare event, but she needed to make this trip. If what led John to California was the pull of longing, for Diana it was the friction of anger. How could any woman, Diana had asked herself since adolescent days, abandon her child? What kind of person does this?! How could Diana be left to stare blankly at doctors when all three children needed to be delivered by Caesarean section and she had no family medical history to share? How could pet owners be more certain of the pedigree of their cats and dogs than she was of her own past?

The conference in Anaheim offered them a sense of promise and community, this city of palm trees and home to Disneyland. In a photo Diana took, John looks joyful, wearing faded jeans and dirtied white sneakers, balancing himself on the base of a fountain whose jets of water sprayed plastic pink flamingoes anchored inside. One conference session seemed tailormade for the two: how to conduct a genealogical search for children born in Italy, led by a woman more than twice their age named Florence Ladden Fisher. John and Diana had no idea of Fisher's fame in the adoption rights movement when they walked into that room.

Fifteen years earlier, in 1974, when eleven-year-old John skirted past travelers under the immense ceiling and milky skylight of the Santa Maria Novella train station to head to the SIP offices, a cataclysmic shift was taking place on the other side of the ocean concerning the rights of adopted children. In that

same year, Florence Fisher had become the irrefutable leader of the American adoption rights movement. She had recently published *The Search for Anna Fisher*, the story of finding her birth parents after discovering she was born Anna Fisher, adopted by a couple named Rose and Harry Ladden, which became essential reading for adopted children.

Fisher challenged the near-universal belief that adopted children needed to put the past behind them, that asking questions, or even worse, seeking their birth mother was an act of ingratitude toward adoptive parents, a "slap in the face," as was commonly said. At the core of this attitude—why would you want to find the woman who gave you up?—existed the belief that a birth mother didn't want her child, rather than that she may not have had a choice. When questioned by the *New York Times* why an adult adoptee underwent such a search, Fisher replied, "The need is not that of a child for a parent, but rather a need to acquire a history and biological relatedness in a world that has asked us to live a contrived identity in a contrived reality, not just as a child but for all our lifetime."

She formed the Adoptees Liberty Movement Association, ALMA, for the Spanish word for soul. ALMA lobbied to open sealed files to make birth records available to any adoptee over eighteen who sought them. Fisher has been credited for helping to spark the adoption rights movement in the way that Rosa Parks's refusal to give up her seat on the bus to a white passenger and Rachel Carson's publication of *Silent Spring* spurred the civil rights and environmental movements.

This public prominence led to Fisher's involvement in a case of an Italian child adopted in America. She had been contacted by President Ronald Reagan's office after the White House received a letter from a retired fighter pilot written on behalf of an Italian friend who was trying to find his lost brother. The

man claimed that his father, a peasant farmer from Avellino, had sent his eight-year-old brother to America in 1957 through a Catholic Church program with the false promise that the boy would remain in touch and return to Italy when he turned eighteen. Reagan's office asked Fisher if she could help the man, and after an arduous search, she found his brother, who had been adopted by a family in California. Fisher brought him back to Avellino, where his father, who lay in a hospital bed, begged his son's forgiveness.

She began poking around the office of a Catholic agency in New York City and said that she had seen cards in file boxes with the names of thousands of children sent from Italy to America for adoption. There could be ten thousand of them, she claimed. Diana and John looked at each other in disbelief. The room in which they sat was nearly empty, a few international adoptees from Ireland, France, and Spain; they were the only two in the room born in Italy. Could there really be thousands of others like them? It seemed unreal, but Fisher impressed John, who was energized by her encouragement and zeal, and would always remember her as his first mentor.

Through the years, younger, like-minded women and men took over Fisher's leadership role, creating groups with names more radical than ALMA, like Bastard Nation, and she fell out of the public eye. But in 2020, with John's help, I located Florence Fisher, three weeks shy of her ninety-second birthday, living alone in lockdown in New York City during the coronavirus pandemic, and as feisty as historians have depicted. When I told her about my research into the orphan program, she responded in her inimitable way: "You mean they were stolen. Let's call a spade a spade, and people in authority in Rome colluded on this." Although the years had muddled details for her, the adoption rights pioneer still remembered her trip to

Avellino, uniting father and son. "Of all the things I ever did in my life, that was the best thing. August 1985, when we walked into the hospital."

John's world was broadening. Back in Chicago, he tried to maintain the exhilaration of those California days and bought a copy of *The Search for Anna Fisher*. Reading this adopted woman's demand to find out who she was, John could hear the timbre of Florence's voice with each turned page and detect his own emerging one. Her story described emotions that he, too, had experienced in the private space of his bedroom in Florence. He thought about his mother's guiding words to her son in those days: books are your life companions, the place to look for answers. Gone was the boyhood fantasy world of Robinson Crusoe, replaced by the restless pain and persistence of Florence Fisher's search for her birth parents, a new set of footprints in which to place his own.

Putting into practice what he had learned at the conference, John contacted a man running a mutual consent registry, which enables adoptees and birth parents to place their names into a large shared database. Mutual consent registries can provide a means, albeit an aleatory one, to reunite. John requested the names of registered adoptees who had been born in Italy. About forty-five people fit the description, but the names couldn't be released without their consent. The man offered to forward John's request for information, and John teamed with Diana to form an official group. They called themselves CIAO, Caring Italian Adopted Orphans, not mentioning that only two caring members currently existed, with both unsure if they were even orphans. They put together a flyer with a series of bullet points explaining the group's mission as adult adoptees seeking to search for their birth parents. John borrowed language that

Florence Fisher had once used for an advertisement she placed in a small newspaper that sought contact with other adoptees and resulted in an overwhelming response.

Of the forty-five people who had registered, CIAO received twenty-six responses, enough to startle John and Diana, who now had tangible proof they weren't anomalies. John would next discover the number of children sent to America, the truth between Fisher's guess of ten thousand and his personal experience of five, having added Diana to the list of the Campitelli clan. John met a man named William Gage who was born in Germany and adopted by an American couple. Gage, struggling with his own sense of difference and alienation, ran a group called Kinsearch that sought to connect German adoptees. Using the Freedom of Information Act, he requested from the Immigration and Naturalization Service (INS) the number of children sent from Germany to be adopted in America.

The government responded to Gage's request by sending the relevant INS yearbooks which, along with Germany's numbers, included statistics for Italian and Irish children sent to America under the immigration status of "orphan visa." Italy's share dwarfed Ireland's contribution from its Magdalene Laundries, with over 3,700 Italian children sent between 1950 and 1970. Gage shared the information with John, who included it in his flyers, explaining the magnitude of what CIAO could become. "He opened up the whole world to me," John says. "Now we had factual, statistical evidence of how many children came in with orphan visas. So I had a starting point."

Gage also wrote a monthly newsletter called *Geborener Deutscher*, German by birth, which he distributed by mail to adoption support groups throughout the United States, and he mentioned CIAO in his newsletters. Gage's efforts brought forth more names, adoptees born in Benevento, Milan, and Rome,

and John began to see that children from all over Italy had ended up in America during this same time period.

Being bilingual and bicultural, as John's university days connecting with students at the Normale and Cineca showed, offered essential tools for his work ahead. He wanted to trace these thousands of adoptees, but first he had a more personal dream to pursue. John requested a work assignment in Switzerland and Italy and his company agreed to a year-long transfer. In 1991, he embarked on his return with Florence Fisher's firm words in his head: "You guys gotta wake up! You'll never get what you want until you wake up and fight for your rights."

- 5 -

John would begin, no doubt, where the phone books first led him. He sent letters to the province of Turin and the city's primary maternity hospital, Sant'Anna, as well as resuming his old method of cold calling people who might have information. For the first time since his infancy, John went back to the Turin Institute, which had closed in the mid-eighties and now housed a community of people with disabilities along with some supportive housing for single mothers and children. He was spared the sight of cribs lined up in narrow rooms where the babies once had been kept. Only the offices of the lay head administrator and mother superior, decorated with elegant parquet floors and a fireplace with a wood-carved mantel and majolica surround, escaped the sterility of the wards, stripped of hue like spilled bleach on patterned fabric. Yet compared with the rest of the country's *brefotrofi*, particularly the sorriest places starved of resources in the South, the Turin Institute was top-notch, exceeding the reputation even of Milan's, where the windows installed high on each floor prevented little heads from ever seeing the world outside.

John could glimpse only a faint sketch of these early years, yet a frisson of connectedness, fleeting and intuitive, haunted

him. He tried to place the buildings, which sat along a lush path in a neighborhood called Crimea, to that time before memory guides us. There was an institutional gray one from the 1950s, and three elegant nineteenth-century structures, which originally served as private clinics, painted in terracotta and cream.

John began to fill in the blank of his past by making critical connections, meeting people who had worked at and understood the history of the *brefotrofio*. A compassionate social worker described its day-to-day routines and passed along the names of others who might be able to help. He visited the Sant'Anna Hospital and met its medical director who shared a cultural connection, having studied in America and married an American woman of Italian descent.

The medical director explained the law of anonymous surrender and the significant hurdles ahead. John never envisaged how centuries of Catholic history had secured a Sisyphean rock at the start of his path. His mentor Florence began her search with the essential clue of her birth certificate, the moment seared in the child's memory of seeing the surname Fisher on a document she had found in a bureau. But the vast majority of Italian babies sent to America during the years of the orphan program carried the legacy of anonymous surrender, of all those sorrowful mothers from the Middle Ages onward who had placed their baby into the abandonment wheel, known as the *ruota degli esposti*, and with the turn of the wheel forever said goodbye, the child now in the care of the institution, a nameless ward of the state.

While the wheels closed at the end of the nineteenth century, the law of anonymous surrender remained in place and became critical to the smooth operation of the twentieth-century orphan program. Eliminating this crucial piece of identifying

information secured the irrevocable separation of mother and child, and by dusting off this ancient law, an American law firm polished the legal mechanism that enabled the Vatican to facilitate its international adoption scheme.

There would never be any person with the surname Davi aware of a boy named Piero born on September 23, 1963, because somewhere at a desk in Turin a bureaucratic scrivener clocking in at the Registrar of Births was charged with creating fictional surnames on birth certificates for illegitimate children. I picture a haggard man in a dusty warren, breathing the stale air of cigarettes and burnt espresso, pushing away piles of folders and loose papers to make space for these legal-sized documents filled in by hand. The clerk was a contemporary version of those medieval scribes who stripped newborns of family identity and ties, assigning them the name of the foundling home to which they had been surrendered, the permanent stain of their illegitimate status. In the city of Florence, for example, babies relinquished to the Ospedale degli Innocenti assumed the surname "Innocente." In Naples, they were called the "*esposito*," exposed to a public space. Esposito, that common Italian-American surname, is a relic of this painful legacy.

This practice existed until the nineteenth century when the belief emerged that the surnames of illegitimate children should no longer carry the stigma of their birth line, and generic names were chosen instead, using, for example, the categories of animal, vegetable, and mineral, like those labeled slips of paper providing clues for a game of charades. What inspired the modern clerk's choice of made-up surnames? Death certificates, old phone books, stories from the local newspaper, school rosters from a third-grade classroom? Did he have a separate list of common and uncommon names? Did it take twenty seconds

or two minutes to create and ink this lifelong false identity? Did he prefer not to?

But here, in Turin, in the final decade of the millennium, John had the good fortune of meeting a man who offered to help him without blatantly violating the medieval code. He asked John for a little time to research the case, and the Church's orphan gladly obliged. Two weeks later, the medical director contacted John. He found the file of a woman who on September 23, 1963, checked into the Sant'Anna Hospital and gave birth to a boy named Piero. He sent John the non-identifying information confirming his surrender from a "*donna che non consente di essere nominata*." This fragment from John's files would have been another whisper into history's void, except the doctor shared, sotto voce, a critical piece of information: "You're wasting your time looking in Turin. You have to look down south because your mother is from the province of Brindisi. That's all I can tell you, don't ask me anything else."

John had no connection to the South so he contacted a childhood friend from Florence named Achille for advice. Achille responded by putting into play the time-honored "I know a guy" strategy of getting things done. John's friend knew a friend who had a cousin who happened to be a journalist for the *Quotidiano di Puglia* and, as is sometimes the case in this just-throw-the-ball scenario, it landed in a player's glove. The intrigued journalist took many notes and soon published a two-page feature on John's search. After days of sleepless anticipation, John's hopes were deflated, the article yielded no information, surprising the journalist who was accustomed to receiving anonymous phone calls after publishing this type of human-interest story.

The journalist offered to put John in touch with a reporter

from *La Stampa*, but John didn't understand why the Turin-based newspaper would be interested in running a story about a woman from Brindisi. "I think that she might have conceived you in Puglia," the journalist told John, "but then she went up north because many of the women down here went up north to hide their pregnancy from the local town." John felt naïve—it was the first time he considered the idea of being conceived outside the city of his birth. He had not thought about how or why his birth mother had arrived in Turin, only that he was born there. With little to lose, John agreed and shared his story with *La Stampa* and again a journalist wanted to run it—this time on the front page. And once again John experienced the same arc of anticipation and defeat, told the next day that the paper's editor refused to publish the story. The apologetic reporter explained that the law in Italy prevents a person from searching for his birth mother if he was anonymously surrendered.

"There's a law?" John asked incredulously. John had come of age as a young man in an America which, thanks to a Supreme Court led by Earl Warren, had expanded civil rights and civil liberties. He was shocked to learn that a government could tell a newspaper what, and what not, to publish, and that he had no right to look for his mother. After these two unsuccessful tries, John could have responded with fatalistic acceptance, a public shrug and private anguish to the denial of a dangling hope and haughty belief that one's history could be reconfigured. But instead, John channeled his New World side, which simply put, places faith in the belief that for every locked door exists a master key.

John called *La Repubblica* and informed a reporter of what had transpired. The newspaper welcomed the opportunity to publish a story that a more traditional competitor had just killed. The day after the article appeared, a woman called the

newspaper office to say that she knew the birth mother. John was twenty-seven years old, and in the few months since his arrival, a doctor and journalist had just helped solve his child-hood mystery, an outcome that many people had worked exceedingly hard to make sure would never happen.

- 6 -

"Zia Torino," as John refers to his aunt, his birth mother's sister, called *La Repubblica*. The story and dates in the newspaper added up, plus the photo of the adult John with his uncanny resemblance to Francesca confirmed any lingering doubt. So as the gods would have it, the woman who played Hera to her sister, ruling over the birth, concurring with their brother, the *carabiniere* stationed in Milan, that Francesca had no choice but to travel north to surrender her baby (for God's sake, thanks to her shameful situation, his job was now on the line!); the woman who insisted that Francesca reside in a home run by nuns because people would talk if she lived with her in Turin; the woman who said impossible when Francesca pleaded to keep the child, was the person who volunteered to reunite mother and son.

Zia Torino told the journalist that she was willing to help but needed time. The story of baby Piero had been shoved into a container decades ago, and she wasn't about to telephone her sister to tease then drop this swaying two-ton load from its old unstable crane. The situation needed to be handled with delicacy and she had devised a plan: the following month a cousin was getting married and Zia Torino would be traveling south

for the wedding. At the right moment, she'd pull aside Francesca to tell her that her first-born son was looking for her.

John, reeling from all that he was learning, tried to imagine the sisters' conversation and what would transpire. He didn't want the mother he had spent so long looking for to faint upon hearing the news, especially if he couldn't be there to catch her. He agreed, but unbeknownst to the reporter or his newfound aunt, John had been forging a backup plan. Having been disappointed too many times, he needed to pursue all available routes, especially because the days of his yearlong assignment in Italy were ending soon.

The social worker also had offered to help. Perhaps the medical director and social worker warmed to John because they saw in his plaintive eyes a childhood wound, or because he was an intriguing curiosity, an American who pleaded flawlessly in the mother tongue. The plan she hatched employed a networking strategy remarkably similar to Achilles's, except with an apostolic bent: she knew a nun who knew a nun at a convent in the town where John's birth father lived. Over the years the nun had kept her ears attuned to the local gossip, and word was that this man had been run out of his former village for getting a worker pregnant. The date of his appearance matched to the time of the olive picker's disappearance. When the article ran and Zia Torino replied, the nun's hunch was confirmed. The nun then called a social worker in the town where Francesca now lived.

Francesca would be told a white lie, that an important matter concerning her pension had arisen needing to be handled in person at the local social service office. Francesca, who no doubt must have been concerned about this pension issue, arrived with her husband, a man she had become engaged to when she worked as a nanny in Turin. He was also from the

same southern province and had been stationed north as a police officer. The couple had been married for over twenty-five years and had five children. The social worker asked to meet alone with Francesca. The stunned couple agreed, and privately asked Francesca if her husband knew about the child whom she had given birth to in 1963.

At what rate does the heart beat when confronted with such a question? Of course he knew. He had accompanied Francesca to the *brefotrofio* when she asked for Piero back. They planned to marry, making an honest woman out of her. But the mother superior had lied, saying that little Piero was already in America, having reserved him for Barbara and Russell who had visited the *brefotrofio* again after adopting the identical twins. ("I saw John in the crib and he was crying and I said, 'I want him,'" Barbara told me.) *Make peace, woman. Your child has been sent to America. He is with a good family.*

Yes, Francesca said, my husband knows about the child.

Your son is looking for you, she replied. Are you willing to meet him and welcome him back to your family? At least she was sitting down. John didn't have to worry about her falling to the ground or choking while munching sugared almonds during the family wedding.

In the time it took to put together these various strands that led to Francesca sitting in that office, John's overseas assignment had ended and he was now working for a computer software firm in Los Angeles. The social worker called him at 1:34 a.m. (John kept the Pacific Bell phone record) to give him the telephone number of Francesca, who was waiting for him. At 2:10 a.m., (11:10 a.m. in Italy), on September 1, 1991, John, soon to be twenty-eight, heard for the first time in his conscious memory the voice of his mother.

There were so many questions to ask, too many for a phone

call. Still, the conversation stretched into the early hours of the morning, and John was awake enough to think of recording it, which he replayed often like a cherished melody. John proposed they continue the conversation through correspondence. Francesca's first letter arrived in his mailbox on September 11th, one decade before the rest of the world, too, would remember that date. For three months, mother and son exchanged letters and photos, a stack of stories and pictures, of siblings and a life that did not include him, but whose details he nevertheless caressed.

Carissima Francesca, began one of John's letters, "I don't know if I should call you mamma or Francesca . . . with these few lines I would like to express my joy in having finally found you! From now on, my life will never be the same; in those few minutes that we talked to each other, a wall collapsed that oppressed me for years." He concludes by addressing her as "Mamma" for the first time.

This pas de deux in prose, the outstretched arm yearning for the distant hand, became the prelude to their meeting in November when he arrived in Brindisi's small airport terminal. After retrieving his luggage, he headed to customs where the officer flipped through John's passport and asked the requisite, "Are you here on business or pleasure?"

"For me, it's going to be a very pleasurable moment because I'm here to meet my birth mother after twenty-eight years."

"Really?"

Not the usual answer to which a customs officer is accustomed.

"Come inside," he told John. This was too good a story to give up, just yet. The officer brought John to an enclosed space with a window and pointed to the small gathering of people outside.

"Do you recognize her here?"

John spotted her immediately.

"But you never met her before?"

"No, but we exchanged pictures, so I know what to look for and she looks exactly like me. And there she is with her husband, waiting for me."

"Okay, I'll let you go."

"It felt like such a long trip to get there," John tells me, "but after twenty-eight years I was able to see myself and the person I always wanted to see. It was like two worlds coming together. It is very moving to finally be able to touch, to smell, to feel another person that you know is your mom."

Francesca brought John to their home and the next day she baked him a birthday cake. She knew, of course, that his birthday was two months earlier, but it was the first time in her life that she could celebrate this day with him, a day she had thought about each passing year. John was overwhelmed by how warmly the family greeted him—her children, his half-siblings, and her sisters who lived nearby. Everybody in town knew that the American child whom Francesca had given up for adoption was back.

"That made her very happy," John tells me. She wasn't the only elated one. Sara remembers the first time she saw John after he met Francesca. She said it was as if a different person stood before her, at peace in a way she had never seen her brother before, his birth mother providing the missing piece to a life puzzle that he had waited for over a quarter century to hold.

The day had turned to dusk, and the clouds hanging low that morning finally turned to rain beating on the windowpanes. Before I packed my belongings, there was one more thing John wanted me to see. We went upstairs, the girls still in good spirits despite the many hours this foreign visitor had occupied their parents' time. Next to the girls' bedroom is John and Simona's

where he wakes up each morning to his favorite piece of art by Russell, a matted and framed print made from a woodcut.

I had seen two of Russell's prints in Barbara's California apartment, abstract images that she hung near a framed glossy profile of her husband's gray-bearded face. "He was a saint," Barbara tells me, meeting his gaze with her own. She asked if I knew how a woodcut was made, which I didn't, and explained the process, how Russell drew the scene on paper before transferring the image onto a woodblock. He carved his sketch onto the wood's surface and used a chisel to make deep cuts into areas where he didn't want the print to carry ink. He then layered the surface with several colors of ink and smoothed a textured sheet of paper onto the woodblock to make his prints.

The picture that hangs in John's bedroom is not abstract but representational; it is signed R. Campitelli in pencil and marked the fifth of thirty prints. He created the image in his Tuscan studio during the same time when his young son acutely felt the need to find his birth mother, and like his son, knew nothing about who she was. Dark ink renders the central figure Russell carved in the form of a shadow. She is an olive picker working in the fields.

In Russell's print one of the woman's arms, like Daphne escaping from Apollo, metamorphoses into a branch of the olive tree. When the young John was dialing all the Davis in Turin, seeking truth in a phone book's black lettering, hoping to create his own family tree, Russell had unwittingly whittled an essential clue. An olive picker, just like Francesca, who had toiled in the fields the day she conceived the baby whom Russell and Barbara Campitelli would adopt more than three years from that day.

Of course, how could John, as a child or an adult, ever have been able to make this association? The thematic designs of any

life are imperceptible, unequipped as we are to know the unlived past or to imagine the unseen future. We're left stumbling in the dark, making patterns when none exist while failing to see what rests before our eyes. Perhaps the act of surrendering a child leads to a biological separation so profound that mother and child, whether consciously or not, hurtle toward connection to break the sphere of loss. And in doing so, create fertile settings for unsettling synchronicities.

The olive picker also looked for signs about the son she gave up, asking God and the blessed Virgin to protect her boy in America. She wondered, as any mother would, about every aspect of his life, where he lived, what his adoptive parents were like, what he looked like, what made him laugh, whether he was happy, well fed and cared for. Answers were impossible, of course, all Francesca had were her prayers. Each day she went to church and in the dimly lit foyer dipped her hand into the marble basin of holy water before kneeling on a wooden pew, seeking answers and some peace for herself and firstborn son. The next morning, she returned, as well as the one after, as months turned into years, all without answers, praying for a clue about her child in her local parish that just happened to be named Chiesa di Santa Maria in *Campitelli*.

- 7 -

If the arduous path to finding John Campitelli's birth mother, with its curious intersections in space and time, possessed the emotional nuance and inventive form of a well-crafted poem, by comparison the story of meeting John's birth father read like a badly derivative screenplay. Its model: Pietro Germi's two classic satires of the milieu of Southern Italy, "Divorce Italian Style," released two years before John's birth, and "Seduced and Abandoned," the year after. In short, John's birth father denied everything, with some foolish melodrama packed in between.

Francesca told John who his birth father was and where he now lived. John also learned that his uncle, the *carabiniere*, was the man who had run the olive grove boss out of town. He had returned south from Milan to defend the family honor and when his sister's boss pleaded ignorance an argument erupted. Punches were thrown and the *carabiniere* reached to where instinct led, his service revolver. Luckily, a more levelheaded brother who had accompanied him that day grabbed his arm, deflecting the shots and saving the life of John's birth father. No bullets are necessary, the more sensible brother announced. The olive grove boss, he declared, was now persona non grata and had a month to get out of town. Message received, he soon fled.

The *carabiniere*'s brother may have stopped his sibling from going to prison but, as Germi depicted through the character played by Marcello Mastroianni in "Divorce Italian Style," the man would have been eligible for a reduced sentence for having committed a crime of honor. Germi, who had been associated with the neorealists, had conceived of his film as a social drama but changed his mind writing the screenplay. "The really comic side," he explained, "would always suffocate the tragic aspect, so it was only natural to pick a grotesque vein, the only one really possible for these incredible stories of 'crimes of honor.' It is sad that they lead to blood and mourning; but all the rest, the thoughts, acts and facts that lie behind and around the crime are absolutely foolish, ridiculous."

Best to awaken audiences to the horror of all those lives that had been lost, to the murder of wives caught cheating, or of virgin daughters and sisters engaged in premarital sex. Better to laugh than to cry at the territorial "right" of a husband, father, or brother to kill them or the men who had made them cuckolds or stained the family honor. The *delitto d'onore*, crime of honor, its original principle formulated by the emperor Augustus a mere twenty centuries earlier, remained in Italy's penal code until 1981.

A decade after the penal code had finally been removed, John, in his usual straightforward manner, knocked on the door of the man said to be his birth father, whose response to seeing John for the first time in his life was a testament to how little things ever really change. The flustered man, who'd heard the gossip about John's reappearance, told him he had the wrong guy. His cousin Frank, who lived in New York, was John's father. John stared at a man whom he, too, resembled, not quite believing what he heard, but also not wanting to believe that he was being lied to.

To the former olive grove boss who now owned strawberry fields, New York meant little more than an imaginary spot in the world where everyone gets lost in the crowd. He had no clue about John's determination or detective skills. So when John asked where and he mentioned the name of some upstate town (which happened to be a ten-minute drive from the Campitellis' first home), the poor guy thought that he had found the perfect alibi. Even when John responded, "Okay, I'll go and find Frank," the man never believed him.

"You find Frank," he said, pointing his finger to John's chest. "He's your dad."

The following year John wove his way to New York to look for Frank using, of course, the most basic tool from his box, the phone book. John knew the nature of these small New York towns, where everyone knows everybody. Frank owned a butcher store and the locals who frequented the shop all knew where he lived, in fact, just a few blocks down, they told him, describing the house and pointing the way. Frank answered the door and saw standing before him a young man with the features of his cousin. He smiled broadly, not quite believing the situation, and before John even uttered a word, said, "I bet he sent you here," figuring his cousin had pointed the paternal finger his way. He invited John inside, reaffirming that, in fact, he was not John's father, and introduced him to his children as part of the family. When John returned to the home of his birth father, the nonplussed man had little choice than to, finally, three decades later, own up.

During much of the nineties, whenever John could manage to get time off, he traveled to Italy, visiting Francesca and spending time with his newfound half-siblings. For Laura, his paternal half-sister, the appearance of this stranger who walked into their lives was an unimaginable gift, having coincided with the recent

death of one of her brothers. She doted on John and cooked him fish specialties of her region, hoping to convince him to like the food he most detested, the smell cleaved to the shirts of Paul and David.

Back home in California, John was sharing details of his searches with the Campitelli family and their surprising twists and turns along the way. When Barbara and I met, she told me about the first time John informed her and Russell of his desire to find his birth mother. She remembered that he called them one Labor Day when he was in his early twenties and asked, "Can I search for my mom?" Not knowing about his early efforts in Florence or poking around for clues in college, the question took them both by surprise.

"Well, we knew that with his determination whether we said yes or no, he would do it. So, we said, of course. You know, after all, you can't deny that. We always tried to give our kids a sense of security and opportunity so they would have the security to know where they came from, a little bit at least. And opportunity, so what they wanted to do, they could do."

Equally determined to broaden CIAO, John was using his computer savvy to do so. With a browsable internet and social networks still some years away, in the early nineties only those well-versed in the language of computers were utilizing a few cutting-edge systems to connect people around the country, and world, as John had discovered in college. One such tool was a computer server known as Bulletin Board Systems where people could exchange information on public message boards. Users dialed in by placing the telephone's handset into a rubber coupler that sat on top of a modem. Imagining the birth of a larger network of adoptees communicating on these bulletin boards, John and Diana renamed CIAO to the simpler and more accurate Italiadoption.

John's brother, Paul, too, became interested in knowing about his past. Paul and David still worked the same job as when their parents and siblings left Florence, at the central fish market, and Paul needed a way out, both twins suffering from problems far worse than their lack of a high school degree and dead-end job. They had started drinking as teenagers, hiding their heavy consumption from the family, and as the years wore on their addiction worsened and included hard drugs. With his health failing and desperate to make a clean start, Paul asked John if he could live with him in Los Angeles and help him find a job. John, who felt as if he already had lost both brothers with the move back to Ithaca, said yes and soon secured work for Paul in a school kitchen preparing lunches for children. Russell and Barbara, who had moved to California to be near John, were equally relieved to have at least one of the twins nearby where they could help him.

At first things went well for Paul. The school kitchen turned out to be a good fit. Although academics had always been a hurdle, Paul thrived in social settings and happily took part in the clamor of pots and pans and easy banter, as he had done in the bustle of the open market. During this period of recovery, the urge to find his birth mother and piece together his early life grew deeper, and he turned to John again for help. Paul only possessed his New York State birth certificate, a useless piece of paper for ascertaining any information about his Italian past. John reached out to Francesca on the off chance that she might have heard about a woman who surrendered identical twins to the Turin Institute, but the years didn't add up. The twins were born in 1956 and Francesca arrived in Turin in 1963. John also applied to Turin to get Paul's original birth certificate, but based on John's own experience, he expected to be put through endless

bureaucratic hoops. To his great surprise, John received Paul's birth certificate shortly after submitting the request.

John couldn't understand the discrepancy. A decade had passed since he had applied for his own birth certificate, but Italian law hadn't changed. So why was it this easy to hold Paul's original birth certificate in his hand? That's when he realized that the twins, unlike John and Sara, had been recognized at birth, not anonymously surrendered, which meant that their mother's name, Maria Gardenghi, appeared on the document.

"Bingo!" John declared, back to the phone books of Turin, this time with the potential to find answers. Three people named Maria Gardenghi were listed, but none had any connection to the twins. Looking further down the page, John saw the name Rodolfo Gardenghi, and remembered Paul's actual birth name, Barbara and Russell christening him Paul Rudolph Campitelli, as they had done with their youngest son John Pierre to honor his birth name, Piero. He called the number, and indeed this man turned out to be Paul and David's uncle. John flew to Italy to meet Rodolfo, a kind man who explained that his sister had struggled with alcohol addiction for much of her life, and died of uterine cancer over a decade earlier, in 1981. He told John the name of the cemetery where she was buried, and John went to visit her grave, taking a photo of her picture on the tombstone. John also checked in on David in Florence and showed him the photo, but David expressed no emotion. "Yeah, but she didn't keep us, so why should I care?"

This memento mori from the trip, a photo of a tombstone photo, would be the sole artifact that Paul would possess of his birth mother. Shortly after John's return, the Campitellis learned that their hope of helping Paul start anew in California had come too late. With Paul's health deteriorating, doctors ordered a series of tests and discovered that he was HIV positive, having

become infected from shared heroin needles. He spent the last year of his life in a community home for AIDS patients where John visited his brother every weekend carrying a hot meal.

Paul died on August 6, 1996, at the age of thirty-nine. The next year, the lifelong symbiotic dance of the identical twins completed its last step. In Florence, David died from AIDS-related illness, also from shared heroin needles, one year and nine days later, on August 15, 1997.

The nineties began with tremendous promise for John. In the sought-after field of computer software, he was becoming an expert, enjoying work that allowed him to travel around the world. The boyhood mystery of finding his birth mother had been solved, closing one painful chapter. The adoption support network he created kept growing, as did his role as translator to a complicated Italian landscape.

By the end of the decade, however, grief and uncertainty had shadowed this joy. Mourning Paul and David, John, like all survivors, wondered what more could have been done, and this nagging question compounded his fury about the practice of sealed birth records. As John learned more about the personal struggles of fellow adoptees and their refusal to accept the truncated version of their history, a tragic outcome of the orphan program's secrecy befell his own family, who had never been given any family histories and medical information.

Shortly before Paul arrived in California, Russell and Barbara learned about the condition known as fetal alcohol syndrome, which was being studied in the international medical community in the seventies, but only brought to mainstream attention in America with the 1989 publication of a memoir, *The Broken Cord*, by the author Michael Dorris. The memoir chronicled Dorris's struggles with the son he adopted, a Native American

boy who suffered lifelong disabilities because of alcohol poisoning passed through the womb. Barbara and Russell realized that many of the developmental issues that Dorris described matched their experience with Paul and David.

The painstaking care that Barbara and Russell had taken over the years, trying to teach the alphabet using sandpaper letters created by Maria Montessori, guiding the twins' small hands to trace the scratchy surfaces, always had been marked by frustration and disappointment. Only after adopting John and Sara, who thrived from this same method of learning, could the couple confirm that something was wrong with the twins' development. But throughout Paul and David's lives, Barbara and Russell had been left in the dark about the root of their problems. Would they have made different decisions had they known about the mother's alcohol abuse? Did Italy's more lenient attitude toward drinking, with easy access to flasks of flowing wine, compound the twins' problems during their adolescent years? Would they have insisted that Paul and David come back with the family to America? Or had the tragic outcome of the twins' lives been marked at birth?

This tortuous path of what ifs, with its strangling obsessive loop, only led to more personal despair. But John was recognizing a larger truth, that a part of his family story touched the lives of every Italian adoptee in America. As long as records remained sealed, these adults not only would be deprived of the chance to know the person who brought them into the world, but also vital information about their medical history and potential genetic markers of disease.

By the end of the decade, the sought-after field of computer programming also took an unforeseen turn. Software may have been changing America, but investors had been buying into many dot-com companies that proved worthless. The bubble

burst and stock prices plummeted in what became known as the dot-com crash. Computer programmers, particularly in California where many of these companies were located, faced the prospect of widespread layoffs. John wanted out and sought a fresh start to the new millennium. The company he worked for, Lotus, had been bought a few years earlier by IBM, and John requested a transfer to Europe. IBM offered him a one-year placement of his choice in Paris, London, or Milan. An easy decision, he'd be packing his bags for Milan.

Russell and Barbara asked why he would leave a life in the United States for one in Italy, but it was an odd question coming from a couple who once had chosen to do the same thing. Despite their sadness, they knew that John would make his own decisions, and, once he met Simona, that their son would settle in the country where he was born and spent his formative years. When John and Simona married, Russell and Barbara Campitelli welcomed Francesca. ("She's lovely," Barbara told me. "She calls me up on the telephone. Yeah, she calls me Santa Barbara because I adopted her son.") When John's daughters were born, Francesca knit baby shoes that could be worn.

John's return to Milan also helped to broaden, as Barbara describes it, "his mission." Continuing his research in Italy, John met three women who founded a group called *Figli Adottivi e Genitori Naturale* (FAEGN) to assist adopted children and birth parents. The women, adopted domestically, were determined to give voice to others like them whose identity had been lost during their earliest days in the *brefotrofi*, a far larger number than the children sent to America. The founders wanted to expand the group's reach, but with widespread social networks not yet developed, and unversed in this computer language, they had no public platform for doing so. John created their first online presence using a Microsoft public message board

system. Along with this technical knowledge, taking his cue from Florence Fisher, John shared the vision and language of the American adoption rights movement with the Italian group.

Today John continues to lead the Italiadoption group, now composed of several hundred Facebook members, and works with FAEGN, with nearly four thousand members, still struggling to change Italian adoption law that seals records for one hundred years. For the adoptees in America, John serves as a curator of collective grief, a translator to their lost Italian world, and an invaluable navigator to conducting searches and the Italian court system. Group members vent their anger about sealed files, share the hurdles of ongoing searches, and add doses of dark humor, like one man who posted a photo of handmaids from the television series adapted from Margaret Atwood's novel with the one-word caption, "Mom??"

Getting to know John in the past few years, I only once saw him grow visibly angry. The outburst occurred on that March day that began typically gray and ended in pouring rain. John had offered to drive me back to my hotel, adroitly maneuvering slick city streets when our conversation turned to discussing the euphemistic language used by priests, nuns, and lay workers to describe the program.

"I'm not an orphan, for God's sake!" he declared, veering into another lane of traffic and cutting off a car while insipid pop music played on the radio. "My parents were both alive when I found them. The Church called it the orphan program because they had to sell it. 'They're all orphans. You're the good savior of these poor orphans.'"

This scene stands out because I have become accustomed to John's steady temperament and disciplined tactics in finding answers to an orchestrated plan shrouded in secrecy. John's approach to solving this mystery, I came to understand, reflected

his natural proclivity to the language of computers. His methods, like that of a coder who inputs a set of repeated instructions in a specified sequence to converge to an optimal answer, are iterative. The frequent route to the Santa Maria Novella train station, the telephone numbers copied and dialed at the SIP office, answered by dozens of Turinese households, would morph over the years into plugging text into computer highways and sharing data points on a server with students at the Normale and Cineca. And as those clunky old computers transformed into sleek new devices, social media replaced bulletin board systems, and science added the game-changing discoveries of genetics, John's ability to help a few people changed to thousands. Yet still, the foundational path to finding his birth mother and to unearthing the story of an adoption program born in the Vatican in the aftermath of World War II had been laid by a boy tracing the chunky sandstone streets of Florence to the Santa Maria Novella station. Along this trail he painstakingly charted, John would discover many stories veiled in silence, shame, and the powerful forces of denial.

Sometimes a family secret begins with a single thread, a genetic trait, an irrevocable act, that stitched through time connects even distant relatives. But other secrets are knit from a thicker yarn, one patterned by culture, history, and religion, which shape people's lives in ways never imagined. When those secrets, woven not from the steady work of a single hand, but the rapid spools of a powerful machine, unravel, so, too, does their staggering damage, crossing oceans and continents.

Part Two
The Vision and the Mission

- 8 -

I'm sitting at a large wooden desk in a building on the Upper East Side of Manhattan, taking the last sips of a late morning cappuccino, waiting to unpack more files from more boxes kindly handed to me by a small woman with white hair pulled back into a bun, whose soft wisps, like autumn milkweed, brush her pale cheeks by end of day. She is a meticulous librarian, one who even catches mistakes in Wikipedia entries. I've been at this desk three days a week for several months now, sorting through the correspondence of two American clergymen in charge of the orphan program, Monsignor Andrew P. Landi, who worked in an office on the Via della Conciliazione in Rome, and Monsignor Emil N. Komora on West 14th Street in New York City.

I stare at the box that will begin my day's work, another of dozens stacked before me that explain the "how" of this program, the bureaucratic mechanisms of transporting nearly four thousand children to the United States, the numbers tallied each month, the legal arguments made and legal issues skirted, as I piece together the program's operations. But I want to understand its why, to pinpoint the place of these Italian mothers and their children in history's long grasp. For women, the why is

essential because no matter the progress made history always comes back to haunt us, and to remind us that our hard-won freedoms are never guaranteed.

Among the thousands of pages I have been poring over, two sentences stand out, keep pulsing in my head, the first and last lines of the consent form each new mother had to sign to surrender her baby. One of many documents needed to process each new orphan, this form was labeled C-14. I read the lines again and again, fingering the translucent onion skin sheet along with its smudged and water-stained carbon, once pounded by the levers of typewriter keys clacking against a ribbon's black ink, now faded by decades, in spots barely legible. Like moth hovering toward light, I keep circling back, my rote navigation disrupted. I'm stuck here, I think, because the two sentences illuminate that famous feminist phrase of my youth: the personal is political.

I am a Catholic.

I sign the present document of my own free will without any compulsion or coercion.

Each time I parse these spare sentences, impregnated with ornate tiers of shame and guilt, my anger grows. In the first sentence of the document, the woman officially declares her Catholicism, admitting her depravity. In the final sentence, the description in the predicate stomps out the faint assertion of the "I" in its subject. An Italian Catholic woman, shamed as a sinner for her out-of-wedlock birth, signing a form in the fifties or sixties to relinquish her child to the guardianship of the Church. What free will? How can the "I" exist when no self is left?

A basic truth of our lives: People get told what to do all the time without even hearing a whisper. From the moment of birth, a carapace of history and culture, of religion and family

imposes its distinct shell upon each of us, weighing down through the years, calcifying over the decades. We react before learning how to act.

To carry a baby in your womb for nine months, and then to give up that child, is to be devoid of choice: poverty, rape, sexual ignorance, family pressure, dereliction of male responsibility, all played roles in this story. Birth control was illegal, possession could land you in jail, a dictate of the State, and a mortal sin, tantamount to murder because it blocks the male seed, a dictate of the Church. The idea of bodily autonomy beginning to float in enlightened educated circles in the 1960s, when Francesca had surrendered her baby, was a laughable conceit. Those abstract concepts of freedom and self-determination were incomprehensible, particularly to women from Southern Italy, lucky if educated through middle school, in some households needing to produce each month for their mothers the bloody sanitary napkin as proof of their purity.

To imagine the mindset of the scared new mother who held the pen, and of the nun or social worker who pointed to the signature line, authorizing the Church's version of the best of all possible worlds, I must constantly shift between historic visions, of then and now, of two distinct value systems, the former, which until only recently, had all but disappeared from modern life, dissolved by a paradigm shift known as sexual freedom. I consider my own childhood, granddaughter of *contadini*, and the ways in which their values, what I learned at home, in church, and at Sunday catechism, shaped the entirety of how my parents raised me. The sense of shame, deep shame, affixed to the pregnant body was ingrained in me long before I had any concept of sex. It is the shame attached to the pollution of sexual intercourse and the superiority of virginity, ideas fashioned in the fourth century by the ascetic writings of Saints

Ambrose and Jerome and sealed by Saint Augustine's concept of original sin.

My earliest image: I am a little girl, five or six, playing with my favorite doll. One afternoon, bored with the ritual of rocking the baby and holding a small bottle of fake milky liquid to her pink sealed lips, I come up with a new pretend game. I tuck the doll under my shirt, make the fabric billow to create a big belly, copying the women I see in our pristine suburban neighborhood of white picket fences and imitation Tudor homes, and head to the kitchen, the domain of my mother.

"Look, I'm pregnant."

The look of horror that flashed across my mother's face that day, the anger piercing her narrowed hooded eyes, terrified me. "Don't ever do that again!" she shouted. I ran back into my room crying, for what, I did not know, but the moment remains fixed, the haunting gaze imprinted. The dirty word pregnant would not fall again from my lips.

When I became a mother, our baby boy only five months old, my husband was invited to teach in Milan. I found it appealing to push a pram in a country that still retains the popular image of *mamma e bambini*, the pronouncement of a fierce maternal love and attachment that seemed more powerful than anywhere else I knew. When our son was four years old and we were vacationing in Rome, I could envision no culture more charming than one whose people stretched kneaded dough into the shape of a heart and delivered the reimagined pizza onto my child's plate. But my alluring ideas about the land of *mamma e bambini* had been formed without historical knowledge, my failure to understand that such maternal love had been denied through the centuries to countless women considered unfit.

I didn't know, in fact, that the system of anonymous infant abandonment originated in Italy in the thirteenth century and

flourished in the following centuries, as unwed mothers placed their illegitimate babies into an abandonment wheel, a practice that spread to most of Catholic Europe and Russia. I didn't know that in the seventeenth and eighteenth centuries the Church used its populace to spy on the bedroom behavior of couples, like an ancient prototype of the Stasi except focused solely on the Church's primary enterprise, sex, insisting that midwives report to parish priests all out-of-wedlock births. I didn't know that hundreds of thousands of infants perished in these disease-ridden institutions, or that the Church held the horrifying logic that babies baptized inside would be protected in heaven, a far better fate than being raised in sin on earth.

Institutions with names like Bologna's "Hospital of the Little Bastards" marked these children from birth. In Protestant countries, however, the rates of abandonment remained much lower as Anglo-Saxon society looked down upon out-of-wedlock births but believed it was both parents' responsibility to raise the child they had conceived.

This Roman Catholic Church attitude toward women did not cease in the twentieth century, it just assumed a new form. With commercial airline travel and a clause added to the Displaced Persons Act, the Church could send the "little bastards" to adoptive families in America. The religious and social pressure that forced women to surrender their illegitimate babies echoed the medieval logic of the abandonment wheel.

The beliefs that laid the foundation for the Church's orphan program can be traced to ancient Italy, but the decision to send large numbers of children to America was also a decidedly modern and political one. To understand more fully what began in postwar Italy and continued into the late 1960s, another shift in vision needs to take place, beyond the room where the mother held the pen and the social worker pointed to the signature line.

A headline for a newspaper photo tucked into a manila file reads, "First Italian War Orphans Arrive in U.S." The picture, taken before their departure in the summer of 1951, reveals a dour lot of five girls and four boys. The girls, whose ages look to range from three- to ten-years-old, wear patterned dresses with puff sleeves, white anklets, and thick-soled black shoes, along with, oddly to the modern eye, head coverings that resemble a nun's short veil or a kerchiefed storybook maiden. Their eyes dart from the camera or embrace it as wary supplicants. The boys, ages about three to seven, whose faces express a grim register of pout to scowl, are dressed in white shirts and dark shorts. Pope Pius XII stands in the center of the photo, hands clasped, with the children flanked beside him. Among the people behind the Pope are his niece, Princess Gabriella Pacelli, and Monsignor Landi; both the priest and the Pope's elegant niece, unveiled, and wearing a dark sweater with a single strand necklace, accompanied this first batch of children on their flight to New York, serving as the program's earliest ambassadors. Thirty-five other children were issued visas for America that year.

Those nine children legally entered the United States because of an amendment added in 1950 to the Displaced Persons Act of 1948. A report to the American Congress explained the issuance of five thousand new non-quota visas under section 2(f) of the amended Act, which was intended "to provide homes for children who lost one parent or both parents as the result of Nazi and Communist aggression." The original Displaced Persons Act had defined a "war orphan" as a child under sixteen-years-old who had lost both parents to the conflict. But the revised amendment changed the definition of a war orphan to a child with one parent who was "incapable of providing care" due to the "death or disappearance" of the other parent. The broad

definitions both of disappearance, and of the ability to provide care, allowed for much latitude in the years to come.

Those five thousand visas were made available to eighteen European countries, but the majority were wary of sending off children to the United States, especially because families suffering from the devastating losses of war wanted to preserve kinship ties. Yet Italy, land of *mamma e bambini*, running its program under the auspices of the Catholic Church, eagerly chose to make use of them. The National Catholic Welfare Conference, the leading organizational arm of the American Catholic Church, and the group in charge of the orphan program based in Rome, explained in its 1950 annual report: "A preliminary survey by the War Relief Services personnel abroad would indicate that most of the aforementioned countries are not anxious to have their young citizens emigrate. Therefore, the area of concentration for the most part in relation to these orphans eligible under the bill will be Italy. We feel that many Catholic children will be able to come to the United States to take their places in good Catholic families."

Throughout the 1950s, the Church lobbied for this amendment—originally intended as a temporary measure—to be extended numerous times by an American Congress. In 1961, the United States made this new definition of orphan permanent, allowing foreign children to enter the country as immigrants to be adopted by American couples without any quota restrictions. This was the legal mechanism that allowed thousands of Italy's illegitimate children to come to America over those two decades, the route traveled by John Campitelli, his siblings, Paul, David, and Sara, as well as my cousin. The orphan program would remain unchallenged, except for an alarming few months for the Church in the summer of 1959, when a spate of bad publicity about the black marketing of Italian children to

America threatened to end what had become by then a highly efficient adoption machine.

The war orphan—which turned into the orphan—program found its particular Italian form in the accumulated effects of the legacy of anonymous abandonment, the ashes wrought by two decades of Fascist rule, and the new political realities that Italy faced. It was an odd confluence of Cold War politics and ancient religious beliefs about women, sex, and sin, intertwined in the aftermath of World War II. To use a twenty-first century image to analogize what transpired in the mid-twentieth century, when the personal and political had become fatefully interlocked, a national emergency (in Pope Pius XII's deeply ascetic eyes) had befallen Italy with enemies poised not only at its borders, but already penetrated within. The Pope's response to these myriad dangers was both quick and concrete: The Church needed to build a wall of chastity.

And who would end up paying for it? Women, of course.

- 9 -

A Latin inscription stretches across the stone entablature of Via della Conciliazione, 4, the building in which the National Catholic Welfare Conference once ran its war orphan/orphan program under the leadership of Monsignor Landi. It reads: ADSIS CHRISTE EORVMQVE ASPIRA LABORIBVS QVI PRO TVO NOMINE CERTANT.

Help us, Christ, and inspire the efforts of those who fight for your name.

Pope Pius XII financed the building's construction, located on the famous basalt road commissioned by Mussolini to commemorate the signing of the Lateran Accords, connecting the secular city to the sacrosanct white travertine colonnade majestically embracing St. Peter's Square. Number 4's spare symmetry, Latinate writing, and a neoclassical sculpture that juts like a fussy brooch pinned to the center of the top-floor's white marble facade, symbolize the grand and bland of Fascist architecture, imposing an unadorned brute force on all who have entered.

I walked into Number 4's near-empty lobby one fiery summer day, sharing the space with a few straggling tourists heading to a small store at the other end to buy bottles of water and packaged

ice cream, equally dazed by the power of the midday Roman sun. Futilely flapping the slim lapel of my sleeveless white cotton blouse glued to moist skin, I tilted back my head to take in what looked to be a thirty-foot ceiling. Somewhere in offices housed vertiginously above me, the orphan program once operated, routinizing Catholic hegemony each time a baby was surrendered, quickly baptized and brought to live in a local *brefotrofio* until an adoptive placement was secured, vaccinations administered, and paperwork completed, usually about two years, at which point nuns or lay workers took the children to Rome by train to await the upcoming flight to America.

Those who fight for Christ's name had found their twentieth-century enemy, an enemy to which these orphans would be inextricably tied. Certainly not Fascism, which the Vatican not only tolerated but lent its support by signing with Mussolini the Lateran Accords, officially making Catholicism the state religion, signified by the Road of Reconciliation on which Number 4 stands; nor even Nazism, as the Church has found itself in the odd historical position of explaining the pope's silence during the Holocaust and of helping through the Vatican's postwar papal aid mission, both unwittingly and knowingly, Nazi war criminals escape out of Italy by means of the Brenner Pass. No, the enemy was Communism and Pius XII intended to prevail.

Since the beginning of the twentieth century, communism had posed an existential threat to the Church, and with the world order rapidly changing, Pius XII became obsessed with preventing the very real prospect of the Italian Communist Party leading the government. *Chi vota Comunismo vota contro Dio*, as stickers posted on the country's crumbling stucco made clear. To help a war-shattered country teeming with millions of refugees, the Vatican created a large-scale humanitarian aid organization, the *Pontifica Commissione di Assistenza* (PCA), which

delivered essential food and medicine, and also, as it would turn out, orphans, to America. Monsignor Ferdinando Baldelli was the person who, according to Sister Pascalina Lehnert, the Pope's housekeeper and personal secretary, suggested the idea of creating this massive national relief effort. Pius XII placed Baldelli in charge of the PCA, his work overseen in the Vatican by Monsignor Giovanni Battista Montini, the future Pope Paul VI. Without Baldelli's close investment in the orphan program, its scale would never have been possible.

The Vatican's humanitarian aid program, as historians have pointed out, supported not only the Church's mission of caritas, profoundly needed in the starving, ravaged country plagued by smallpox, typhoid, and tuberculosis epidemics, but also served a critical underlying agenda for the Pope, stopping the spread of communism and seizing from the ruins of Europe the opportunity to re-Christianize the land. Pius XII had emerged from the war in an extraordinarily powerful leadership position, but with Italy destitute the Pope needed financial backing for his mission. America, the victorious new superpower and a partner equally determined to stop the Communist threat, provided these funds, depositing money for the PCA directly into the Vatican bank. During this time of shifting allegiances and Cold War intrigue, even the monsignor who ran the Vatican press bureau, Federico Fioretti, was a spy working for the Americans.

The American Catholic Church also greatly helped the pontiff. Growing in wealth and influence, it provided the PCA with a substantial portion of its funding. The money came mainly from the National Catholic Welfare Conference (NCWC), led by the efforts of New York's powerful Cardinal Francis Spellman, also a rabid anticommunist who owed the rise in his career to Pius XII. Through these generous American coffers, the PCA became the central aid organization in Italy.

The NCWC not only worked with the Vatican, but in various instances with the American State Department and the CIA to involve itself in Italy's affairs. Cardinal Spellman organized a massive letter-writing campaign among Italian-Americans imploring their families back home to vote for the Christian Democrats in the critical 1948 election. Over one million letters arrived in Italy, many to non-relatives, often with a few precious dollars tucked inside. As Paul Ginsborg noted in *A History of Contemporary Italy*, American intervention in that election, which the Christian Democrats won in a huge victory, "was breath-taking in its size, its ingenuity and its flagrant contempt for any principle of non-interference in the internal affairs of another country," with the United States government designating a staggering $176 million, over $2 billion today, in "interim aid" to Italy for the first three months of 1948.

This deep interlocking relationship between the *Pontifica Commissione di Assistenza* and the National Catholic Welfare Conference shaped the war orphan/orphan program, carved from the Vatican's Cold War vision and mission. Landi first arrived in Italy in 1944, then a thirty-eight-year-old priest who had been running a drive out of the diocese of Brooklyn to donate clothing for war victims. He had gained the attention of the head of the Catholic Relief Services, a refugee assistance program run under the auspices of the NCWC, who, impressed with the priest's managerial and Italian language skills, recruited him to help with the organization's efforts in Italy. Landi, along with three other American priests, met Pope Pius XII on their second day in Rome, arranged by Cardinal Spellman, and eventually the priest was made director of the Italian mission for War Relief Services-National Catholic Welfare Conference. In recognition of his work, Pius XII named Landi a monsignor in 1945.

By 1951, Monsignor Landi, who continued as director of the Italian relief mission, also was placed in charge of the war orphan program at Number 4. He, along with Monsignor Baldelli, would remain the program's principal architects over two decades, with Baldelli, the voice of the Vatican, serving as the liaison, and primary lobbyist to the government. Politically, sending off these children as part of the Vatican's refugee relief efforts was a win-win situation for all the powerful parties involved—a critical ally received a small gift from abroad during the baby boom era, when childless American couples were clamoring to start a family. Taking the children out of the government-supported *brefotrofi* to become future American citizens also removed a financial burden from the Italian state. The NCWC received its own financial rewards, charging couples (at least by 1957, according to its internal correspondence) $475 "to cover the expenses for processing an orphan child," excluding inland transportation costs. It was the equivalent of about $4,500 today, amounting to multimillions over those two decades—not to mention future donations from forever grateful couples.

And it probably wasn't lost on the Vatican, visualizing the sustained political game needing to be played, that the illegitimate, long the country's poor and outcast, would make prime future recruits for the Communist Party, like so many of those fiery young workers who had joined the early Partisan Resistance, essential pawns on Palmiro Togliatti's side of the chessboard. Boys from the *brefotrofi* were particularly hard to place into Italian homes, as couples preferred to adopt girls, and they represented the majority of the children sent to America. With a Church-crafted orphan program in place, all the children could be raised in good Catholic homes.

But no matter how swift the Pope's access to President Harry Truman, nor how strong the Vatican ties to the Central

Intelligence Agency, Pius XII's political influence dwarfed when compared to his tremendous pastoral abilities to stop the Communist threat. The pontiff understood that he needed to keep his flock out of communist pastures and he risked losing the Church's long-held grip on moral behavior if he did not. As the war orphans, refugees needing to be saved, had become entangled in Cold War politics so, too, did the predicament of unwed Italian mothers. The Pope saw before him a country overflowing in sin, proof of which resided in the huge postwar spike in out-of-wedlock births. "Evil is being spread," the Pope warned, "through books, pictures, spectacles, broadcasts, and fashion styles. . . . It can be seen in the immodesty prevalent on the summer beaches and it is being fostered by organizations."

At the end of decades of Fascist rule, after emerging from the death and destruction of a world war, parched throats longed to drink in new life, tossing the desiccated husk of authoritarianism for the newfound freedom of skimpy bikinis and leftist politics. As the hardened earth of long-held orthodoxies began to shift, many felt its dangerous tremors. During such tumultuous times, a well-trodden response often takes place: traditional forces portray a society that has lost its moral compass, and ultimately blame and vilify women for this sorry state of affairs.

- 10 -

The Pope's spiritual weapon against his Communist foes was the Virgin Mary. Beginning in 1950 and lasting until the end of his papal reign in 1958, an extraordinary decade of fervent belief and fertile imagination, Pius XII unleashed an unprecedented campaign that placed the Virgin Mary in the forefront of Italian moral consciousness and religious devotion. Among the many actions taken in her name, all performed at feverish pace, the Pope declared the dogma of the Virgin's Assumption into Heaven, naming 1950 a Marian year; canonized a virgin martyr; pronounced Mary's Queenship, dedicating May 31st as its new feast day; delivered an encyclical to midwives proclaiming "a virginal maternity, incomparably superior to any other, but a real maternity, in the true and proper sense of the word"; along with an encyclical denouncing the not "fully proved" theory of evolution that the "Communists gladly subscribed to." Pius XII declared in his encyclical to midwives that "the child in the womb, has the right to life *directly* from God and not from his parents, not from any society or human authority," an idea that became the rallying cry of America's right-to-life movement, powering its decades-long crusade to overturn *Roe v. Wade*.

His was a papal offense that dated as far back as the sixth

century when Byzantine emperors in Constantinople threatened the authority of the Church and popes heralded a triumphant Mary to reinforce the hierarchy of the heavenly kingdom over emperors who return to dust. Only the Virgin mother, Pius XII told hundreds of thousands of the faithful gathered in St. Peter's Square could "reign over our intelligence" to "annihilate the dark plans and the wicked work of the enemies of a united and Christian humanity."

Across the ocean in the New World, the model of the perfect mother was June Cleaver, star of the popular American sitcom "Leave It to Beaver," whose oven-mitted hands delivered warm trays of freshly baked cookies. In the Old World, however, the model of the perfect mother was a Divine Virgin, whose tapered fingers clutched a plump baby Jesus. The Pope's repeated emphasis of the supremacy of the Virgin's purity not only raised, in screeching decibels, the stigma of unwed mothers, but set a pretty high bar for married ones, too.

Cultural historian Marina Warner, in her brilliant examination of the figure of Mary, *Alone of All Her Sex*, reminds us that of the Catholic Church's four established dogmas about Mary, "her divine motherhood, her virginity, her immaculate conception, and her assumption into heaven, only the first can be unequivocally traced to Scripture." That has left to the Fathers of the Church the centuries-long task of carving and polishing the image of woman through their eyes, using sources from the Apocrypha and ideas from the classical, Islamic, and western world.

The Madonna exhibits, of course, the most bountiful and merciful qualities, the quintessential mother who loves, suffers, forgives, and tenderly holds her son in infancy and death, worthy of emulation by both sexes. But in a religion that asserts celibacy as the highest moral realm, heralding Mary as the ideal

woman—who remained a virgin during the birth of Jesus and throughout her life—has created a precarious psychological tightrope for women, emphasizing the pollution of sex while simultaneously establishing their primary role as childbearing vessel.

For men, these ideas about the Virgin, refined through the centuries, established room for a dangerous seed of female hatred to breed, a reminder that women's earthly carnal bodies try men's restraint from their basest animal longings, which Christianity has taught them to loathe. Virginity for pagan goddesses, who chose both periods of chastity and also of having lovers, had signified autonomy, not moral sanction. Warner argues that the Christian religion broadened this classical concept of virginity "to embrace a fully developed ascetic philosophy."

"And it was in this shift, from virgin birth to virginity, from religious sign to moral doctrine, that transformed a mother goddess like the Virgin Mary into an effective instrument of ascetism and female subjugation."

The figure of the Virgin soared through the collective consciousness in the light of cerulean blue when on November 1, 1950, a Jubilee year, the Pope announced before a crowd of hundreds of thousands in St. Peter's Square the dogma of her Assumption into Heaven, the idea that her body had never decomposed, ascending both physically and spiritually, a status that had been accorded only to Jesus. Although the belief lacked scriptural sources, it had been part of Church tradition since the seventh century, the image of her robed and barefoot on a cloud surrounded by angels and putti, depicting her transcendence from the temporal to eternal realm, among the most famous of Renaissance art. For only the second time in Church history, Pius XII declared the dogma ex cathedra, bringing a dictate of ex-communication to anyone who failed to abide his words.

In the days preceding his announcement, the Pope believed that her Divine pleasure had been revealed to him by the brilliant coruscations of the sun, a heavenly nod to his infallible decision. During a period of four days that October and early November, while taking his routine late afternoon stroll in the Vatican gardens, the Pope witnessed an otherworldly occurrence, interrupting this period of walking and reflection. In a time of year and daylight hour when a plump sun sits low in the sky, radiating an incandescent white, the Pope watched its disc, surrounded by halos, agitate and convulse. The rays, to his great surprise, did not blind him, but rather, fixing his gaze upon the sun absorbed their pulsating embrace. This four-day phenomenon convinced the Pope that he had witnessed a solar occurrence echoing Fatima's "miracle of the sun," when seventy thousand pilgrims gathered that October of 1917 to await a sign of the Virgin and saw the star of the solar system defy the laws of the cosmos, spinning out of control as if dancing before their eyes. The Pope long had a deep connection to the Virgin: his consecration as archbishop in the Sistine Chapel took place on May 13, 1917, the same day the Virgin appeared to three children in Fatima, when among the prophecies heard by them was her promise to seek the conversion of Russia. And now as pontiff, she was appearing to affirm the dogma he was about to proclaim in her name.

The Vatican newspaper, *L'Osservatore Romano*, made this observation about the heavenly spectacle appearing before the pontiff: "It is not our task to formulate deductions from these singularly analogous events (the original solar miracle and its repetition for the Holy Father), but the intervention of the Most Blessed Virgin is frequent in the gravest days of the history of the Church, even with intimations to the successor of Peter personally."

Just five months earlier, nearly half a million people had gathered in St. Peter's Square to witness the canonization of virgin martyr Maria Goretti in the first open-air sanctification in Rome, the crowd too huge to hold in the basilica. Maria Goretti's canonization may have been Pius XII's singular act, supplanting all else in his arsenal against the Communist seduction, to psychologically terrorize teenage girls for decades.

Tales of saints, of course, are ways in which to humanize and dramatize Catholic doctrine, spotlighting models of behavior that blossomed from ordinary lives. The pope, wearing the red mantle of purity, chose from the stuff of ancient bloody legend a standard of female morality for modern times. He compared Maria Goretti to the fourth-century virgin martyr St. Agnes. The gory story of St. Agnes was of a Christian maiden who after refusing a prominent pagan suitor finds herself subjected to repeated acts of torture and attempted rape until she dies from a dagger plunged into her throat—but with her virginity still intact.

Maria Goretti, born in 1890, was a peasant girl who lived with her sharecropping family in a village near Nettuno. She was just shy of twelve years old, the same age as the martyred St. Agnes, when her short life came to an end. One afternoon, a twenty-year-old farmhand named Alessandro Serenelli, whom Maria knew well, demanded that she submit to him, holding a weapon in hand. The girl repeatedly refused his advances, provoking Serenelli to stab her fourteen times. The next day she succumbed to her wounds but forgave Serenelli. The court sentenced the attempted rapist and murderer to thirty years imprisonment, and during this time Serenelli reportedly saw a vision of Maria, dressed in white and holding flowers, causing him to repent of his sin. After imprisonment, he spent his

remaining decades living with an order of Capuchin monks, performing menial tasks and upkeep of the grounds.

In canonizing this martyr of purity, Pius XII elevated a peasant girl to a saint and found his precept for the young: "With splendid courage she surrendered herself to God and his grace and so gave her life to protect her virginity." From Pope to Holy Year pilgrim, priest to parish, nun to schoolchild, sainted holy card to pliant hand, the story's dark message, better for a girl to be murdered than to lose her virginity, crossed countries and continents, considered by Catholic youth with horror, or mocked with derision. Sara Campitelli remembers the unsettling feeling of learning about Maria Goretti as an Italian schoolchild in the 1970s, internalizing the frightful instruction and wondering if she could abide by it.

In a memoir about growing up Catholic in postwar America, author Caryl Rivers recounted how during each Lenten season the nuns played a record over the school loudspeaker that dramatically reenacted Maria Goretti's attempted rape, complete with Serenelli's labored breaths. "I remember sitting in the cafeteria, my brown lunch bag perched on one of the white Formica-topped tables, chewing my egg-salad sandwich and listening to the Maria Goretti story:

No, no, it's a sin!
PANT PANT PANT. You must do as I say.
It's a sin! A sin!
PANT. PANT. PANT."

The specter of Maria Goretti haunting the intimate lives of European youth surfaces in the works of Edoardo Albinati and Annie Ernaux, both authors remembering the Church's propagandizing message. Albinati writes in *The Catholic School*, "If

a girl wouldn't play ball, then you'd say, '*Manco fosse Maria Goretti!*'" ("She thinks she's Maria Goretti!"). And Ernaux in her memoir *The Years*, "They laughed up their sleeves at the story of Maria Goretti, who had preferred to die rather than do with a boy what they longed to do." Yet despite the French girls' bravura, "shame lay in wait at every turn." Explains Ernaux, "Between the freedom of Bardot, the taunting of boys who claimed that virginity was bad for the health, and the dictates of Church and parents, we were left with no choices at all."

Even in the nineties, the name Maria Goretti remained part of the Italian vernacular, no longer an anamnesis of sexual terror but its rhetorical opposite, a young woman's tool of seduction. A Milanese friend, a university professor, remembers offering a lift home to one of his students, who before getting out of the car looked him in the eye and said, "I'm no Maria Goretti."

Yet in the fifties and sixties, young Italian women were afforded no such linguistic luxury, the fear of mortal sin and family shame shadowing every action and decision. The Pope's moral crusade against Communism had ensured that virginity saturated the air in which Italians breathed, even if men continued to exhale with the guttural grunt of machismo, long the country's secular form of worship. To be young and power-less and give birth out of wedlock was a condition of disgrace, a fall from grace. To whom could these women turn?

As the choppy rumble of piston engines revved at Ciampino Airport, the paperwork at Number 4 passed from desk to desk, its final stop with Monsignor Landi, whose goal was to process as many children, categorized as "2(f) War Orphans," as possible to board those turbulent flights (children proposed and documented by the Vatican's PCA). Monsignor Baldelli urged Landi to keep up the pace. "It is his opinion," Monsignor Landi wrote to Monsignor Komora in New York, "that a constant flow of

children would be of exceptional value in arousing interest and collaboration throughout both P.C.A. and on the parish level."

But essential for surrender was the consent form, labeled C-14, signed by the mother of her own free will. By the mid-1950s, when the popular war orphan program had spanned to almost every region in Italy, this form couldn't be replicated fast enough. "We are completely without C-14 forms," Landi lamented to Komora, "may we ask that you send us an airmail supply of these forms upon their receipt from the printer."

- 11 -

Newspaper articles about the little Italian war orphans flown across the Atlantic for adoption reflected the newfound pride of the moral victors of World War II. America, now protector of the free world, bountiful and merciful, welcomed needy children, one of the few places on earth that could provide them with a better life. The National Catholic Welfare Conference staged photos of the orphans with the US Capitol, spotless white beacon of democracy, in the backdrop. Local papers printed feel-good photospreads of the orphans welcomed by their new parents. Of all the media attention, however, one article stands out, a lengthy six-page feature in the country's premier magazine, the *Saturday Evening Post* with a readership of over four million, which introduced the idea of the Italian war orphan needing a home.

The article appeared in April 1950, a year before the Vatican's send-off of the first nine war orphans to America. Although the tale of a private adoption, the staggering incongruities in the story highlight—in light of what was about to transpire in Italy through the Church's orphan program—the freedom of choice that privilege always accords. The story's author, the renowned war correspondent Martha Gellhorn, tells of her arduous but

ultimately successful effort to adopt an Italian war orphan. As the nearly full-page glossy photo makes clear, handsome mother gazing at her little boy nestled together on the steps of her villa in Mexico, Gellhorn found an adorable toddler with tousled blond hair and elfin smile. His name was Alessandro, and she called him Sandy.

The seasoned reporter's journey throughout Italy in search of a child four years after the war, a story of outrage, sorrow, and ultimate joy, reads as a command of duty for the kind-hearted replete with fairy tale ending. Even before embarking to America, she and a recuperating Sandy, convalescing from bronchitis and measles, are rewarded rest from their trials at an Italian friend's "castle near the sea" where they slept in spacious rooms wallpapered in green and red damask. Gellhorn traveled in Italy's aristocratic circles and one of her good friends, the Marchesa Iris Origo, would become by decade's end a powerful advocate—not from a moral stance but one of noblesse oblige—of sending the babies of the *brefotrofi* to America.

In her signature reporting style, distilling fervent emotion into trenchant sentences, Gellhorn describes her odyssey visiting Italian orphanages and witnessing the horrors of war that had been absorbed by a country's children. "This was too terrible, I thought; this was against nature. No one was meant to go from one pitiful place to another, from one cruel place to one which was only dirty or sad, and inspect children as if pricing meat. It couldn't be true, and in all these thousands of children, not one had survived as a child. They ought to declare war on grownups, I thought furiously, who killed their childhood."

Overwhelmed, and making an honest, if albeit slightly guilty, decision, she decides not to adopt a child who had lost a limb, one of the multitudes of casualties of the adults' battles, but rather a healthy infant or toddler. So Gellhorn hires a lawyer who

advises her to head to his city, Florence, where he feels confident that she'll have success. At a home run by nuns in nearby Pistoia for about twenty children, the journalist describes the moment when she was struck, spotting the perfect boy, her "blond fatty," almost a year-and-a-half old.

Gellhorn, a nonbeliever, shared one instinct with the Catholic Church: she needed to leave the reader with the impression that she had adopted a war orphan. Even though Alessandro was born several years after the war ended, he is presented as a victim of its tragedies, parentless, dropped off "by a woman, not his mother, a stranger from a village in the hills." But this sentence typed by the journalist was not true. According to her biographer Caroline Moorehead, Gellhorn knew that Alessandro "had been deposited with the nuns by his mother in a state of near starvation, that she left no name or address, and that he was illegitimate."

Gellhorn had decided at the age of forty, single after her divorce from Ernest Hemingway, that she wanted to adopt a child. Her prominence as a fearless journalist who chronicled the Great Depression, the Spanish Civil War, and World War II brought letters of reference from her good friend Eleanor Roosevelt, as well as the American ambassador to Italy and the Italian ambassador to Mexico. While the pope was shaming Italian women for out-of-wedlock births, Americans would be introduced to the enticing prospect of adopting a war orphan from the archetype of the modern woman who spurned social convention. Gellhorn had moved to Paris in her early twenties and soon began an affair with a married man, a respected French journalist who at the age of sixteen had been seduced by his forty-five-year-old stepmother, the writer Colette. By the time Gellhorn was twenty-five, their impossible relationship led her to have two abortions. At twenty-eight, she met Hemingway,

with whom she had a three-year affair. When the famed author left his wife and begged Gellhorn to marry him, before agreeing she wrote in her diary, "I can do very well without marriage. I'd rather sin respectably any day of the week. . . . I think sin is very clean. There are no strings attached to it."

After the first few years of raising Sandy, which Gellhorn described as blissful, the charm wore and the weight of caring for a child became too great a trap for her peripatetic life. She enrolled Sandy in elite boarding schools in Switzerland and America, but their distant relationship continued to unravel and Gellhorn berated him for a lack of gratitude, and worse, his weight. The "blond fatty" who struck her like a bolt in Pistoia, no longer pleased as a chubby adolescent. On top of all the young man's troubles—eventually dropping out of college, using hard drugs, landing in prison for possession and dealing—Gellhorn, at one point, even added a clause to her will stipulating that Sandy's share of her inheritance was dependent upon him being an appropriate weight.

Gellhorn's decision to hire a private attorney and adopt directly from a foundling home was a practice the Church didn't particularly like but tolerated during the years it ran the orphan program, as long as the children were processed under the auspices of the National Catholic Welfare Conference. Once the program took off in 1951, three key clergyman headed its operations and handled almost all Italian adoptions: Monsignor Baldelli sent priests and social workers from the PCA to search the country for available children, Monsignor Landi formulated the policy and handled the processing and international logis-tics, and Monsignor Komora found homes for the children in America and acted as their temporary legal guardian through the Catholic Committee for Refugees.

The chief criterion for adoptive parenthood was, in Landi's

words, "impeccable Catholicity." Mixed marriages—mixed meaning Protestant—were verboten, the occasional slipup worthy of an archbishop's attention. Italian-American couples, longing for a child of similar heritage, composed the majority of applicants. Yet one large problem shaped the program from its start: few war orphans ever existed. Italy, starved and impoverished, was no doubt a shattered land. In formerly German-occupied cities like Naples and its environs, the population scavenged for food and water, hidden bombs exploded on luckless passersby, and residents roamed the streets with handkerchiefs covering their noses and mouths to fight dual typhoid and smallpox epidemics. It was a place that had to adapt itself, as writer Norman Lewis—stationed in Naples as a British intelligence officer—observed at the time, "to a collapse into conditions which must resemble life in the Dark Ages."

But war orphans, true war orphans, not linguistically constructed ones, could rarely be found, in Italy or in all of Europe. The American government, in an effort to answer the demands of childless couples clamoring to adopt war orphans and aid this humanitarian cause, commissioned a study that confirmed an intuitive assumption—if parents died in bombings, their young children most likely died with them, and those truly orphaned were usually taken in by relatives wanting to preserve family ties. The trickle of war orphans arriving in the United States primarily came from Eastern Europe, adolescents between the ages of fourteen and eighteen. Yet throughout the fifties, the Church promoted the idea in American newspapers that they were placing little orphans from war-torn Italy, despite the mathematical improbability of its claims.

Correspondence early on between Monsignors Landi and Komora establishes that the Church never intended for its war orphan program to be about finding homes for these parentless

children, the saddest refugees of World War II. In June of 1951, Monsignor Landi wrote to Komora explaining that a Church representative in Naples had been fielding questions from a dozen of these children from Italy, Russia, and Eastern Europe, between the ages of eleven and eighteen, who were concerned about how long they would need to live in American institutions before adoptive parents could be found.

Komora didn't have an answer. He said that processing "displaced orphans," in other words, a true war orphan, wasn't "comparable to that which is expected for the war orphan program." To assist them, he explained, the Catholic Committee for Refugees would need "to go out and find families and then we must sell them on the idea of taking these children into their homes," which they had neither the resources nor interest in doing.

Sending very young children reflected the desires of American parishioners eager to start families of their own, and who, like Martha Gellhorn, wanted to adopt an adorable baby or toddler, or if none were available, a young child. Not an adolescent scarred by the miseries of war. Or as one couple's handwritten note requested, they would love a little orphan girl, preferably around Christmas time. Like the large pastel bows announcing newborns festooned on the brass bars of the private maternity clinic in Florence that Sara and John Campitelli passed on their way home from school, the children were packaged as gifts for good families, care of the Catholic Church. But someone needed to shop for those gifts.

By the fall of 1951, Landi was arranging for the children to be transported on Linea Aerea Italiana, which flew from Rome to New York on Tuesdays and Fridays each week. The over twenty-hour flight, before the use of jet engines, was powered by pistons, which meant lurching and jolting through

turbulence accompanied with a persistent droning buzz. Monsignor Komora complained about the Friday departure, which would force his staff to work on Saturdays, but Monsignor Landi preferred this schedule to avoid packing the children into the weekly Tuesday flight. "If anything should happen, God forbid, to one of these planes with a large number of children," he cautioned, "the resulting publicity may be very detrimental."

To fill those airplane seats, Baldelli sent priests and social workers on field trips throughout Italy. Initially most of the orphans the PCA proposed were between the ages of five and ten years old, despite Landi repeatedly stressing to Baldelli that American couples preferred infants or very young children. On top of this, the children, arriving in ragged clothes, weren't making a very good first impression on their New World parents, described by social workers as "wretchedly dirty" emanating the "most obnoxious smells." The walk through customs only added to the staff's humiliation as some children managed to sneak a dried salami or hunk of cheese into their suitcase. Landi's boss in New York, Monsignor Edward E. Swanstrom, complained about a child who "had to be refurbished," like a damaged piece of furniture before he could be sent to his foster parents. Although the Rome office tried to find spare clothing from the Vatican supply room for its war relief missions, not much was available.

By the mid-1950s, however, Monsignor Landi had come up with an ingenious and economical way for the unkempt children to arrive in America nicely clad to meet the parents, attired in baby bonnets, bow ties, and V-necked sweaters. After the initial greetings had been dispensed with, and the children were in the hands of the waiting couples, the monsignor insisted that the staff ask for the clothes back. The little skirts

and pants, expensive and time-consuming purchases, were folded once again, the bonnets and bow ties thrown into boxes, shipped backed to Rome for the next batch of children flying across the Atlantic.

In those early years, before the Church had honed its recruiting and fashion skills, the program's major stumbling block continued to be the absence of available infants and toddlers. Monsignor Landi's superior in the United States was fielding his own complaints from eager parishioners around the country anticipating an orphan baby, as well as from leaders of groups like the Sons of Italy requesting batches by the dozen to be doled out to members. Landi cautioned that he couldn't badger the PCA, whose assistance was paramount. "In order to avoid the accusation of 'stealing Italian children' we have studiously kept from looking for children ourselves." Although not a lawyer, Landi employed the logic of a good one: the National Catholic Welfare Conference didn't take children from their mothers, instead it sent more capable local priests or Vatican-hired social workers to do so.

Through the PCA's publication *Caritas*, Baldelli spread the word to clergy, explaining the new law and how it benefited illegitimate and abandoned children. One article included a photo of a child who looks to be about six or seven poised on a plump cushion in front of a large console television set, her adoptive parents sitting on a couch behind her. The girl, with back to the camera, eyes focused on the television screen, wears a crisp white blouse and black jumper tied with an oversized frilly bow. The father is dressed in a suit, and the mother's crossed legs reveal elegant black high-heeled shoes, as if this were how American families relaxed each evening in front of the TV. "*Una vita serena e felice, ricca di affetto e di materna attenzione, aspetta i bambini emigrati in America,*" ("A peaceful and happy

life, full of affection and maternal attention, awaits children who emigrate to America") the caption reads.

One year after the first nine war orphans blessed by Pope Pius XII embarked on their journey to America, the National Catholic Welfare Conference put out a press release stating that more than four hundred "Italian refugee children" had been placed there. Although it's impossible to re-create the thousands of encounters between the PCA and families that led to the emigration of these children, tragic mistakes were made, either the result of bad decisions nudged by misery or from purposeful misinformation.

One persistent lie emerges—that the child could remain in touch with the family and return to Italy at the age of eighteen. A member of Monsignor Landi's staff described this situation in a memo, explaining that "much confusion, intentional and unintentional, was created in the minds of parents or guardians here by those who first came into contact with them." He theorized that parish priests or town clerks may have misled parents because they thought emigration the only solution to the horrendous conditions in which people lived, "and did their utmost to convince people to sign parental releases on the subterfuge that children could correspond or otherwise communicate, could someday return to Italy, could send for remaining relative, etc." This lie was told not just in the early postwar years, but throughout the decade, as Florence Fisher discovered, tracking down in America the lost brother who had been taken from his family home in Avellino in 1957.

Documentary filmmaker Basile Sallustio suggests the exchange of money played a role. In his 1998 film, "My Brother, My Sister, Sold for a Fistful of Lire," Sallustio told the story of Pia Dilisa, who spent forty-five years trying to locate her three siblings, all of whom had been part of the war orphan program.

After their mother died, the fate of Pia's younger siblings had been sealed. Their father remarried the next year and his new wife, who proved to be a loveless stepmother, convinced him to accept a priest's offer to send the children to America. Pia, then ten, watched her sisters, four and seven, and her nine-year-old brother leave the family home on top of a donkey, never comprehending that they wouldn't return. Pia's father clung for the rest of his life to the words he had been told: his children would come back to their village at the age of eighteen. But like many other families, naïve, illiterate, impoverished, who became entwined in this program, the children disappeared forever.

Five decades later, Pia sought answers, knowing only the village rumor that her father had sold his children to the Church. Sallustio's camera records several priests whom Pia questioned shouting at and stonewalling her. Yet with the help of the filmmaker, Pia's nephew by marriage, she persisted, discovering that her youngest sister had died of a fever at six years old, living in an institution in Naples while awaiting adoptive placement. Her brother, Domenico, and sister, Antoinetta, both left for America in 1952. Pia and the filmmaker flew to America to try to solve the mystery of what happened to her siblings, and among the people they confronted was Monsignor Landi in New York City, who refused to offer any information.

After chasing many leads, they went to Chicago, where a sympathetic worker at a Catholic agency provided information that led to Domenico and Antoinetta, who by then were in their mid-fifties. Pia learned that her siblings had been separated in America and had never seen each other again. Domenico's first adoptive family rejected him, and he spent the next two years in a Chicago orphanage, finally adopted at the age of twelve.

Domenico was luckier than some other Italian children, who, rejected by couples and unable to be placed elsewhere, grew up in American Catholic foundling homes. The amateur nature of this adoption program, especially at its start, led to these kinds of scenarios. One adoptive mother returned a child after two weeks; another couple sent back two children three years later claiming financial difficulty. Another Chicago couple requested a boy and girl but decided to keep only the girl, her brother sent to a Catholic foundling institution on Staten Island in New York City where he was raised.

But there was also a small group of Italian children in those early days of the program who were old enough and plucky enough to demand to go home, causing the Church further embarrassment and grief. A monsignor wrote to Landi, "Three children have already been sent back to the Catholic Committee and two more are on the way, all claiming that it was made clear to them that they were merely to come here for a visit, that they would be in contact with their parents and relatives, etc." He implored Landi to make certain in the future that no communication could ever exist between Italian mothers and their children.

The pain suffered by children arriving in the New World mirrored an unfathomable sorrow in the Old. Mothers duped into giving away their children sent letters to the National Catholic Welfare Conference, the Italian consulates in America, any authority they believed might help. With howls of rage that leap like flames off the page, they cursed America and whoever discovered it, pleading for the blessed Virgin to intervene and return their children. "I have lost my peace," one mother writes, after "a pious local priest" advised her to send her daughter "to the United States through your well-deserving organization."

A brother writes on behalf of his sister:

I beg of you to return to us our little Fiorentina for her mother is
ill due to this separation between them. Please have the goodness
to send her back—her mother can rest neither day or night. We
will take care of all the expenses for her return. . . . It is imperative
that she returns for her mother is very ill since the departure of this
child. The child was very reluctant to leave and needless to say, it was
against her mother's will too. . . . We are prepared to send a medical
report concerning the present condition of my sister.

Another mother pleads:

I feel the strongest and most acute sorrow that pierces my heart for
my children Sauro and Tina. I expected anything except to find so
much ignorance concerning this emigration. I am alone and sad.
I beg that my children be repatriated because I was encouraged
that they could write now if I cannot see again my children I want
to shorten my life. But today what you see and is verified makes
you lose your faith. . . . Sauro and Tina you can never forget your
dearest mother. I find myself so deceived and I do not even know
how.

Komora responded coldly to this woman's pleas to get
back her four- and five-year-old, of that tender age when shy
heads turn from strangers to burrow in their mother's thigh.
He informed Landi that Sauro and Tina were in the process
of being adopted, in accordance with the wishes of their new
foster parents. "Of course," he said, "you realize that these
children were accepted in good faith, and that any attempt to
invoke the decision of the release would have serious conse-
quences. Frankly we are quite concerned about this since it is

quite possible it would jeopardize the whole Italian program," Komora concluded, penning his signature below the monsignors' customary closing salutation, "Sincerely yours in Christ."

Despite the steady stream of misinformation, the shrieks of mothers and tears of children who no longer knew what a mother meant, the pages of the calendar years turned and Landi doubled-down, ensuring that the program continued and tightening its secrecy. When the temporary amendment to the refugee legislation was set to expire on June 30, 1952, allowing until the end of October for the last child to be flown out of Italy, the monsignor portrayed the situation in dire terms. He suggested a "superhuman" effort be made to process the children's visas, even if it meant placing them in American foundling institutions before adoptive homes were found.

That following January, Monsignor Baldelli held a meeting with Monsignor Landi and government representatives from the ministries of interior, justice, and foreign affairs. Baldelli began by expressing his deep gratitude to everyone involved in carrying out this program. He assured them that the difficulties they encountered "do not cause grave concern nor do they endanger what we have achieved," and indeed, he and Monsignor Landi were hoping for new US legislation to be passed. Baldelli proceeded to discuss several unresolved cases, all of which resulted in the same conclusion: that a priest (designated by the regional PCA representative) needed to persuade the mother that it would be in the best interest of her children to be placed with another family in the United States or in an institution.

Soon Baldelli and Landi would be preparing for the next phase, set to begin the following year. But this time they wanted to avoid the early pitfalls, those irritating mothers demanding

their children back, as well as other stumbling blocks along the way. To accomplish this, Monsignor Baldelli devised a plan that would make the placement of children in America virtually impossible to trace.

- 12 -

In the late afternoon of February 1, 1954, Monsignor Baldelli convened a group of eight, seven men and one woman, representatives of Church and State, for a meeting to discuss the renewed efforts to send war orphans, now almost a full nine years since the war had ended, to America. It was the season in Rome when the air is damp and the basalt cobblestones sleek and pocked by puddles, during days when people huddled in drafty offices before spending long nights in drafty homes, a time of perpetual chill. The Piazza Benedetto Cairoli, with a small park and granite fountain, housed Monsignor Baldelli's office, located in a building adjacent to the church of San Carlo ai Catinari. The PCA, which now was known as the POA, occupied three floors of the adjacent office space. The previous June the Vatican renamed this body the *Pontificia Opera di Assistenza*. Baldelli's suggestion to Pius XII a decade earlier to create a commission had proved prescient: what once had been conceived of as a temporary postwar relief effort had achieved official status.

And by now, new emergency legislation (the Refugee Relief Act) had passed in the US Congress to replace the previous temporary amendment, allowing a fresh stream of orphans—the reason Baldelli called this meeting. The American

legislation, stricter than the original, required a consent form from the mother, signed under oath (of her own free will), acknowledging the "irrevocable" relinquishment of her child. The one-word addition pleased Landi's team, who hoped the strengthened language would eliminate the messy situations of mothers pleading for their children back that they had encountered in the last three years.

Since the beginning of the war orphan program, the Church had danced around Italian law, which only permitted adoption in accordance with its own principles—that an adopter must be at least fifty years of age (by way of exception lowered to forty) and must have no other children. Many Italian couples, and Americans who adopted privately, like Martha Gellhorn, skirted this strict rule by using the power of *affidamento* which entrusted the minor to a guardian. But because this affiliation didn't become valid until after a period of three years, the Church had rejected that arrangement.

The new consent form, however, posed a much bigger legal hurdle than the age distinction. The Ministry of Justice found it "absolutely opposed to Italian law." The form had no value, the representative from Justice explained, because consent must be given by both adopter and adoptee, or in the case of the latter, if under the age of twelve, by an Italian tutelary judge, or for overseas adoptions, the Italian consulate abroad. Furthermore, the form's renunciation of rights had no value because certain rights "are essentially not renounceable."

The maternal bond, forged through nine months of patient wait, bodily transformation, and birthed in pain, is not extinguished by the scrawl of a pen to signature line; it is an emotional truth, for sure, but according to Justice, a legal one, too. The mother has the right to change her mind before the adoption is finalized, as well as the right to information to help assure

her that her child will receive appropriate care. Even if a valid adoption had taken place, the minor, whose Italian citizenship is kept until the age of twenty-one, always retains his personal rights and duties towards his family of origin, and the government is held responsible for his care and guidance until that time.

Surely Justice's concerns weren't pleasing to Monsignor Baldelli, who just the prior year had configured the same government ministries to laud their good work in making the orphan emigration possible. And a mention of the Italian consulate's role was assured to make Monsignor Landi cringe because from the beginning of the war orphan program both he and Monsignor Komora worked to edge out the consulate, which had requested the names and addresses of adoptive parents that the Church refused to provide.

But as the meeting continued, Baldelli's true agenda became clear. The monsignor had not assembled this group to follow the letter of Italian law, but rather to find ways in which to elide it. The program's past difficulties had not dissuaded Monsignors Baldelli and Landi but furthered their resolve to farm out Italy's problematic children to good American homes.

Landi, who reasoned with acrobatic agility, dodging obvious contradictions by cartwheeling over them, proposed a solution. The monsignor suggested drafting two forms, one for Italian authorities, which would contain no renouncement of powers and rights, and the second, privately signed by the person charged with guardianship powers (i.e., Monsignor Komora in New York City) to be used exclusively before American authorities.

Baldelli concurred but wanted to take this program a step further to avoid the type of pitfalls being discussed, and which the Church had just experienced firsthand. The only children

who should be selected for emigration, he suggested, should be full orphan illegitimate ones, that is, mothers who anonymously surrendered their child, as their ancestresses had done with each turn of the *ruota*, to a provincial *brefotrofio*. Without the mother's name, these cases could never be traced, preventing a mother from trying to claim back her child, or the child, once of age, to search for the woman who brought him into the world.

Landi agreed "perfectly," adding that some exceptions could be made for minors requested by relatives in the States. Justice grumbled a bit about the lack of legal value in all of this, but Foreign Affairs and Interior were all in. Baldelli requested that the Ministry of the Interior send a circular letter to all the prefectures to research minors eligible for emigration and Interior promised to do so. The representative from Foreign Affairs took it upon himself to sum up the meeting's conclusion: minors would be entrusted to the National Catholic Welfare Conference, and the adoption would be accomplished in the United States.

With the matter resolved, Baldelli dismissed the government representatives, asking only Landi and his staff members to remain to discuss practical procedures. They divvied up responsibilities for this next phase of the orphan program, deciding that the POA would continue to provide priests and social workers to search for children, and that a deputy of the POA would be named to oversee Landi's work at Via della Conciliazione, 4. The POA initially would pay these salaries, later reimbursed in American dollars from the NCWC.

The meeting, which had begun at 5:30 p.m., officially ended and Landi, along with two members of his staff, left the Piazza Benedetto Cairoli to head home for the night. By all regards, the discussion had been a success, the way to proceed determined. The next phase of the orphan program, continuing until the

end of the 1960s, would focus on sending Italy's anonymously surrendered children to America. And there were hordes of them, with a Church at the height of its postwar powers so eager to help. Social workers sent Landi tantalizing leads, like the offer by Cardinal Mimmi of Naples "to talk with the Presidents of Institutions and Provinces to open the door for NCWC, as there are six thousand illegitimate children in Naples area alone. Cardinal Mimmi says this will be a personal help to him, who is responsible for the spiritual help of each of these youngsters."

A year later, Baldelli summoned again the three government ministries, and a representative from Justice reiterated what had been said the year before. Although "fully aware of the generosity of the American people and of the opportunities they are giving to the unfortunate children of Italy, nevertheless, Italian legislation does not strictly speaking provide for the emigration of these children." But strictly speaking, it didn't matter. Baldelli and Landi proceeded as usual, circumventing the rules and gathering the support of enough government ministries to do so. Monsignor Landi always used discretion in his writing, referring to the "orphan" children, but there could be no doubt what this program was all about: the plan suggested by Baldelli at that first of February meeting, and six years later announced in capital letters on the subject line of a memo to Landi from the president of the provincial administration in Benevento, RE: PLACEMENT OF ILLEGITIMATE CHILDREN IN THE USA.

The quotas provided by the Refugee Relief Act, combined with the Church's focus on anonymous surrender, paved the way for the expedient passage of children to the United States and by the mid-fifties dramatically increased the number of infants available for foreign adoption. For those in power, political affiliation generally determined their reaction to this large emigration. A social worker named Carla Persia, hired by

the POA and loaned to Landi, filed a detailed report about her work over three years, from 1954 to 1957, when she had been assigned to look for babies and children in northern and central Italy.

Persia gushed about the high scope of the program, thanking Landi and Komora for "guaranteeing a serene and secure future" for these children (as well as for gifting her with an unforgettable trip to America when she escorted five children awaiting adoptive placement to Detroit). The program's success, Persia explained, existed only because of the persuasion of the POA social workers and priests: "I wish now to point out that if during the whole of 1954 and the beginning of 1955, the statistics resulting from our work did not run very high, this was mainly due to the fact that the Orphan Program was almost completely ignored and therefore our work was one of penetration and information, which gave results in the years following." For Persia, this meant visiting twenty-seven provinces, contacting provincial presidents, directors of institutions, physicians, nuns running the *brefotrofi*, tutelary judges, mayors, and families. She investigated 305 cases, resulting in more than half receiving adoptive placement in America, with another seventy-five cases pending.

But of those twenty-seven provinces Persia scoured, only sixteen responded favorably. "The political factor," she wrote, "has proved to be negative to the program. Many Provincial Administrators are represented by men of leftist tendencies, who were courteous when consulted but have referred no cases to us. On some occasions it has been deemed advisable not even to consult them."

Orphan summaries prepared by Landi's staff every few months, reviewing the program's activities and showing the investigation of thousands of potential anonymous cases,

affirmed Persia's comments. Social workers griped about their work being obstructed in leftist regions while conservative ones opened their doors for the children's removal: "While the Provincial Administration of Perugia is communist, the President of the Province was not opposed to our program, making it possible for us to obtain referrals of illegitimate children from that area. However, the Director of the Foundling Home does not approve of the emigration of minors, thereby cutting off the largest single source of referrals from this province."

"The provincial administration of Lucca is not disposed to consenting to the emigration of its children."

"La Spezia has a communist-controlled provincial administration which is not amenable to the adoptive placement in the States of its wards, but the local branch of the Pontifical Relief Commission has referred some cases to us which do not require the approbation of the public authorities and we shall process these children."

"At Verona, however, we obtained the wholehearted cooperation of the Provincial Administrator as well as the Director of the Foundling Hospital and already a number of referrals have been made to us." Perhaps not surprisingly, Verona's wholehearted enthusiasm for involving itself in the intimate affairs of women as documented in these Church files has continued right up to the present day. Fiercely anti-choice, Verona, the Romeo and Juliet city of love, today is known as "the city of life."

- 13 -

In a program that abounded in risible inconsistencies, one of the most absurd elements may have been the transportation and lodging of the infants and children. For one, they traveled across the ocean without their new adoptive parents, a scenario unimaginable today, bouncing and hurtling on piston engine planes, the earliest groups barely chaperoned. ("As you know," Monsignor Landi wrote to Komora, "the children are for the most part unaccompanied and, as you can appreciate, the air hostess cannot devote her time exclusively to the orphans during a twenty-odd hour flight.") The children usually traveled in small groups, accompanied on the flights by nuns, priests, social workers, or whomever else could be rounded up to transport them.

Airlines pitched in by recruiting some of their workers to fly with the children as well as advising Landi's office when nuns had booked tickets on New York flights. One adult usually looked after four children, and infants sat on the lap of an adult or an older child. The brunt of changing diapers and childcare fell to the airline stewardesses, and for the duration of the international flight the pilot served as the children's legal guardian.

When the planes arrived in New York, many children needed

a room for the night before heading across the country to meet their new parents. To deal with these complicated logistics, Monsignor Komora rented a top-floor suite at the Chelsea Hotel in Manhattan, equipped with baby and youth beds, bathroom, and small kitchen, staffed by three women aides on call to serve as housemothers. The child travelers returned to the airport the next day with their Church escort, prescribed a mild medication to help them sleep through the final leg of their journey. Adoptive parents who lived close enough to drive to the hotel received logistical instructions from their local Catholic agency that sometimes read like the penultimate directive of an elaborate treasure hunt:

> Be at the hotel by 5:00 p.m.—ask the desk clerk for the Catholic Committee room—wait there and the children will be brought to you.
> Good luck on your trip and the start of parenthood.

But most curious of all was the choice of the Chelsea Hotel to house children sent to the New World to be exculpated from sin. Although conveniently located for the priests and staff of the Catholic Committee for Refugees, just a ten-minute walk to its 23rd Street location from their West 14th Street offices, the hotel was infamous for its debauchery. The Chelsea attracted a glamorous bohemian elite, as established poets and writers and globally famous rock stars—Jimi Hendrix, Lou Reed, Bob Dylan, Warhol icon and Velvet Underground singer Nico would check in over the next decade—stayed in rooms as shabby as they were tawdry. "No vacuum cleaners, no rules, no shame," playwright Arthur Miller summed up the ambiance behind the hotel's gothic red brick facade.

Which meant that during those two decades, somewhere on

a floor below the revolving suite of Italian children, the poet Dylan Thomas fell gentle into the good night, succumbing to a fatal coma after telling a girlfriend, "I've had eighteen straight whiskies. I think that's the record." Where on the first floor, prostitutes and pimps hung out, Andy Warhol roamed the halls filming "Chelsea Girls," and you might even find a naked woman stepping into the elevator—or Janis Joplin, whom Leonard Cohen met for the first time during a 3 a.m. elevator ride, escorting her to his room once the doors parted, a night immortalized in his song "Chelsea Hotel No. 2." With masterful understatement, a student of social work attending the Catholic University of America and writing her 1968 dissertation on the good work of the orphan program, noted that the Chelsea gave the children an "opportunity for rest and reassurance by a mother substitute, but necessitated adjustment to the hotel setting."

A particularly distressing aspect of Monsignor Landi's intransigence and lack of compassion toward mothers pleading for their children back, his urging to move children out of Italy quickly when the temporary legislation approached expiration—even if it meant putting them in foundling institutions until, or if, adoptive placement could be found—and his insistence on absolute secrecy to ensure the permanent severance of the maternal bond, was that Andrew Landi had spent his prime boyhood years in an orphanage.

His parents, immigrants from Southern Italy, arrived on New York's shores in 1894, settling into a small house where an auto repair shop stands today on a busy industrial strip in Brooklyn. His father, Alessandro, a short olive-skinned man, worked as a tailor to support his wife, Concetta, and their seven children. It's hard to imagine the short life of the monsignor's

mother as being anything but arduous. Concetta was pregnant at seventeen, delivering a child every two years until she became ill and died at the age of thirty-one. At the time Andrew, his family name Andrea, was four years old. For the young boy there seemed to be no end to the family's tragedies: his father Alessandro died shortly thereafter. Andrea's next home was an orphanage, and only in adolescence did he return to his family, taken in by a married older sister.

Despite the miseries of his childhood, Landi was unbothered by separating children from their mothers. The orphan team under the leadership of Monsignors Baldelli and Landi diligently carried out the Church's belief that an unbridgeable chasm existed in the ability to raise a child between a teenage bride like Landi's mother, pregnant at seventeen, and one who gave birth out of wedlock.

Everyone involved in the orphan program believed that they were performing an unmitigated good, preventing abandoned children from potentially spending their childhood and youth in crowded *brefotrofi*, providing them instead with spiritually rigorous and materially comfortable homes in the United States. The Church labeled any opposition to its work the product of Communist troublemakers. Even the clumsy logistics—airline pilots acting as legal guardians and stewardesses changing diapers, adorable outfits for good first impressions returned to Rome for reuse, lodging at the no-rules, no-shame Chelsea Hotel—were viewed back then as proof of seamless bureaucratic and organizational skills.

By the close of 1955, the orphan program was fully underway. A chipper year-end summary described how after two years of contact with the Ministry of Interior, full cooperation had been achieved. The Ministry had even volunteered to follow up on Baldelli's request to allow the NCWC to enter into

areas originally unfavorable to the program. "The future looks bright," a member of Landi's staff reported. "The popularity of this program is really just taking hold in Italy and it seems that emigration of orphans should become a regular part of the emigration program for Italy."

Monsignor Landi died in 1999 at the age of ninety-two, long retired from his international work, but acting until his death as the assistant treasurer of the Catholic Relief Services. In the nineties, when filmmaker Basile Sallustio brought Pia Dilisa and his camera to Landi's New York office to question him about the program and the whereabouts of Dilisa's siblings, the monsignor was an old man, his face locked in a grimace, his thin lips parted as he listened. He repeated multiple times that he could offer no help, he had neither information nor answers. When asked about all of the children who left Italy during those years, Landi responded, "They were offered to us. We didn't take them."

To offer, such a Catholic verb, one whose permutations I learned from the nuns in Sunday school—the priest serving as the intermediary to God by offering the mass; the faithful, stained by original sin, making an offering, which means parting with something that is our own. Perhaps the logistics of the program had taken place too long ago for the monsignor to recount the memos in his files reminding him that an approaching tourist season could portend good news for finding potential American couples, or another stating that "Msgr. Landi has employed a priest who is traveling throughout Italy, visiting the institutions and in general looking for children who can be proposed as anonymous cases."

Only one person, Virginia Formichi, "the last of the Mohicans," as she calls herself, could speak today about the program. A San Francisco native, whose family originally came

from Italy, she sailed by passenger ship to Rome in the fall of 1955 to replace the previous "orphan supervisor," carrying an impressive resume, a master's degree in social work, law degree, and post-graduate studies just shy of a PhD at the University of California at Berkeley. Formichi worked at Via della Conciliazione, 4 until 1962, when she left to pursue other projects abroad for the Catholic Relief Services, returning to San Francisco a decade later. Eventually she left social work to help manage her father's large real estate portfolio and today lives alone in an apartment in the Marina section, one of the city's prettiest neighborhoods that borders the bay.

When I traveled to San Francisco in the winter of 2018, I had hoped to interview Formichi in person, but at ninety-one, nursing a dislocated shoulder and bad cold, she preferred to speak on the phone. Despite my best efforts to ingratiate myself, offering to pick up anything she might need, she snapped, "I have friends" to my transparent entreaties. She did, however, enjoy talking on the phone about her days in Rome and work on the orphan program, which we did on several occasions. For Formichi, those years were exhilarating ones, despite having to adapt to physical deprivations to which urban Americans were unaccustomed, poor telephone lines, lack of heat, and mold on apartment walls (the cause, she believes, of a lifetime of respiratory problems).

But her reward came from carrying out the mission of the orphan program, and she explained that over three thousand babies were placed in American homes during her seven-year tenure. I danced around the question of illegitimacy, knowing how careful Monsignor Landi had been to call the children orphans in his correspondence. But to my surprise, Formichi showed no reticence, responding that almost all of the children sent to America were illegitimate. "Well, I never want to say

never," she chuckled, "but it was from the provincial *brefotrofi* where we got most of our children."

"Their families would have, so to speak, excommunicated them. It was a terrible scandal in those days." She mentioned the better-known situation of unwed mothers in Ireland and called criticism of what had taken place in the Magdalene Laundries "a lot of baloney." According to Formichi, most of the women who anonymously surrendered their babies to a *brefotrofio* like the Turin Institute originally were from the South of Italy. While some, like John Campitelli's mother, had come to hide their pregnancies, others had moved north seeking employment, hoping to take part in the postwar economic miracle that had eluded their half of the country.

But life, as we know, does not always work out as planned. Formichi summed up what had happened to these women, to their dreams and longings, to plans thrown off course with a slingshot's force with the matter-of-factness, and perhaps whiff of moral satisfaction, of one who followed the rules toward those who didn't: "Then they met the policeman or the fireman—and we got the children."

Part Three
My Child No Longer

- 14 -

Yet each of those children, the ones described in that throw-away line—*then we got the children*—was some mother's child. A flesh-and-blood woman, not a symbol of a fallen Eve to be hidden and humiliated. A mother like Lia Maria who lost her twin babies to the orphan program. Her son and daughter were born in 1963, the same year as John Campitelli. Lia Maria spent most of her adult life searching for answers about what had happened to her daughter, whom she named Antonella, and with the grace of God, her son, Marco. During her desperate search to reclaim the twins, a social worker told her that her baby boy was in extremis and had been given his last rites. It was a death she wanted to deny, but had no proof in which to do so, and so lived each day with this fear enveloped into her abiding sorrow about the fate of her children.

Because the municipality in which she lived had no record of the American adoption, on her son's eighteenth birthday the police came knocking, demanding to know why this young man had failed to enroll for his military service. Nearly two decades later, still without a trace of what had happened to Marco, Lia Maria could not answer these accusatory questions. Where is my son, is my son alive? Questions no mother ever wants to posit.

Today Lia Maria lives in a modest and well-kept house in the countryside about an hour outside Milan. Even now, when I stare at a photo of the two of us smiling that day, my arm around her shoulder, bending slightly as I used to do with my own mother, she seems a typical mamma, at ease in her home, the past hidden from the camera lens. With silver hair neatly coiffed, she wears a black striped wool sweater with a small furry dog stitched onto the side of the chest and comfortable gray pants. Her eyeglasses, tinted a soft rose, obscured the expressiveness of her brown eyes.

In the photo, we are standing in front of where her kitchen and dining room meet; resting on the counter are a flour-sugar canister set, a can of cannellini beans, and a ceramic spoon holder. Framed photographs of her family sit atop the break-front cabinet that demarcates the dining area. John Campitelli introduced me to Lia Maria and took this picture. He knew her story because John's name had been passed along to her over a decade earlier as someone who might be able to help find out what had happened to the twins.

She offers me an espresso and biscotti, shuffling between stove and table in thick gray slippers embroidered with a kitty cat face, explaining the family photos, filling me in on the lives she loves, and which define her. A vase of tall yellow roses sits on the floor, which were sent, she tells me proudly, by her sons who live nearby—the ones from later years, whom she was allowed to keep—for her seventy-sixth birthday on March 4th. "*Il giorno di Lucio Dalla*," Lia Maria adds. John, detecting my confusion, chimes in that Lucio Dalla was a well-known Italian singer.

The fame of Lucio Dalla had not crossed the ocean to America, but later typing the singer's name into a Google search, I learned that Dalla's birthday, 4 marzo 1943, was also the title of his first

hit. The song originally had been called "Gesù bambino" but censors in the early 1970s blocked the title's religious allusion. The folksy ballad, which is not autobiographical despite its date-of-birth title, tells the story of an illegitimate son's entrance into the world. When his mother was just shy of sixteen, a nameless foreign soldier had made love to her in a meadow. Their time together was brief; the handsome man soon goes off and dies on a battlefield. The girl, possessing only one garment, a skirt that inches up her growing belly, names the child, either in whimsy or as a keepsake of this fleeting love, Gesù bambino.

It was impossible to read these lyrics and not consider their shared birthday from a different perspective, a reminder of how Pius XII's response to the ravages of World War II had trailed Lia Maria's reproductive life. Among the ruins of Mussolini's alliance with Hitler were women raped by foreign soldiers, women who exchanged their bodies for soldiers' meager food rations, women who fell in love with or sought out strangers in uniforms to escape their plight. The social dissolution and rising numbers of out-of-wedlock births by the end of the 1940s—a result of the Communist influence, said Pius XII—fed the Vatican's desire to send Italy's illegitimate children abroad.

In 1963, the year of the twins' birth, the by-then smooth machinery of the war orphan program changed the life of this woman born on 4 marzo 1942, the year before Lucio Dalla. Of course, in the sixties, no occupying foreign soldiers were fathering the children in the country's *brefotrofi*, just the average Italian man, which meant that the supply of adoptable babies remained high.

Lia Maria was twenty-one when she discovered that she was pregnant again, already the mother of a one-year-old girl, Rossella, whom she was raising on her own. Her father sent Lia Maria away from home when she became pregnant with

Rossella, ashamed of this dishonor, a curiously harsh response from a man who was not her biological father but had recognized this illegitimate daughter of the woman he married. Lia Maria went to live with a friend of her mother's, working for this family to earn her keep, and later found a job as a hotel chambermaid, a place where she could sometimes take Rossella with her while she worked. Her aunt also helped out in this quilt work of care that single mothers piece together.

Rossella's father, a married man, never offered Lia Maria a penny in child support but he did occasionally come by to visit his baby daughter, every month or so during her first year. The only gift he left was to get Lia Maria pregnant again. At this point, the life she was trying so hard to make work began to unravel. Her personal galaxy of jumbled decision-making, combined with an absence of protection and resources, familial and financial, gained critical mass, and like an asteroid derailed from orbit began its spiraling descent, and inevitable crash.

Lia Maria's hotel supervisor fired her upon discovering she was pregnant, and with a new baby on the way the desperate young woman had little choice but to return to her mother, who was an alcoholic now living alone. The stress and arguments that ensued, Lia Maria believes, caused her premature delivery at eight months. During labor, she remembers the nurse calling the doctor, surprised that they were delivering not one child but two, her son born at 4.8 pounds and daughter at 4.2 pounds. Although Lia Maria knew of a family history of twins, a history both on her side and the babies' father's, she never imagined that she would be giving birth to two children, her troubles doubling that day. A week after their birth, Lia Maria's mother told her that she could not return home with her babies and pointed her to the city's *brefotrofio*.

When discussing her time there, where Lia Maria lived for the

twins' first three months while Rossella stayed with her grand-mother, she shudders as if a current of cold air had just pushed through the room. The babies were kept on the ground floor, the mothers lived separately on the floor above. Each morning she slipped on a pink-and-grey striped smock that had been handed to her, tucked her dark hair into a white cap called a *cuffia,* and felt, she said, like she was wearing a prison uniform.

Between 5:30 and 6:00, the mothers headed downstairs for the scheduled feeding. As soon as they finished nursing their babies, they were sent away. As for the rest of the hours: "And then, and then, nothing, we went to do the housework, we went to work. Cleaning the floors, cleaning the church, cleaning the basement because the basement was connected with the Macedonio Melloni [the neighboring maternity hospital] and all those children who were not recognized were all brought there."

British psychologist John Bowlby's famous theory of attach-ment, first published in 1953, which suggests it is critical to a child's long-term emotional development to establish a secure maternal bond during the first two years of life, never was the goal of the *brefotrofio.* Lia Maria tried to remember when and where she ate her meals but drew a blank about this period. I asked if she had made any friends and she remembered keeping the address of one woman she liked, the girlfriend of a well-known singer who refused to recognize their son. But real friendships, she said, did not form at a place like that, a memory best erased.

She circled back to the meals, disturbed by her inability to color in this blank. "But I don't remember the refectory! I don't remember where we went to eat! How do you forget something like that?" Lia Maria clutched and wrung her hands trying to reconstruct the gap, as if in this nervous gesture she could

squeeze drops from the rag of memory, an ongoing battle of wanting to forget the humiliation of this time coupled with a life's need to record those brief months with her twins.

"*Tranquilla*," John said, his calming voice suggesting that he is good with distressed Italian mothers.

It occurred to me later, after John and I had left, too late to offer a possible comfort, that her failure to recall the refectory suggested not a faulty memory but a mother's memory. As the years go by, our cluttered heads dispose more and more information, each recollection composed of the matters most important to us. Lia Maria remembered nursing her twins, along with the emotional deprivations and shame attached to her keep, but what did it matter what food she put into her mouth, the forgettable tastes of cafeteria fare chewed and swallowed between tasks, where and when she ate? Her job was to feed her infants and accept punishment for her sins, cleaning the floors and basement and church, a punishment that was about to be made much worse.

The twins were born in early August and when Rossella's two-year birthday approached in November, Lia Maria decided that it was time to go home, to live with her daughter and mother and visit the twins in the *brefotrofio*. She wanted to be with Rossella and was terrified that the social worker—Lia Maria was required to meet with this woman regularly—would discover that her mother was an alcoholic, a fact that put Rossella in danger of being taken away too.

"For me, Rossella was an overwhelming thing, knowing that my mom was drinking. My mom was always drunk, always," she explained, a woman to whom she entrusted her daughter only out of utmost desperation. She remembered when Rossella was almost three and the two of them went to see an outdoor movie together. When they returned later that evening to

their apartment along the Naviglio canals she heard someone yelling, "help, help." It was her mom, clinging precariously to the balcony, one grasp away from falling into the canal. "An unhappy life," she sighed.

One time during her new routine visiting the twins, she went to her scheduled meeting and the social worker asked how she was doing. Lia Maria replied that she could use a little help, an answer she rues to this day. We can help you, the social worker said. But those words had a different meaning for each woman. Lia Maria interpreted the comment as a form of temporary help while she was putting her life back together. And her life had been improving.

She found a job immediately after leaving the *brefotrofio*, a good paying one during the country's economic boom, working on an assembly line at an electronics company, attaching cathode ray tubes, the projection mechanism before the invention of the flat screen, to the back of television sets. The money she earned enabled her to send a monthly check to the institution, a family allotment for the care of the twins, as she could no longer be there to clean for her keep and theirs.

But after this talk, Lia Maria remembers next the social worker escorting her on a tram to a large office building to see a notary public. "The social worker told me, 'listen, we have to go to a notary because you have to sign the authorization that the children go'—I don't remember the word anymore—'in foster care.'"

The woman who had lived for three months in the *brefotrofio* and then sent monthly checks for the care of her babies—not exactly the actions of someone abandoning her children—believed the arrangement to be a temporary one. So when the notary behind the desk pointed and said, sign here, she did what she was told.

"I, ignorant, ignorant, did not read it and I signed, convinced that the twins were still mine."

Shortly after this encounter, during one of her routine visits, the twins were gone. She panicked, asking a nurse, "But where are my children?"

"Miss, you don't remember what you signed?"

"I signed for the foster care."

"No, you signed the renouncement."

Lia Maria searched for the social worker who had taken her to the notary.

"But what did you want? When we told you that you had to sign for the foster care, look, you signed for the renouncement."

"I . . . look," Lia Maria explains, still deciphering a half-century later what she had done, "I was a bit, not ignorant, I didn't understand certain things."

At this point, Lia Maria was a desperate woman. After being misled about the form she signed, another social worker delivered the horrifying news that Marco was being given his last rites and Antonella on her way to America. Both lies, told with the twisted logic that getting the twins out of a mother's mind early on would ease the blow of losing two children. In real life, not the altered landscape of an unwed mother on Italian soil, the twins had been transferred to a smaller institute in Cannobio on the shore of Lake Maggiore. There they would linger for two years, until 1965, far from their mother's eye.

Moving the twins from Milan to Cannobio was another means to help facilitate sending illegitimate babies to America by making opaque the child's situation from the frantic mother wanting her baby back. A report on Milan's *brefotrofio* by Church-employed social workers who visited and detailed the day-to-day operations of these institutions noted: "The children of frail constitution, or those for whom there is concern about

undesirable interference on the part of their mothers, are trans-
ferred to the Institution at Cannobio."

Lia Maria hounded a social worker who lived near her for
answers about her son's health and the twins' whereabouts but
learned nothing. Her search continued when the twins were at
Cannobio and in the years after but every attempt she made to
find her children led only to more stony silences. Lia Maria was
forced to reconcile with her sorry fate. At the age of twenty-two
holding pen to paper she had made—what she feared then and
is certain now—the biggest mistake of her life. She had become
one more in a countless line of disposable women, a cog in
the production machine of Italy's infant abandonment system,
which by the twentieth century was powering the supply of
babies for domestic and international adoption.

- 15 -

One day when Rossella was a little girl, bored and looking for something to play with, she decided to rummage through her mother's drawers. Between shiny trinkets and scraps of paper, she found a small square black-and-white photo of her mother holding two tiny newborns.

"Mamma, who are these two babies?" she asked.

"But she was small so I told her, 'they are my friend's two children who died.'"

The girl, whose mother left her with her grandmother for three months to live in the *brefotrofio* a floor above her twin babies, may have sensed deception, revealed perhaps in a blink of her mother's eyes or an odd register of her voice. Rossella tore up the photo, the only image Lia Maria had of herself holding Marco and Antonella. Many years passed before she had the courage to tell her daughter the truth.

Lia Maria's life had moved on. She met a man, eventually married him, and along with raising Rossella, they had three sons together, sons who live near her today, and send their mother roses on her birthday. Her relationship with their father, who died years ago, ended after she found him cheating on her. The second time, she threw him out. She keeps his

framed photo along with the others on her shelf, but its place seems more a vestige of familial respect than affection, as Lia Maria's memories put him second in the category of bad choices in men.

The constant in her life, along with raising a family, was her determination to find her lost children. "Always, I always, everyday thought about it, always."

Lia Maria went to churches to see if any records about the twins existed. She returned to the town hall so many times that the clerk upon seeing her exclaimed, "Oh mamma, she's still here!" She went to the juvenile court to try to find the document she had signed. A clerk told her that a fire had destroyed all the files, a lie so obvious she didn't even know how to respond. Despite all those attempts for answers, Lia Maria has never been able to retrieve the document she signed that day.

She now had a partner in her search, her daughter Rossella, by then a married woman, who having lived for so many years with her mother's pain, and wanting to know her siblings, joined her mother's quest. Rossella planned to go to court, pretending that she was her sister, Antonella, and request her documents. But her husband found out and stopped her: "Are you crazy? They'll arrest you and put you in jail."

Lia Maria's youngest son, Alessandro, tried to dissuade both his mother and sister from their relentless efforts, fearful that his mother was setting herself up for more disappointment. You don't know what happened to them, he told her. They might not be alive. They might have been in the Twin Towers when they were destroyed.

This comment shook her, and she began to entertain the idea that the twins died on September 11th. Lia Maria noticed the look of disbelief on my face, one which registered the unlikelihood that of the over three hundred million people who live in

the United States, she'd cling to the dubious odds of this having happened.

"Because I always thought, in America it's in New York. I never thought about other states. Yes, I thought of New York."

Not to mention, I considered, that her mind had been well-trained by social workers to soar to calamity when imagining the fate of her children.

The twins were far from the Twin Towers, safely ensconced in rural Pennsylvania in a small town called Plains. Their adoptive parents had changed the babies' names from Antonella and Marco to Maria and Danny. In 2001, the year of the September 11th attacks, the twins were mourning the death of their mother. Cleaning up their childhood home, they found their adoption and naturalization papers, a reminder of many questions that had never been answered. Maria had thought about her birth mother, especially during her teenage years, but didn't want to press her adoptive parents for answers.

With both now gone, she tried searching for her Italian family but gave up after several unsuccessful attempts. It wasn't until a decade later, in 2012, when Maria was getting a divorce, that her lawyer needed to know her birthplace and she told him Milan. With her Italian roots on her mind, she mentioned this fact to her supervisor at the family-owned department store where she worked. Maria's boss became intrigued and asked if she could do some internet searching for answers about her biological family.

Meanwhile, Rossella switched her research to methods that wouldn't, as her husband feared, lead to her arrest. She connected with an Italian adoption group, as well as John Campitelli, who from his own records found the date of the twins' adoption in America. On a Facebook adoptee and birth mother search page, Rossella posted this plea: I am looking

for my twin siblings *ANTONELLA* and *MARCO* born on 8/10/1963 in Abbiategrasso, province of Milan. She included their mother's surname (Lia Maria had recognized her babies so her name was on the birth certificate) and their date of adoption.

Maria's boss, peering adoption internet sites, stumbled upon this page. She shared it with Maria, who was dumbfounded—all the information matched. Forty-nine years later, the face of a woman named Maria popped up with a reply in English: I am Antonella. I live in the USA with my twin brother.

"My god," the person running the site replied.

Soon after, the two sisters, Maria and Rossella, spoke by phone with the assistance of a translator. They had decided to connect before giving Lia Maria the momentous news. They arranged a Skype call between Danny and Maria and their birth mother, which lasted for more than two-and-a-half-hours and was translated by one of Lia Maria's granddaughters. The mother told the twins to put their faces close to the screen so she could examine them since she could not hold their cheeks in her hands. She longed to hug them, to touch them, but this would be a good enough start.

The twins, of course, wanted to come to Italy, but feared the trip would be too expensive for limited budgets. Lia Maria and Rossella took care of the costs, sending them plane tickets and making all the arrangements. The reunion would take place in Sicily, where Rossella has lived on the southwestern coast in Selinunte ever since she married a Sicilian man. Lia Maria and her three sons headed south to unite at her daughter's home.

In America, the *Times Leader*, a newspaper that covers northern Pennsylvania, learned of the search and reunion, and ran a lengthy human-interest story filled with the details of the

twins' discovery and voyage to Italy. A huge picture of Maria and Danny covered almost the entire front page of the feature section. The twins described their magical ten-day trip, the hugs and many tears, the walks on the beach, the champagne toasts, the abundant Sicilian cuisine, octopus, eggplant, cheese, olives, grilled meat, and Limoncello. Lia Maria gave Maria a watch and a necklace with four hearts to represent each of her siblings in Italy. In the article, Maria said that she and Danny would be back in a couple of years.

The reunion took place in 2012. Years later, Lia Maria takes me into her bedroom to show me pictures of Danny and Maria. The framed photos rest on her bureau, near the rosary beads that drape her bedpost, giant close-ups of their faces, as if replicating their first Skype call when she asked the twins to move close to the camera. She kisses their pictures every night in a bedtime ritual, but she has not seen them since.

They keep up through Facebook, which Lia Maria has now learned to navigate on a smart phone, but communication is difficult when you don't share the same language or culture, separated for half a century. After the initial thrill of the visit subsided, Maria and Danny settled back into the familiar routines of their American lives. Mostly they communicate with their birth mother by posting pictures and videos and using the universal language of emojis. Lia Maria showed us a brief video of Danny, a cacophonous burst of noise that she believed was a birthday party for his friend. John explained that they are celebrating St. Patrick's Day with its typically raucous Irish-American tradition of beer drinking. "*San Patrice*, John?" she asks confused. John and I exchange glances, the uneasy feeling of understanding more about a stranger in this circumstance than their own mother.

By now the sun has long set and we must be on our way. I

turn off the tape recorder and as we approach the front door, exchanging goodbyes and my hopes to see her again, Lia Maria says, *"Che storia brutta, eh?"* I give her a hug knowing no words can offer a good enough response.

- 16 -

The Sunday I met Lia Maria, I first went to church. Not just any church but the Basilica di Sant'Ambrogio, commissioned by Milan's patron saint in 379. Of the early structure little remains except for part of the original floor plan, as well as Ambrose himself, who lies robed in white pontificals in a crypt deep inside. The church that stands today at this ancient site was built between the ninth and twelfth centuries in Lombard Romanesque style and restored in the nineteenth century. It's a low structure, imposing not in size but in its aura of austerity, built with bricks that look, depending on the bleach of the sun's rays, a deep ochre or sand. Two bell towers of uneven heights frame the basilica and a four-sided portico leads to the entrance.

The mass had already begun when I entered and stood in the rear of the nave, the air thick with clouds of incense that drifted down the central aisle like a perfumed Milanese fog. After the organ sounded and the readings were spoken, I focused my gaze on the priest who climbed the steps of the pulpit to deliver his homily, for it was Ambrose's ancient pulpit that drew me here.

I wondered whether being an Italian-American Catholic woman educated at a Jesuit university that teaches you to think yet insists upon institutional orthodoxy (don't even try, as some

of my friends discovered our freshman year, to advocate for a women's health center on campus) nudged my fortitude to be angry about words uttered over *sixteen hundred years ago*. Okay, I might hold a good grudge, yet I also felt in good company. For when women collectively, exhaustedly declared that enough was enough, a critical idea moved from the remote halls of academia to the universal message of a hashtag: the abuse and mistreatment of women couldn't be remedied without addressing its structural roots.

Before I would learn later that day about Lia Maria's "*brutta storia*," I wanted to recall ancient stories that laid the foundational pillars of Roman Catholic belief about women, purity, and sin. Beliefs derived not from Jesus' gospel message, "He that is without sin among you, let him first cast a stone at her," but from the ascetic writings of the fourth-century Church fathers. Ambrose, who earned the sobriquet the Doctor of Virginity because of his extensive writings on the subject, his student Augustine, and Jerome formed the triumvirate whose ideas led to the Christian ethos that all sexual desire is inherently evil, and any child born of such desire a sinful flesh. This fourth-century discourse turned virginity into the faith's supreme virtue and sexual behavior became the quotidian means in which to display Christian life.

I was standing on grounds near where Ambrose had once preached the story of the virgin martyr Agnes. Written by Ambrose, the tale became widely popularized in the Middle Ages with the publication of *The Golden Legend*, a compilation of the lives of saints by Jacobus de Voragine. The author, a friar and later archbishop of Genoa, penned seductively gruesome stories that would have topped a medieval international bestseller list if those early printers had created such a savvy marketing tool, with more editions printed than the Bible. The

story of St. Agnes, a virgin martyr who died at the hands of Roman persecutors in the beginning of the fourth century, begins in Jacobus de Voragine's version with this lovely girl born of noble lineage walking home from school one day when the son of a Roman prefect spots her. The boy, smitten at first sight, promises Agnes jewels and great riches if she will marry him, but the twelve-year-old girl, in a terrible jolt to this nascent male ego, rebuffs him because she is "pledged to another lover."

"The one I love is far nobler than you, of more eminent descent," Agnes continues, piling on the blows of her rejection. "His mother is a virgin, his father knows no woman, he is served by angels." She has been embraced by his pure arms, and her body is with his body. The suitor, considering this definitive and rather prurient rebuke, returns home in a jealous sulk, throwing himself on his bed, and whimpering to his father.

Sadly, only the reader, not this dimwitted pagan, understands that Agnes is speaking of Christ. The furious and powerful father responds first with "soft words" then with dire threats, telling Agnes that since her virginity holds such importance, she must sacrifice to the goddess Vesta or be thrown in with harlots. Her refusal results in humiliation and torture: being stripped naked and sent to a brothel, offered to the prefect's son and his pals for their pleasure, and set on fire. A series of divine interventions protect her—miraculously growing hair covers her body, powerful rays of light fend off the boys, and in a culminating flourish parting flames leave her untouched. Yet after surviving each battlefield blow to deflower her, a soldier plunges a dagger into Agnes's throat. Her bloodied lifeless body earns her the crown of martyrdom, ascending into heaven to meet her true spouse.

Centuries of retelling added more layers of baroque contours to Agnes's legend, but even in the fourth century Ambrose's

sermons so unnerved his upper-class parishioners that they stopped bringing their daughters to church, fearful the girls would choose to remain virgins and refuse a prosperous marriage, Karen Armstrong tells us in *The Gospel According to Women*. Armstrong, a British author of Irish descent and a former nun, argues that these early writings shaped Christianity into the only major religion to hate and fear sex and to turn childbearing, which in other cultures is women's chief source of pride and power, into an act "tainted with evil." She succinctly encapsulates women's predicament: "Consequently it is in the West alone that women have been hated because they are sexual beings instead of merely being dominated because they are inferior chattel."

Stories transcend time, drift like clouds through the collective consciousness, poised to be plucked from the heavens to land at the necessary moment. These violent ideas about women, matched by an almost eager willingness to sacrifice girls to protect an ideal virginal form, merged into modern discourse under the reign of Pope Pius XII, who catapulted the legend of St. Agnes from Ambrose's fourth-century pulpit to the golden altar of St. Peter's. In 1954, four years after canonizing his chosen virgin martyr Maria Goretti and naming her the modern-day Agnes, the pontiff released the encyclical *Sacra Virginitas*. His words embedded the connection between virginity and the martyr's perfect death: "In truth, virginity gives souls a force of spirit capable of leading them even to martyrdom, if needs be: such is the clear lesson of history which proposes a whole host of virgins to our admiration from Agnes of Rome to Maria Goretti."

While those thousands of illegitimate children sent to America to escape the sins of their mothers may have flown commercial airlines, spiritually they were carried upon the

wings of Ambrose. To walk through the Bishop of Milan's city today, beginning at his fourth-century basilica and heading outward, is to spatially encounter the ways in which ancient ideas and legends take root, fortify, and spread, endorsed by the state, absorbed by the people, and enacted by the religious and lay institutions built over the centuries to promote and sustain them; it is to bear witness, in Roland Barthes's well-known formulation, to how myth transforms history into nature.

Milan's urban layout is defined by three concentric circles that radiate from the city's original defending walls and roughly align to these early fortifications. Ambrose's basilica stands in the ancient center, known as the *Cerchia dei Navigli*, named for the canals, long paved over, that once surrounded the medieval city. Today these demarcations mostly tell a story of real estate prices, class status, and the relative safety of darkened streets the further one travels from the inner rings. But the circles of Milan also are useful markers to trace the movement of ideas through time, entrenched in bricks and mortar.

To travel this involute network—starting from the medieval basilica to the second circle that sketches the walls left by its sixteenth-century Spanish rulers (*Cerchia dei Bastioni*), to the nineteenth-century external ring road (*Circonvallazione esterna)* marking where the city center ends, and its peripheries begin—is to follow the ideological curl of Ambrose's teachings. Beliefs which begot the Church's regulation and control of sexual reproduction, which begot Italy's system of infant abandonment, which begot the modern *brefotrofio* where Lia Maria lived with her newborn twins.

A twenty-five-minute walk from the Basilica di Sant'Ambrogio into the city's second ring leads to where Santa Caterina alla Ruota once stood, today the site of a large medical complex. For centuries unwed mothers anonymously surrendered their

infants to the wheel of abandonment in the institution's window. Astoundingly, a modern version of the ancient *ruota* is now back at this medical site, the wheel reinvented in a high-tech form and rebranded as the *culla per la vita*, cradle for life. The steel door contraption resembles a large oven and unlocks to reveal an interior door containing a plastic bin lined with a thin cushion. Here a mother can anonymously deposit her newborn and medical staff are alerted. In 2006, Italy's anti-abortion movement—communicating Pope John Paul II's message of the "culture of life," a phrase he used in a 1995 encyclical to oppose the "culture of death," of which abortion was a major culprit—reintroduced the *ruota* in this high-tech, temperature-controlled version. By 2016, these devices arrived in the United States, known here as "safe haven baby boxes" and located in fire stations throughout the country, promoted by the right as a solution to unwanted pregnancies in a land where a conservative Catholic majority of Supreme Court justices overturned *Roe v. Wade.*

In Milan's outermost third circle, the slabs of stone by now piled high to all of these monuments to female shame, stands the *brefotrofio* where Lia Maria lost her twins. A sprawling red brick building with tall arched windows, today it houses government offices. When the *brefotrofio* opened in 1912, it connected by an underground passageway—the basement corridor that a half-century later Lia Maria and the other unwed mothers had to clean—to the maternity ward of the hospital Macedonio Melloni. All Italian women have unwed mothers to thank for the construction of the modern maternity hospital, built during the nineteenth-century when most respectable married women gave birth at home with a midwife's assistance. These hospitals, physically connected to foundling homes, were built to keep hidden unwed mothers who were assigned fictitious names.

The maternity hospitals, historian David Kertzer writes in *Sacrificed for Honor*, ministered "more to social than to medical needs, defending these women not against disease but against dishonor." Kertzer's scholarship on this subject—a second book, *Amalia's Tale*, recounts the life of a nineteenth-century midwife in Bologna—became my essential guide to understanding Italy's ancient system of infant abandonment and how its logic had been applied to the modern-day orphan program.

It was another unsettling incident in Lia Maria's life that led to my thoughts about the circles of Milan. During one of her many return trips to the *brefotrofio*, where she always believed the answer to the twins' whereabouts could be found, she went to the records office and spoke to the clerk. Inattentively, he asked for her name, date of birth, etc. When the clerk checked the birthdate, 4 marzo 1942, he wondered if she was trying to locate her mother. Confused, Lia Maria replied, "But no, I'm not looking for my mother, I'm looking for my children." The record clerk explained that the date corresponded to an infant registered on that same day with her name and her mother's surname. In this moment Lia Maria discovered that she, like her twins, had begun life in the same *brefotrofio*.

Just think how history repeats, she said, sounding fatigued. Born out of wedlock a few years after Italy had partnered with its German marauder to wage their fascist war, Lia Maria's mother had climbed the concrete steps of the *brefotrofio* to its portico entrance, framed in winter months by a garland of gnarly branches and brittle whitened twigs that cast a ghostly pallor. Her mother remained in the institution for six months; twenty-one years later, Lia Maria's mother instructed her daughter to ascend those same steps.

An aphorism often attributed (incorrectly it seems) to Mark Twain maintains that "History never repeats but it often

rhymes." The tragedies of the past don't assume the same form in the present, life is too complex for literal duplication, but patterns emerge, in both private and public life, which create correlated verses for old ideas: behold the ancient *ruota*, which in twenty-first-century Italy became the *culla per la vita* and in America the safe haven baby box.

This made-in-Italy system of sexual control that spread throughout Europe and to Russia was the logical result of the Church's obsession with female purity. What resulted, from the Middle Ages until the wheels finally closed—Milan's in 1868, followed by Turin, Genoa, and Venice—was extraordinary carnage. Major urban cities like Florence had extremely high rates of abandonment, but none rivaled Milan, which by 1875 had the astonishingly high rate of over 90 percent of illegitimate babies abandoned to its foundling home, higher than almost anywhere else in the newly formed country, and double that of its cosmopolitan and more secular rival, Paris. Plagued by filth, disease, and malnutrition, over half the babies abandoned didn't live to their first birthday, a death rate more than double that of the general population. As one social reformer observed, each foundling home should have placed over its door the motto: "Here babies come to die at public expense."

For sure, the modern *brefotrofio* was absent the physical horrors of the prior centuries, when hundreds of thousands of babies had perished. But the foundational logic of the *ruota*— its emphasis on the unwed mother's right to secrecy to veil her shame, the father's lack of responsibility, and the ecclesiastical and lay belief that they could better determine the proper upbringing for these unfortunate children—would be reflected over five centuries later in the ideology of the postwar orphan program. The religious belief that women needed to be punished for the sin of an out-of-wedlock birth lasted well

enough into the twentieth-century zeitgeist to determine the fate of my cousin, and John and Sara Campitelli, and Lia Maria's twins, and thousands of others who go about their middle or old age trying to imagine the face of their birth mother.

Nineteenth-century reformers challenged the practice of anonymous surrender after Unification when the Church's firm grip on family life began to slip. The reformers argued that abandoning children was a greater sin than an illegitimate birth, and that men needed to bear responsibility for the children they fathered. But fierce cultural resistance made enacting a repeal impossible. To ask men to be held accountable for their illegitimate offspring would create a severe "disturbance of family peace." This logic was part of the reason why, by the first World War, the only European countries besides Italy with a ban on the search for paternity were Poland, Serbia, and Romania.

These shared foundations—absolute secrecy, punishment, paternal absence, and the belief that the Church could best determine the children's upbringing—allowed thousands of babies to vanish from Italy to America. As Virginia Formichi, her legal mind still intact at the age of ninety-one, told me, the program was able to operate expeditiously because "in Italian law an unmarried girl doesn't have to acknowledge that child and it automatically becomes a ward of the province in which it was born." She is referring to the ancient law of anonymous surrender that still exists today.

As the mass in the Basilica di Sant'Ambrogio concluded, the notes of the pipe organ swelled throughout the pews, a liturgical timbre that still fills me with awe and imaginings of transcendence from inherited dogma. A group began to gather in the left side aisle that was labeled the women's section. Priests in regal red robes embossed with crosses and leaves threaded in

luminous gold dotted the length of this section, where ample-bodied middle-aged and old women wrapped in woolen blazers and tweed coats approached them. The women genuflected before the priests who in a sweeping gesture lifted their clerical capes and leaned down to tent the kneeling supplicants. Under these ornate makeshift drapes, the women whispered their confession and the priests bestowed penance and parting blessings.

I wandered over to the small gift shop in the back of the church and asked a woman working there about this practice, which I had never seen before, accustomed to the confessionals' wooden doors and the thick burgundy velvet curtains drawn during my childhood. She explained that it was an Eastern Orthodox ritual performed by Romanian priests who had come to the church for a special mass. I bought a bookmark and returned to the side aisle of the basilica to continue to watch this unusual display of women vanishing behind clerical capes, a fitting image it seemed as I had awoken that morning with disappearing women on my mind.

- 17 -

Of all the stories I had been hearing about unwed mothers, one lingered hauntingly as I was unable to disentangle its attendant visual image, the Mater Dolorosa, from my mind. It is the story of a birth mother I will call Caterina. She has never made her name public; her daughter, Mariagnese, serves as the ambassador to her mother's story. Mariagnese was born in Bergamo in 1955, adopted ten months later from a religious institute there, not by an American couple through the orphan program but an Italian couple.

Her adoptive father, working in Bergamo, was from Sicily and asked his boss for a transfer to Catania. He wanted to arrive in a familiar place far from where people could ask questions, with a wife from Milan and a new baby they planned to call their biological own. Her parents always kept the adoption hidden from Mariagnese, but as she grew older the fabric of this secret, rubbed against the sharper edges of intuition, began to unravel. "But then I understood it, like everyone else, as a girl of twenty I understood it," she told me.

Mariagnese's father died when she was twenty-eight and mourning him stirred again that strange feeling within. It could be stoked by a furtive glance from a relative or an honest stare

in the mirror. This time she asked an aunt to tell her the truth. Yes, the aunt replied, you were adopted, but you needn't worry about finding your family because you were abandoned in front of a church. Mariagnese tried to absorb this startling image of herself, an infant wrapped in a bundle and placed outside of a parish church, a life dependent upon the comfort and rescue of strangers. With such a sad anonymous beginning, she thought, best to leave this past behind. "So, I gave up, I did not give a damn to look because being abandoned in front of a church, what was I looking for?"

Why would she search for a woman, she reasoned, who had forsaken her maternal responsibility? Mariagnese also worried about hurting her mother, her remaining parent who raised and loved her, and who would never admit to the adoption. So Margianese continued to avoid this harsh truth, knowing not to touch a thorn brushing skin, and abandoning all possibility of inquiry during the last decade of her mother's life, who suffered from Alzheimer's disease and needed Mariagnese's attentive care. But after her mother's death in 2009, her aunt, who lived in Milan, reemerged asking again if Mariagnese was interested in finding out about her past. But aunt, she replied, how can I look for my origins if I was abandoned in front of a church?

The passing decade caused the aunt to change key, offering a new variation of her old song: "Look, I don't know if it's true, put a question mark on this, but when your mom and dad came to get you, they told me a story, that your parents were minors and that they told them both—she told me both—that you were born dead."

Those devastating words transformed Mariagnese's life. At fifty-four years old, she had been handed a piece of information that pierced her sense of self, and which gave her the precious space in which to imagine a mother different from the

one who in desperation had deposited her on a church stoop. As Mariagnese continued her story, talking fast but with the composure of someone who for years has been processing all that had transpired, I recalled the unexpected phone call from my cousin that bright morning in May when his midwestern tongue announced *Buon giorno, cugina,* and he began telling me what he was learning about his origins while asking advice about a connecting flight to Milan, the conversation that had brought me to Italy on this day to talk to women like Mariagnese. I recalled his one sentence that shook me most, blurted out in a register of anxious disbelief: "My birth mother could be alive and not even know I exist!" The growing network of American adoptees from Italy must have been sharing the story of Caterina, or other birth mothers like her, who were told their babies had died.

The oldest of four children, Caterina grew up in a poor family from the town of Mozzo near Bergamo where life was one of hard physical labor. Her younger sister had been working since the age of twelve, but Caterina had respiratory problems preventing her from doing this same labor. During a bout of illness, her parents sent her to a sanitorium and while conducting blood tests the doctors discovered that she was four months pregnant. The horrified fifteen-year-old, ignorant about how a baby came into the world, never considered that the eighteen-year-old boy she loved had impregnated her.

Caterina was then made to disappear. The sanitorium sent her to a home for unwed mothers run by nuns. The home forbade her parents and siblings from seeing her until after the baby was born. They tried to make the story go away, but in a small town, word spreads and soon almost everyone seemed to know. To make matters worse, the boy denied he was the father, a claim the man still makes today, further destroying her

already shredded reputation. Isolated from those who knew her best and loved her most, she remained alone with the nuns and other female sinners like her, working for her keep and waiting as her body grew.

For Caterina, who never married or had another child, Mariagnese's birth has been a lifelong suffering. When her daughter asked her mother what happened in the delivery room—how could she not know that Mariagnese was born alive?—Caterina could share only a few details before shutting down. She heard her baby's first cries. She remembers the voice of a doctor saying the newborn wasn't doing well. She remembers them sweeping the baby away before she could glimpse its tiny body. She remembers several hours, or what felt like an interminable time, alone in bed, trembling and waiting. Finally, the nun who ran the home, along with a monsignor, approached Caterina. Your child has died, they told her. We tried to do everything we could to save it. Put your heart at peace, they told her. Words that tore her heart to pieces.

She remained in the ward for a couple weeks, recuperating before being sent to another religious institution run by the same nun, where she would live with young mothers like her. There she resumed her domestic duties and was sent to work as a maid at a villa owned by a wealthy family. But no mother, young or advancing in childbearing years, who imagines the child turning and kicking in her womb, growing as she has grown, who thinks of this child each day of those long months of human gestation, escapes the trauma of being told that her child has left the world hours after her birth. The heartbroken teenager kept asking about her baby. Several others, fed this same lie in belief of a larger truth, were begging to know more about their newborns too.

Closure needs certainty; closure needs a visual memory; and

closure, when living under the watchful eyes of nuns, sometimes needs the tincture of punishment, a female penance for the moral stain of straying far from the Virgin Mother and the model of their day, Saint Maria Goretti, whose short life had taught the necessity of accepting death over defilement. So, the nuns led Caterina and two other weeping young mothers to a closure that fit within the framework of their faith, to a cemetery in Bergamo. It was a large cemetery with a separate section for children, and some of the tombstones were quite grand and beautiful, artfully arranged with bouquets of flowers. Others were just a mound of dirt.

Caterina was brought to a barren lump of earth marked simply with a wooden cross with Maria written on it, a name the nuns had chosen. She had wanted to call her daughter Agnese because, as fate would have it, the baby was born on January 21st, the feast day of Agnes, Ambrose's favorite virgin martyr, and so in quiet respect the names were combined. Caterina returned to the grave to mourn alone this little creature, abducted like a goddess to the underworld hours after seeing light.

She stayed at the home for young mothers like her until the age of eighteen. Eventually she stopped serving as a maid and was trained to care for the sick, which allowed her to become a nurse. Caterina dedicated her life to the profession, worked at a hospital in the area, and watched her nieces and nephews grow.

Mariagnese discovered the story of Caterina after she began an internet search that took years and the help of skilled adoptees to produce answers. In 2014, fifty-nine years after her birth, and five years after hearing her aunt's life-altering words, Mariagnese boarded a train to meet her birth mother. The year before, a court in Florence upheld a European Court decision that declared it unconstitutional to deny adult adoptees the right to know the names of their birth parents.

On the day they were finally to meet through a court-arranged visit, Mariagnese, who lives outside Florence, traveled to Brescia, accompanied by her husband and lawyer, as well as the judge and court clerk. As she stared out the window of the speeding train, imagining what she would say to this woman, her mother, Mariagnese's hands dipped in and out of her bag, rummaging for items to focus her attention. Mariagnese wondered if she resembled her mother, thinking she'd be square-jawed and plump like herself, and she talked and talked to her lawyer: "I practically felt like I was living on a cloud."

But when she finally arrived at the designated meeting place, the law firm of a nephew of her birth mother, she began to have second thoughts. Anticipation had been replaced by anxiety, airy lightness by sweating palms. "Who knows how she will be, who knows how she will not be," she said to her lawyer. Her nervous chatter ceased upon hearing a disturbing noise, which she soon recognized as the howling cries of her birth mother in the next room. Seized by the palpable sound of her mother's sorrow, Mariagnese was unsure if she could lift her leg to enter this room. The sobs paralyzed her as she feared she would bring this woman, her mother, further pain.

Panicked, she approached one of the people who had arranged the meeting, addressing her like a scared girl on the first day of school. "*Dottore*, I have changed my mind, I want to go home." The woman laughed, saying the *signora* is feeling sick, and with another woman took her by the hands and gave the needed push into the room. "At that point my mom hugged me, we hugged, I had to . . . I stopped crying because she was crying so much and kept saying, 'it's not my fault, it wasn't me, I didn't know anything, I didn't want to abandon you.'"

Mariagnese breathed deeply, needing to calm herself in order to calm her mother. "Mom, you saw I'm here, I'm alive." The

next thought Mariagnese kept to herself: now it's up to you to continue this relationship. I have done my part.

Her imagination about her birth mom did prove false in one regard, picturing what she looked like—her mother is thin, not plump, with an angular chin, not a square jaw like Mariagnese. Both share a high forehead, partly covered by wispy bangs of thin brown hair. But, for the rest, as Mariagnese did her part in seeking to find her, Caterina did hers to nurture this nascent relationship, one that could only begin in Mariagnese's middle-age and Caterina's twilight years. Which meant that day Caterina became a mother, grandmother, and great-grandmother, as her daughter has four children and two grandchildren.

They began spending holidays together, along with five or six visits during the year, keeping up in between with lengthy phone calls. "She comes here and even hangs my laundry, right from the beginning! You got it? It is not after three years that she does this, she immediately did all these little things like that. As I have felt like a daughter again. It is not true that we should feel like children only when we are little, because even at this age we sometimes feel the need to be children."

Many people have asked Mariagnese what it was like to be in that room in that moment, an unfamiliar place embracing the stranger who is her mother and who had lived with the lie of her infant's death. Her answer has never changed, "it's the same emotion as when the first child is born, the same for a mother."

But Mariagnese also had to disentangle the nagging thoughts and trailing guilt poised to strike unannounced each day. When Mariagnese returned home the evening of Caterina's first embrace, the journey long and her senses overwhelmed, she thought, "Oh well, I met her but now what do I do?' She found a photo of her parents to place on her pillow that night and she slept beside their faces. She wanted, needed their approval.

Throughout this search for her birth mother, Mariagnese, attuned to the delicate alterity of the adopted child, often wondered what her parents would think, as they chose never to let her know that she was not their biological offspring. That night, sleeping beside their photo, she hoped they would understand her innate desire to find the woman who gave her life. Still, she feared their disapproval and experienced again their loss, mourning anew. But this feeling gradually lifted, as the intensity of initial mourning usually does with time's passing.

Caterina once, some years back, accompanied Mariagnese to a conference in Florence about adoption rights, the only public appearance she ever made. During a break, they approached a juvenile court judge and asked why nuns and social workers had chosen to tell such a horrific lie to the young mothers. The judge replied that it wasn't uncommon back then, telling a mother her baby had died was believed to provide a cleaner psychological break than bearing the lifelong pain of losing a child to adoption. Mariagnese is convinced, having heard multiple stories from just this one province—a woman who worked in a *brefotrofio* said she, too, witnessed this being told—that many biological mothers throughout the country never signed a document of anonymous surrender because they believed there was no baby to surrender.

For many years after the mother and child reunion, Mariagnese lived in this wondrous space of discovery, traveling and spending time with Caterina, a gift of rebirth for them both. Today the story has morphed into one of bittersweet memory. When I spoke again with Mariagnese, Covid not only had ravaged the country but found its center in Bergamo. As the bodies piled high, the terror and isolation of the pandemic, accompanied by the suffering of not seeing the daughter denied to Caterina most of her life, became too much to bear. While

mother and daughter talked on the phone, traveling was impossible, and Caterina quickly declined. A fierce sciatica kept her bedridden and she took strong painkillers to ease her suffering. This nurse, who spent a lifetime carefully dosing medication, took too much, clouding her mind and leaving her helpless. Today, the shadow of the woman who had just been given new purpose in life, Caterina has become unrecognizable. With Caterina in need of institutional care, her family was left with no choice but to place her in a home, Mariagnese forced to accept this next stage of their short life together.

It is impossible to listen to Mariagnese's story, the unexpected joys—"Stop mowing the lawn," Caterina commanded her brother early one morning when Mariagnese was visiting, "My daughter is sleeping," that delightful stress on the word *daughter*—without the mind drifting back to that mournful trio of young women from long ago. There at the home for unwed mothers, they followed the nuns on their cemetery journey, each brought to her own mound of freshly piled dirt, that all-too-common lie infected with a twisted new embellishment. In today's world of visual overabundance, a kaleidoscopic stream of pixels forming images on giant screens and pulsing soundtracks mimicking the beat of the human heart, such showmanship pales in comparison to that single homely figure: a young mother guided to the grave where she is told her baby lies buried, and where she will return to kneel alone on the cold earth, bowed head and cowed body, a symbol of all those like her who have carried the same burden of shame, grief, and loss.

- 18 -

When I was back in New York, trying to process all that I had
been learning, I reached out to my friend Stefano, someone I've
turned to for decades to better comprehend the land my grand-
parents left over a century ago. A nuanced bicultural thinker,
Stefano is a professor of Italian Studies who first came to the
United States as a graduate student. We met for lunch at a favorite
neighborhood haunt and Stefano listened attentively, helping
fill me in on some of the country's postwar political machina-
tions, as well as other efforts by Pius XII to keep the Communist
Party out of power in Rome. Sometime after our salads and
sandwiches and before our espressos, Stefano mentioned that
our conversation had made him recall a comment of his grand-
mother's, who once told him that when he and his brother were
growing up their mother had a recurring nightmare that her
children would be taken from her and placed in a *brefotrofio*.

Stefano was born in the province of Mantova in 1963, the
same year as John Campitelli and Lia Maria's twins, but under
very different circumstances, to a married couple who raised
their children in a devout Catholic household. With no rational
reason for such a fear, why would his mom be haunted by this
recurring nightmare? According to his grandmother, Stefano

explained, his mother had seen television news clips about the country's *brefotrofi*. Those miserable images of a system routinized into Italian life—cribs of crying babies lined up in sparse rooms with so few workers attending to them—must have been seared into her consciousness, expressed in the deep of night. What worse fate could befall a woman in her prime child-bearing years than to have her children taken from her, to be a mother no longer?

To read reports about some of the best of these institutions, written by social workers in the early 1960s and filed in the archives of the orphan program, is to imagine the panic of my friend's mother, who upon awakening from her bad dream would have needed to pinch and remind herself that her boys were safely tucked under soft covers in nearby beds. These were places where crying babies were not picked up unless believed to be in physical distress, places where children could not feel the tingle of cold air or the tickle of drizzling rain or absorb the warmth of the sun's rays, where they could not spot a ladybug on a blade of grass or grab a smooth stone, forbidden any of these awakenings to the world around them until they were old enough to walk and be taken outside.

As one social worker noted, documenting a *brefotrofio* for two hundred children in the province of Chieti, which she described as among the best of its kind in the country because of the high ratio of staff to children, light-filled rooms, and good quality linen, "given the great regimentation of life in this hospital-like setting, most of the children are retarded in their physical and mental development." The social worker detailed a regimen whose principal activity was sitting on a potty eight times a day, one designed to prevent accidents, and possibly intrigue Dr. Freud. These were places which, only in the clarity of contemporary light, leave one to ask why so much effort by the Church

and funds by the State, undertaken knowing the centuries-long cruelty of the *ruota*, had been exerted and expended to take babies away from their mothers instead of supporting these mothers to care for their babies.

The culture of the *brefotrofio* up until the 1970s—when social mores began to change and the widespread availability of contraception and legalization of abortion would lead to the institutions' closures—was steeped in the same moral brew of centuries past, a bitter cup of punishment for female sin swallowed in the hope of future redemption. Separating mothers from children was not a glitch but a feature, one with long historic precedent. In the nineteenth century, before formula had been invented and babies routinely died of starvation, some institutions began implementing a policy requiring unwed mothers who had delivered in a maternity hospital to live for six months in an affiliated *brefotrofio*. But they could only nurse other women's babies, never their own.

In the brief period of political reform after Unification, the Bologna foundling home eased these rules, allowing unwed mothers to nurse their own infants and paying them a pittance for it. But the director of Milan's *brefotrofio* vehemently rejected this practice from Emilia-Romagna because "women were supposed to be punished, not rewarded, for their sin." One hundred years later, history's rhyming couplet to the director's philosophy had been etched into Milan's *brefotrofio* as a social worker described an inattentive staff taking charge of the infants with a daily rotating schedule of four different women attending to each baby. Meanwhile, Lia Maria, after nursing her babies in the morning, was sent off to clean the underground passageway that connected the maternity hospital to the foundling home. A woman who worked as a nanny at the Turin Institute in the 1970s recalled how a nun made clear that unwed mothers

needed to be apart from their babies to maintain the sterile environment; their presence would have polluted it.

Between those walls of the Turin Institute from 1956 to 1965 all four Campitelli children spent their earliest years, but only John would be lucky enough to find his birth mother and to establish a close relationship with Francesca, Mamma Franca, as he calls her. For the twins, the quest began too late and their mother, battling her own demons, seemed an unlikely candidate for establishing strong ties. Sara, the youngest, born in September 1964, who arrived in America eleven months later, too, would miss its slim window of possibility. The excitement and joy surrounding John's personal discovery in 1991 led Sara, who watched John in the presence of his birth mother, to imagine a similar possibility for herself. The two siblings, then vacationing in the south together, conducted some preliminary inquiries. They followed Barbara and Russell's lead that both John and Sara's birth mothers were from the region of Puglia. But Sara remained tentative, placing the idea of a search in a box to be opened later.

In the orchestra of the Campitelli family, Sara is woodwind to John's percussion, dreamy to direct. She has approached the quest to claim her birth identity with fluctuating breath unlike the more determined beat of her brother. Because she plays out every angle, considering the complex nuances of relationships and the place of each member within the family constellation, reaching out and finding answers has been much harder for Sara. It would take fifteen long years before she finally was ready to open that precious box.

Without John's detective work, Sara probably never would have learned about her birth mother as she, too, anonymously surrendered Sara to the Turin Institute. But John discovered

a bureaucratic mistake on Sara's redacted orphan program case file that he requested from the National Catholic Welfare Conference. The slipup revealed the woman's birthday, and he matched the date with the case narrative's non-identifying information that she had been studying to be a teacher. John began searching lists of certified teachers from the region who were born on that day, another painstaking effort of phone calls, paper trails, and cemetery visits, but the tenacious sleuth succeeded.

Her name was Tonia. She was a bright twenty-five-year-old woman who wanted to be a teacher and was in love with a naval officer studying to be a captain, assigned to three years at sea. The pieces of a life she had been working so hard to achieve were lined up, right within her grasp. But it was 1963 in Southern Italy. She had been born into a prosperous family that lost its money and land after her father's death unleashed a cascading disaster wrought by his bad decisions. Tonia, thirteen at the time, watched her mother, alone and humiliated, left to run a household with four children.

Tonia was now poor and vulnerable, but she was also smart and hardworking. The future rested on her ability to pass the famously rigorous national teaching exam called the *concorso*. In her youthful eyes, everything was possible. But what are the odds of a poor and vulnerable woman from the South back then getting to choose a life of her own?

Attempting to piece together the long-buried story of Tonia's anonymous relinquishment of Sara, I spoke to Tonia's sister Adriana, seven years younger, and to Tonia's second daughter, Rosalba. Adriana remembers their mother sending her sister to a private tutor to prepare for the *concorso*. The tutor was a well-regarded man, younger than most professors of his stature,

whom they knew by reputation and because his wife was related to a close family friend.

"He was a person who was able to tutor with a result. And then Tonia, with other friends, went to prepare for the test. My sister was pretty, she had long hair, she was a beautiful brunette with big eyes but small in stature. This professor had asked her to stay because he wanted to give her more information if she had more time. She naïvely, because you know she was naïve, she did not think . . ."

Adriana's voice trails, unable to say the words of what happened next. He was a father figure, she added, young but paternal. The next day Tonia refused to go back to the lessons. Her mother begged her daughter to continue, having scrounged for the money to pay for them. Tonia responded that the material was manageable, the tutor a waste of time. She went on to pass the written part of the test, leading the family to believe that she didn't need the extra help.

At this point in the story, Adriana digresses, beginning a long and complicated description of corruption in the exam and how it affected her family. She said that another sister, a year younger than Tonia, began receiving threatening phone calls demanding that the family pay a hefty bribe or Tonia would fail and never be able to teach in the region of Puglia. The story seemed an odd departure from what had taken place at the home of the tutor and I asked if she thought the professor had something to do with the phone calls. Adriana said no, she was trying to explain the milieu of Southern Italy and what came into play when future success was based on a high-stakes national exam.

Tonia told her sister to ignore the phone call and she continued to study for the oral exams. Tonia, who was very religious, also relayed the threatening phone call to a priest, whom Adriana described as her sister's spiritual adviser, and he urged

her to report the threat to the committee. Around this time, Tonia began looking for a job in another part of the country, and although everyone was surprised by her decision to go north and leave the family, especially as she awaited the return of the naval officer, Tonia used the excuse of the threatening phone calls. Adriana never knew that her sister left to await her labor at the Pozza di Sicar, the same unwed mothers' home in Turin where Francesca lived the year before. Adriana believes that the priest whom Tonia confided to made these arrangements, that she told him not only about the phone call but her terrible secret too.

Tonia finally told Adriana the truth in 1997 when she was seriously ill and asked her sister to accompany her to Lourdes in search of a healing. Tonia confessed that the tutor impregnated her, that she was forced to flee and to give up her baby. Her stunned sister asked why she didn't tell them, why she didn't ask for their help. But who would anyone have believed, the respected tutor or the poor young woman? Tonia continued to blame herself. "It was a sense of shame, she felt dirty, when instead she wasn't."

"My mother was a really unfortunate woman," Rosalba told me, in a version of this story that differed slightly from her aunt's. She also described corruption tied to the national teaching exam, but in Rosalba's account a bureaucratic mistake changed her mother's life. Tonia passed the *concorso*, however, the committee awarded her spot to another woman who had failed the exam but had the same first and last name as she. "For her, obviously it was an honor to study, so it was something that deeply knocked her down." According to Rosalba, it was known that there was a teacher who welcomed young women into his home and that he exacted a price for his help with the *concorso*.

Rosalba imagines that Tonia went to the professor in desperation over the bureaucratic mistake that had turned her passing test into a failing one. That she went naïvely but also with an inkling that some type of exchange would be expected. Rosalba, unlike her aunt, describes what took place at the professor's home—whether it was after the group tutoring lesson where Tonia had been sent by her mother or on another occasion—in the language of today, not of all our yesterdays: Tonia, forced into nonconsensual sex, was "a victim of rape."

"I use the words for what they mean. She told me these things. I don't know when it happened or how. He was a professor of the *concorso*, she told me this, he was part of the board."

Rosalba, like Adriana, said that her mother was in love with the naval officer and was awaiting to resume their courtship upon his impending return. But she was so horribly ashamed of herself that she left town without ever saying goodbye to the young man who came back looking for her. Tonia clung to this faded memory, a totem of the life she lost the day she stepped into the professor's home. When Rosalba once jokingly replied to her mother's repeated stories about her former boyfriend, "But there is a sailor in every port," her mother snapped, "No, he loved me, he loved me so much, we were really in love."

Unlike her Aunt Adriana, who was a teenager at the time, Rosalba believes that Tonia's mother and some older siblings were aware of Tonia's situation, as well as the professor's reputation, but they blamed her, not him, pushing Tonia to leave the family home, privileging the professor's stature over the daughter's well-being. Rosalba said that her mother told her the story of surrendering Sara in a very tragic way.

"That she had to abandon her, that it was certainly not her will, but she had to abandon her. So, she let herself be overwhelmed by the events that happened, she couldn't make

choices, she couldn't resist. In fact, she fell ill then. I was ten when she had her first illness. She died when I was thirty-two, imagine! Twenty-two years of hospitals, diseases, one after another."

Tonia became one more in this long trail of twentieth-century women traveling to the country's copious *brefotrofi*, stuffing into suitcases their belongings and the last remaining traces of childhood, young women poised to embark on adult life but stumbling at their first steps. Forbidden the sweet fruit of privilege accorded to the men who forced them on this journey, men who chose what they wanted and chose to walk away, their early bargain with life was to accept diminished happiness and denied dreams, to blame themselves for their degradation, and ultimately to lose the agency to escape their compromised lives—a condition otherwise known as being a woman throughout most of human history.

- 19 -

Zia Adriana first welcomed Sara into her home a half-century after her niece's birth. During this visit she told Sara the name of the famous professor and said that his son lived nearby. Perhaps Sara might like to meet the son, she suggested, and see if it would be possible to establish contact, all these years later, with the man who is said to be her birth father. Sara left Zia Adriana's home in the vertiginous blur of beginning to learn about a mother whom she will never know and a father who has never recognized her existence. She needed to call her brother John, the one person who could guide her through this emotionally treacherous terrain.

John sent an email to the professor's son telling him about Sara and how very much she wanted to meet him. The son, a lawyer, read the note late in the evening, at 10:30, ensuring that he wouldn't sleep that night. He called John the next morning and said, yes, to please have Sara contact him. That morning, the contents of the note seeming credible, he went to see his father and told him what had just transpired. The professor listened and remained silent. Later, the son described to Sara the long silence, the facial inflections, and his one-word response when his son asked if this was possible: "No."

"It's very possible," the lawyer said to Sara.

And so, after spending time with Sara, feeling compassion toward this stranger who may well be his half-sister, the son pushed the situation further. He and his wife brought Sara to his father's home, telling him that a friend from Florence was visiting. Years later that day, May 1, 2015, remains vivid in Sara's mind. Sara and I are having coffee in a bookstore café in Florence, where she lives outside of the city with her three children (like John, Sara chose Italy to be her permanent home). She sketches the seating arrangement on a frayed paper napkin next to her empty cup. The professor sits beside his daughter-in-law, Sara is next to the sympathetic son.

"So we talk. He starts. He was dressed very sporty, and he welcomes us as a grand signore, but not ostentatiously. He speaks poetically. How that morning he had gone down to the greengrocer near his home, what he bought and his discussion with the greengrocer. He wanted to talk about himself this way to me. The passion for one's profession, whether it be a greengrocer or a teacher. He talked about how he formed his studies, how he came many times to Florence, how he had friends in Florence, what he taught, who he taught, how he saw the child, how he helped disadvantaged children, which there was the majority."

I asked Sara, after all that she knew, what it felt like to be sitting across from this man, whom she believes to be her biological father, and hear him speak pedagogically about how he saw the child and how he helped the disadvantaged ones.

"It was like being in a piece of theater or a good movie with a good actor. What kept coming to me was, how many lives are lived in one life?" As the afternoon conversation wound to its endpoint, depleted of oxygen and constricting the room's air, the son, responding to his wife's get-to-the-point stare, gingerly

put forth the reason they had gathered. "Well papa, Sara is actually the daughter of Antonietta, Tonia."

Sara is surprised by how family members, or people who knew her parents, do a double take when they first meet her, as if she were an apparition both of Tonia and the professor. She shares her mother's Mediterranean skin tone, a shimmery copper sheen that is striking against long hair she has let grow white. Tonia's hair remained dark her entire life. The professor, even in old age, kept his thick head of white hair.

"Oh, yes, she looks like her," he said. "Yes, the same olive skin."

The son pressed further. Sara, he said, has come to Puglia in search of her roots. Here, however, the professor deflects, refused to be put into this box the room's co-conspirators had constructed around him. He had a reputation to uphold, a wife who has taken good care of him, all far more important than this woman passing through his town inserting herself under his roof that afternoon. After more awkward pauses and stilted pleasantries, they said their goodbyes. The professor approached Sara, his body coming close to hers for the first time that day.

"You need to know," he said, "that my real name, my first name is Michele. My name is Michele."

"And that was it," she tells me, "the best he could do." Those two sentences, that his real name differed from the one by which he was known, amounted to the only private conversation that the man whom Sara believes to be her birth father would ever have with her.

Like any human being, Tonia did not want to be cast away from family and community. She did not want to be isolated, hidden until the birth of her daughter and then forced to surrender her. The scornful gaze of others wounded her, this deeply religious

and intelligent woman who had worked so hard to achieve yet could not escape an inferiority that society had placed upon her.

"Anton Chekhov once observed that the worst thing life can do to human beings is to inflict humiliation," writes essayist Vivian Gornick. "Why *does* it hurt so much, do so much damage, twist us so horribly out of shape? Why does life seem unbearable—yes, unbearable—if we feel discounted in our own eyes?"

Rosalba, the second daughter, embodies the consequences of Tonia's humiliation and speaks with the authority of having been the primary target of her mother's wrath. When we met at an outdoor cafe in Turin, Rosalba was cordial but anxious. She asked for a coffee and bottle of water and rolled one thin cigarette after the other. The steady click of her lighter accompanied the details of her sorrowful story that demanded the pause of each inhalation.

She was born from the marriage of Tonia to a man named Valter, whom Tonia met in Turin when they both were studying to get their driver's license. She was twenty-seven and Valter twenty-two. Tonia was struggling financially, living in a cupboard of a room—Adriana described it as an understairs storage with a bedroom—in today's imagination, akin to the shabby quarters Harry Potter inhabited under a staircase.

"When I was very small," Rosalba explained, "I'm sure that my mother hated me, not me as a person, but because she saw in me that little girl she had abandoned." The least significant act could cause her mother to scream at Rosalba, hit her, throw plates, such was the life she became accustomed to as a child. She recounted an incident when she was three years old and had climbed atop a bathroom stool wanting to brush her hair. "What are you doing up there?" Tonia demanded, her piercing tone causing the frightened girl to fall off the stool. Her mother shouted "all the possible and imaginable wickedness, then a slap on the face, obviously."

Rosalba bore the weight of Tonia's fear, carved from the loss of a newborn whose face she had never seen, whose body she had never touched, so fast was the infant whisked from her after the first cries of birth, according to Rosalba's account of what her mother told her about that day.

Even the simple act of a child standing on a stool could turn into catastrophe. The child could fall on the hard bathroom floor and hit her head. Unable to distinguish the difference between a minor and major threat, any potential danger could be a fatal one.

A few years later, Tonia gave birth to her third child, Giorgio, who has Down's Syndrome. Tonia now believed her life was cursed and her depression deepened. Tonia's mother moved into their apartment to help and Rosalba found some refuge in the presence of her grandmother. As Giorgio grew older, Tonia channeled her energy into helping him, applying her impressive skills in the classroom to their home, teaching her son to read, write, and with Valter's help, to learn the language of computers.

Giorgio, now forty-five, lives with Valter in the apartment where he was raised. We talked in the kitchen, each flanking the sides of a Formica table, Giorgio turned toward his father, confined to a wheelchair. On the table they placed a tin of Tonia's favorite Danish butter cookies to offer me. Giorgio cried when speaking about his mother, saying he still misses her smile.

But misery defined Rosalba's home life, which she described as an abusive environment perpetuated by both parents. Fifteen years of psychotherapy was the only thing that saved her, a space allowing her to come to terms with what she experienced, to try to spare her own two children, in high school and college, from the ripple effects of her family trauma.

Rosalba found herself hating the idea of Sara, this ghostly shadow of an older sister whose birth had ruined her life. So deep was her pain that she sought group therapy in addition to her private sessions, and she described one exercise in which the instructor asked the members to dramatize their anguish. Rosalba chose to act out her rage against this looming phantom. She remembers the precise month and year when she performed this psychodrama, December 2015. The next week her phone rang, and a man named John Campitelli introduced himself, saying he was calling on behalf of his sister, Sara, who would like to meet her. Could it be the universe telling her something, Rosalba wondered, shaken by the eerie coincidence?

After Rosalba became a mother her relationship with Tonia improved slightly. At the start of the millennium, Tonia began telling her more about losing Sara and on one occasion she and Rosalba drove near the home for unwed mothers northeast of Turin, long closed, where she waited out her labor. Tonia told Rosalba that she was sick because she didn't know anything about what had happened to Sara and implored Rosalba to help. But Rosalba, both ambivalent and not having a clue about where to begin, declined. "I didn't even know what kind of nuns we were talking about, for heaven's sake! It was worse than looking for a needle in a haystack."

Rosalba and Zia Adriana both believe that Tonia's initial trauma, which Rosalba describes as the rape, Zia Adriana as the abandonment, led to her decades-long illness and death at the age of sixty-seven. Tonia suffered the most female of diseases: a cancer that began in her thyroid, traveled to each breast, and finally to her uterus. Rosalba describes her mother as being "sick in pieces."

"I think if I ever had to decide or find myself in the situation of having to abandon my child, I think I would be destroyed,

right? As we say, 'your children are a piece of your heart' so that you undoubtedly detach a piece of your heart," says Rosalba.

"She carried a pain so great that it destroyed her. My sister was destroyed by pain," says Adriana.

Their conviction that Tonia's psychological suffering led to bodily illness reminded me of stories of other adoptees I spoke with who discovered that their birth mothers had died in their fifties and sixties. I began to wonder about the physical toll of social ostracism and child abandonment on these mothers, especially considering that the average lifespan of Italian women is long.

Painful treatment after treatment, increased chemotherapy and radiation shaped Tonia's middle age, the race to save her becoming more and more desperate. Throughout, she continued to teach and care for her special needs son until her body surrendered. One day, as if Tonia's early fear of her little girl falling from a stool onto the bathroom floor had been a premonition, she slipped in the same room and hit her head on the tile, falling into a coma from which she never recovered.

Before saying our goodbyes, Sara and I strolled through the Piazza della Indipendenza, the neighborhood of her youth and fondest memories. Florence had been Tonia's favorite city, too, but she would never know that Sara had spent her childhood there, or that the adult Sara was living in its outskirts when Tonia made a last-ditch plea to Rosalba to help find her. Nor could Tonia have imagined that adjacent to the stately apartment building where Sara grew up, a magnolia tree from the garden poked its branches through the window, and its soft fragrant petals, as if in a fairy tale written to soothe a frightened mom, drifted in and coated the tiles of her firstborn's bathroom floor.

After walking Sara to the train station, I headed to the Museo degli Innocenti, the site of the Ospedale degli Innocenti where infants routinely were abandoned to the *ruota* from 1445 until 1875 when the wheel closed. The institution, which remained open, continued to care for the illegitimate and in the fifties and sixties also sent children to America through the orphan program. It felt odd to enter this museum after leaving Sara, who—although unlike Rosalba had been sheltered from her mother's pain—in middle age is still trying to find her bearings in the world, and to make sense of what took place and its imprint upon her.

To roam through the Innocenti's curated rooms, to read about the institution in the handsomely printed book from the giftshop is to enter paradoxical territory. The past, while acknowledged and chronicled, is recast in flattering light, that of a prosperous city responding in Christian fashion to the misfortunes of poor and shamed women and their offspring. Visitors learn of the building's storied past, its loggia designed by Filippo Brunelleschi and built with the famous Florentine *pietra serena* stone, its considerable art collection, and how the Ospedale degli Innocenti reflected, "a place, a history and a name that immediately evoke the Renaissance and its new conception of humankind."

Near the museum's entrance remains the spot for the *ruota*, which, as in Tuscan tradition, was not a wheel but a small square grated window, the *finestra ferrata*, where women placed their babies on a stone slab and slipped them through the fitted grate onto a cushion. It is believed that statues of Mary and Joseph flanked the cushion, awaiting these infants who played the role of the baby Jesus in this maternal act of abandonment. In a fresco above the window two *putti* rest atop a trompe l'oeil swirl of decorative marble and below the grate an inscription from the late nineteenth century reads:

"For four centuries/until 1875/this was the *ruota* of the inno-cents/the secret refuge of misery and guilt/that is aided for eter-nity by the charity that never closes its doors."

Through this selective gaze, the *ruota*—the logical result of the Roman Catholic Church's millennia-long dictates determining how women's bodies must exist in the world—transforms into the humane and charitable response to all of those babies aban-doned over the centuries. Contained inside the museum are the tarnished relics of this past. In its most heart-rending section, a physical manifestation of the broken mother-child bond, one-hundred-and-forty wooden teak drawers slide open to display on black cloth delicate nineteenth-century objects that have been severed in half. The drawers offer a peek at the museum's archival collection, which holds thousands of these relics and written messages, a common practice during every century of the *ruota* and in all areas of Italy. The severed objects—cruci-fixes, medals, colored stone pendants, humble pieces of cloth wrapped in string, holy pictures, all *segni di riconoscimento*, signs of recognition—had been pinned to the swaddled infant in the small hope of being able to reclaim the child at some point in the future, the mother keeping the other half.

A nearby video installation shared contemporary testi-monies, stories like that of a woman named Claudia who, in the same year as Sara, was anonymously surrendered in 1964, but never told by her parents that she was adopted. "It was because of the lie," she tells the camera, that she suffered most, never feeling at one with her family, neither knowing nor not knowing, learning about her adoption by someone else's slip of the tongue. This lifelong imbalance, always a beat off the rhythm of the rest without comprehending the reason, others knowing your secret but yourself denied the truth, she said, is a horrible thing to have happen to you.

Walking through the museum, one floor devoted to its architecture, another to its art collection that includes a Botticelli, the basement to its history, I thought about how these pristine walls could never display the cruelty of infant abandonment, could never be wiped free from the wretched stink of death from malnutrition and disease, from the sorrowful deprivations of childhoods lived in institutions, from the shame of social inferiority and lost identity intertwined with illegitimacy, from the mournful wail of mothers whose voices have been lost to history.

I thought about an article in the orphan program's archives written by a woman named Jolanda Torraca who ran a private institution in Rome for mothers and children called the Opera Assistenza Materna. The article, which heralded the orphan program and took to task the country's juvenile court judges for slowing down overseas adoptions out of concern or opposition, appeared in a 1958 edition of *Italiani nel Mondo*, a bimonthly magazine that dealt with issues of emigration and mostly circulated to consulates abroad. Although privately owned, the magazine was well-known as the unofficial publication of the Office of Foreign Affairs, printed during a time when the government encouraged the emigration of its citizens abroad, pursuing the dubious public policy strategy that shrinking the population was a good economic tactic for a country still recovering from the devastations of war. In an introduction to Torraca's article, the editors explained their support for the renewal of the refugee law, set to expire again, because of its capacity to send "a considerable influx of disinherited Italian children to the United States."

As this branch of the government eagerly sought to rid the country of its "disinherited" children, a reminder of the State's view that the illegitimate were primarily a problem of property

rights, Torraca invoked a haughty and patronizing attitude toward birth mothers. Explaining that the number of abandoned children in the country on public assistance was over two hundred thousand, she wrote: "It must be mentioned that in Italy the great majority of abandoned children is represented by illegitimate children—be it those whose parentage is unknown or those who in the first impulse of affection had been recognized only by their mothers and afterwards had been abandoned because of misery, frivolity or irresponsibility."

Torraca's sole description of birth mothers, her only attempt in a lengthy six-page polemic to understand them—women like Francesca and Lia Maria and Caterina and Tonia—was to reduce their experience to a single clause, a mother, who after the "first impulse" of affection, abandons her child *because of misery, frivolity, or irresponsibility.* Torraca's organization, which handled about two hundred and fifty unmarried mothers a year, supplied babies to the Church's program as the state *brefotrofio* in Rome had refused to cooperate. The National Catholic Welfare Conference reimbursed the institution with a fee for each child. Torraca worked closely with orphan supervisor Virginia Formichi, the woman who memorably described the plight of birth mothers to me as, "Then they met the policeman or the fireman—and we got the children."

How convenient for the purposes of all involved to treat women this way. No messy stories attached to these births, just the heroic rescue of abandoned children. In a culture that prides itself on the image of male sexual prowess yet clings to the notion of female innocence, portraits and figures of the Madonna and child as intrinsic to the landscape as daybreak's haloed light, silencing women has always whitened the complex palette of human sexuality. It's much easier to deny a bodily

existence with the label "born to a woman who does not consent to be named," to extinguish the maternal bond by falsifying birth certificates, to call women frivolous and irresponsible than to talk about what actually took place during those long two decades of "orphan" emigration, despite whether the sexual encounters were forced or consensual. Even the language used to describe these women, "*le ragazze madri,*" girl mothers, infantilizes every one of them and diminishes the untenable choices each had been forced to make.

By shrouding the files of birth mothers in secrecy, the Church erased a past of which it disapproved and replaced it with finely crafted tales about rescued orphans raised in good Catholic homes. They told no stories of birth mothers who became sick in pieces. They took no responsibility for the suffering inflicted upon women whose babies were whisked from them and sent in secrecy to the United States.

But they did not take into account the determination of women who never stopped searching for the children they lost despite each hurdle put before them, nor the questions and persistent longing of children, who today in middle or old age have spent decades in a monologue with their invisible mother, hating her, forgiving her, forgetting her, seeking her, mourning her, all part of a natural human dialogue and urge to understand the person who brought you into the world and to establish blood kin on a too-often lonely planet.

Part Four
The Steubenville Cluster

- 20 -

Across the ocean in America, too, unwed mothers faced social shame in the fifties and sixties, targeted by the shared belief that they were unfit to raise a child. Homes to wait out labor sprouted like daisies over once-barren fields in what came to be known as the "baby scoop" era, a pronounced shift from earlier in the century when unwed mothers had been disapproved of, but in Anglo-Saxon tradition, encouraged to keep their baby. Yet with a growing number of younger mothers, and a country increasingly self-confident of its own ideas, social workers justified removing babies by embracing popularized versions of Freudian theory. No language of disgraced sinners and deserved punishment would be heard here in the New World as social workers excised Christian religious belief from their professional judging eye. Rather, these women were neurotics who had pregnancy fantasies that stemmed from a confused sense of womanhood.

Times were a-changin' as the famous folk singer strummed, and the idea of adopting a child was also growing more popular. A prosperous postwar America abounded in signs of middle-class success. Shiny models of Chryslers and Buicks and Fords lined up in driveways and console televisions in polished

mahogany boxes gleamed in living rooms. Family and domesticity were prized, as was suburban conformity, placing childless married women under the cutting gaze of social stigma, unable to fulfill their destined role as wives and mothers. The demands of couples wishing to adopt were extraordinary. One expert estimated that in the mid-fifties, out of four and a half million childless couples, one million sought to become adoptive parents, yet the pool of available domestic babies was a mere seventy-five thousand.

So nearly a decade into the war orphan—now morphed into the orphan—program, its popularity growing every year, Monsignors Landi and Komora followed another American precept, and matched supply to demand. The United States Congress kept extending the orphan emigration legislation and the Catholic Church kept spreading the word, to parishes, clubs like the Order Sons of Italy and Knights of Columbus, and newspapers that ran feel-good articles about the orphans' arrivals.

Thousands of prospective parents eager to apply for a child learned that Landi's organization, Catholic Relief Services—NCWC, was "the only agency in Italy, charged by the Catholic Bishops of the United States, to aid in the emigration of Italian Catholic children to the United States for the purpose of eventual adoption." And how Landi's Rome office provided Monsignor Komora's New York office, the Catholic Committee for Refugees, "complete dossiers on all children who have been offered to us for adoption in the United States."

Throughout his life, Monsignor Landi never changed the language he used about the Italian children sent to America, *they were offered to us.*

In Italy, Monsignor Landi was becoming known as America's goodwill ambassador, the *Texas Catholic* reported in a glowing newspaper profile of the priest in June 1959, detailing the

monsignor's long postwar history in Rome distributing clothing and food donated by American Catholics, which had amounted by the mid-fifties to over $117 million in relief supplies. As the journalist so aptly put it, Monsignor Landi, by now the well-experienced head of the orphan emigration program, was "a man with a talent for giving things away." In fact, in Rome, the reader learned, Americans admiringly called the monsignor "handy Andy Landi."

When this profile appeared, those same prospective parents would have had no clue that in Italy Monsignor Landi was in the midst of fighting the gravest threat to the orphan program since its inception in 1951. A series of newspaper and magazine articles uncovered a black market for selling Italian children to Americans, and some journalists were connecting this supply chain to the Church program. It was a time in which Monsignor Landi needed to apply all his impressive skills to outmaneuver an avalanche of unexpected bad press, and a potentially fatal blow to the orphan program.

In the late 1960s, when John Campitelli was a little boy growing up in rural New York State, and in the next decade when he lived with his transplanted family in Umbria and Tuscany, he, like all his fellow adoptees in America, never could have imagined that they were part of a much larger story, or social idea, or political decision, that deep in the heartland, dotted along the Rocky Mountains, and up and down the Atlantic and Pacific coasts similar words were being echoed, the stirrings of boys and girls with questions about their pasts that would take decades, if not longer, to unravel.

The young detective had grown more skilled with each decade. He at first acquired the statistical yearbooks of the United States Immigration and Naturalization Service that a

man named William Gage had handed him in the early nineties, which documented the number of Italian children who came to the United States between the years 1950 to 1970. As the years passed and John understood more of what had taken place in Italy, he requested from the National Archives in Washington, DC the passenger lists of immigrants arriving on American shores. The entrance of each child of the *brefotrofi* was marked with the status of "orphan visa." He then cross-referenced this information with the stacks of children's flight manifests that are among the archival papers of the Church's orphan program. The information on the passenger lists—each child arriving with an orphan visa—matched the names of the flight manifests. This information enabled John to compile hundreds of pages documenting the children of the *brefotrofi* coming to the United States, what he calls his bible.

He then spent years redefining the concept of leisure, dedicating nights and weekends to tracking and piecing together this information, logging each needle in a haystack onto Excel spreadsheets, one for every state in America to which an Italian child had been sent. His spreadsheets list each adoptee's date of birth; first and last name at time of birth; city, province, and region of birth; date of arrival in America; commercial airline and flight number; assigned case number; city of agency in charge of adoption; city of adoption; and, perhaps to entertain himself in the late of the night, each adoptee's zodiac sign.

Matching this information to the members of his adoption group, John helped fill in the blank canvas of their past. ("He knew the flight that I came in on as a baby!" I remembered my cousin saying to me in amazement.) Adoptees not only had a forum to meet and share search stories with each other, but some returned to their screens to discover new group members who were old childhood friends. Familiar names began emerging

from two curiously large clusters, which, considering the size of each location, received an outsized portion of children of the *brefotrofi*. One was in Pueblo, Colorado, and the other in Steubenville, Ohio.

Cheaper by the Dozen, popular when I was growing up and still in print today, told the semi-autobiographical tale of a couple with twelve children. When people asked the father why he had so many kids he replied, "they come cheaper by the dozen." This line kept coming back to me considering John Campitelli's discovery that Pueblo, Colorado, with a population of around ninety thousand, received eighty children of the *brefotrofi*, and Steubenville, Ohio, with a population back then of thirty-two thousand, welcomed over two dozen, almost the same proportion as its Colorado coeval.

Steubenville, Ohio is where my father's oldest sister had settled in the early twentieth century, moving from America's east coast to the Midwest to marry and work in this former industrial town. The area attracted scores of immigrants who had failed to squeeze water from Southern Italy's arid land and crossed the ocean in steerage compartments desperate for a new lease on life. Like Plains, Pennsylvania, a five-hour drive from Steubenville, where Lia Maria's twins were adopted, this swath of earth held precious natural anthracite, steel mill and coal mine country where men sweat to earn a living and retired with comfortable pensions until all those steady jobs disappeared. A century ago, Steubenville powered the steel mills churning out the materials of industrial America but only the shadow of this past remains, its shrinking population now under eighteen thousand people.

It was in Steubenville that my father's niece, Betty, a nurse, and her husband, whom we called Dr. John, the popular town physician and chief of staff of the local Catholic hospital, adopted

their son, my first cousin once removed, born Gianfranco Aragno in Turin on July 27, 1958. My cousin, whom I will call "Cousin John" to avoid a John-John confusion with Campitelli, was the sixth child to arrive in Steubenville from Italy's *brefotrofi* in April of 1959. The first, boys aged seven and two, arrived on March 22, 1957, part of a group of seventeen children who left Italy that day for the United States.

The local newspaper the *Steubenville Herald-Star* ran pictures of those first boys delivered to their two new families. A lengthy caption on its front page described how the couples had been patiently awaiting the Italian orphans since filing their applications the previous October. Seven-year-old Bruno, his name now changed to Edward, Eddie for short, just like his adoptive dad, posed for pictures dressed in a suit and bow tie. In one photo he grimaces as his adoptive mother seeks to plant a kiss on his cheek, and in the other he leans between his new parents who each grab an arm, holding a model airplane and looking forlornly into the camera. Sister Mary Louis of Steubenville's Catholic Social Service, the nun who was in charge of placing these children, told the newspaper that while nothing was definitive, youngsters from Ireland might also be brought over in the future. Grateful Steubenville parents even formed an "Adoption Club" and two years later presented Sister Mary Louis with a gift on the anniversary of her twenty-five years of dedicated service.

My cousin arrived several weeks before the Adoption Club celebrated Sister Mary Louis's anniversary. A fanfare surrounded his entrance into town that April 16th, perhaps because of the prominence of his physician father. Leading the "social notebook" on page four of the *Steubenville Herald-Star* was a picture of Dr. John and Betty proudly holding their new nine-month-old son with Sister Mary Louis smiling behind them. The caption under the heading, "Who could ask for anything more?" noted

that my cousin "doesn't appear a bit afraid of the camera," and that the blond-haired, hazel-eyed baby arrived by transatlantic flight from Naples. The latter piece of information was incorrect, he had left from Rome via Turin, but perhaps resulted from Americans' standard assumption that all Italians came from Naples or Sicily. Dr. John and Betty, who always called her son John Francis—overjoyed that a child born Gianfranco, the same name they long had hoped to give their child in honor of his father and maternal grandmother, Frances, awaited a home—met their baby at the Greater Pittsburgh Airport. Another Steubenville couple also awaited the arrival of their new son on the same flight.

Cousin John recalls his parents playing a tape for him of the local radio broadcast from that memorable day, when cameras filmed the event and the announcer excitedly marked each step of the journey that began at the airport and concluded at the couple's Steubenville home: "Here they come, they're coming down Whitehaven Boulevard right now, you can see the baby in the back seat."

My cousin can agilely perform this scenario, imitating the radio broadcaster's voice, choosing the right sentence cadence, modulating his tone, always making me laugh. He has the expansive personality of the extrovert, one that shyer people like me envy. Cousin John is the person who walks into a high school reunion from a school not his own—as he did a few years ago when traveling back to Steubenville, after discovering that his anticipated class reunion had fizzled into a small gathering—and puts on the leftover name tag of the person who never bothered to show up, greeting everyone with a big handshake and smile.

When I recently learned that the only information his parents had been told about his Italian past—"my mother was

in the arts field, she was an actress or a singer, and my father was in the medical field somehow"—this description made perfect sense, a possible genetic key to unlocking the mysteries of personality. Cousin John, following Dr. John's—and perhaps his birth father's—professional field spent most of his career in health care human resources, and as noted at nine months old, is a natural in front of the camera.

Two of Cousin John's paternal cousins also were adopted through this Church program, and he knew of two other children as well, a childhood friend named Marco and a girl schoolmate whose mother had been a signed witness for his adoption papers. But no Steubenville adoptee had been aware of the dozens of children who had arrived from Italy. Only today, now in late middle age, they are discovering through John Campitelli's sleuthing that the boy they waited for the school bus with in the early hours of the morning or the girl they sang next to in choir or the football player from the competing school or the boy in line next to them during high school graduation, all shared the same history, all part of this odd social experiment, spending their first years in Italy's *brefotrofi* and being replanted into America's Catholic heartland. It is a discovery that "completely blows my mind," several adoptees repeated.

Steubenville long has had an outsized reputation for its small size, achieving international attention, sometimes for all the wrong reasons. As recently as 2012, two popular high school football players—in a town that prizes this sport—raped a sixteen-year-old girl who had passed out drinking with them at a party. The players texted photos of the unconscious girl to their friends. As word of the incident spread and newspapers came calling, the football coaches, and later most of the town, dug in to defend the boys. A drunken girl wasn't going

to ruin Steubenville's image of itself, reflected in the bright lights of its high school football stadium, that contained vessel which conjured a once mightier place. But their doubling-down caused the group Anonymous to step into the fray, hacking the teenage boys' texts and videos. The hack revealed that the athletes' friends responded to the photos with comments like, "This is the funniest thing ever. She is so raped right now." A social media storm erupted prompting outraged conversations throughout the country and around the world about sexual assault, protecting athletes, and victim shaming.

In the earlier part of the twentieth century, Steubenville liked to call itself the "City of Churches" because of the abundance of religious institutions crammed into the small metropolis, more than forty of them in the 1930s representing over eighteen denominations. But there were other nicknames for Steubenville, too, ones that captured its darker side. Known as "Little Chicago," Steubenville competed for its smaller share of shady operations. The little city bootlegged illegal liquor during the Prohibition years, and when the nation's ill-begotten temperance experiment ended these operators applied their skills and organized crime connections to new ventures. They ran gambling operations in the backrooms of the town's myriad cigar stores and operated brothels that attracted men from neighboring states to its red-light district. Steubenville's most prized resident grew up during those notorious days: the Italian-American crooner and famous Rat Pack member Dean Martin, born Dino Crocetti.

Steubenville trained Dean Martin well in these darker arts. As a teenager, he worked for a man named Cosmo Quattrone who ran a gambling joint in the back room of the shop he owned, the Rex Cigar Store. Quattrone stationed a man in a cubbyhole burrowed in one corner to hold a shotgun day and night, and he

employed dozens of young men to run numbers for him. It was in the Rex Cigar Store that Dean Martin learned how to deal blackjack and work the craps table and the roulette croupier and run numbers for the horse races. As Nick Tosches wrote in his biography of the singer, in Steubenville "sin as an industry was second only to steel."

But best to hide this past in the City of Churches. Steubenville worshipped their favorite son and welcomed Dean Martin back in the 1950s, the decade that also marked the adoptees' arrivals, with a giant parade and presentation to the singer of the key to the city. In a town where everyone seemed connected to everyone, the name Cosmo Quattrone of the Rex Cigar Store would surface again, but this time, by decade's end, as the proud new great-uncle of one of the Italian adoptees in the Steubenville cluster. When priests from the Pontifical Relief Commission peddled the merits of the orphan program throughout Italy, they promised a new life for these poor stained children of the *brefotrofi*, describing an America filled with riches: television sets and radios and record players and all the fanciest new gadgets. And in the home of the nephew of Cosmo Quattrone those items appeared, regularly and in abundance. Except their adopted child always wondered why the serial number had been scratched off the bottom of every single one.

- 21 -

Most of the children in Steubenville adopted through the orphan program received a second baptism, a sacrament the Church says cannot be repeated. But in Italy, each *brefotrofio* required the baby to be baptized once the child was in its custody and away from the sin of the unwed mother. Many of these institutions turned to the nannies they employed to serve as godmothers. I interviewed a nanny who told me that she was the godmother to over twenty children, so many in fact that she joked she should have written "godmother" on forms inquiring about her past employment. But to be a godmother, she clarified, carried no actual responsibilities because they had no information about the children once they left the *brefotrofio*. Today, Steubenville adoptees can only joke about this absurdity and their second unauthorized ceremony: "Heck yes, it didn't take the first time," one remarked.

Around the age of five, the children went before a judge to recite the pledge of allegiance, waved a little stars-and-stripes flag of America, and officially became citizens of their new country. They had no concept, of course, that decades later it would be difficult, if not impossible, to reclaim the birthright marked on their old passports, which some still hold, the

crimson-covered document remaining a curious artifact or prized possession. Some hadn't yet been told that they were adopted, but were gathering clues, as children do, beginning a trail on a private hunt that might one day lead to past treasure. Only today can they comprehend that the baby photo glued onto the page of their expired passport, like the family trinkets broken in half that lie in purgatorial limbo in the Museo degli Innocenti, may never be pieced back to its origin, the mother and father who created this child.

Today when we talk about ourselves, we use a different language than in the past; the concept of identity has become a fixation. We are curious about our origins and turn to genealogy for mapping ancestry. Similarly, we've changed the language we use about raising children, the word "parenting" now encompassing a set of skills to be acquired and perfected. We discuss ideas like attachment theory and the consequences of its deprivations. We clip newspaper articles about teaching children family history to shape resilience and self-control, offering them a narrative larger than the individual self and nuclear family.

But such contemporary ideas sound quite fancy when thinking back to the harsher childcare strategies of the 1950s, and stranger still when considering the bleak lives of the most forgotten ones, the children of the *brefotrofi*. Italy's "disinherited children"— as the unofficial magazine of the ministry of foreign affairs so transparently put it, eager to empty the country's foundling homes and place the entire lot if it could on planes to the United States—had family histories that had to be erased, like all the *figli di ignoti*, children of unknown parents, since the Middle Ages, surrendered to a societal idea and religious ideal. Yet even in the late nineteenth century, a prescient foundling home director perceived that grave wrongdoings were taking place in these institutions, as David Kertzer records in *Sacrificed for Honor*: "It

seemed to me that they were committing crimes," the director said. "On the third floor women in the maternity ward gave birth in front of everyone, but then when their children were brought down to the ground floor they were called *'figli di ignoti'* . . . Now I say: was it right that we became accomplices in this crime, that is, in robbing these children of knowing who their mother was?"

Children with identities erased at birth can spend decades or entire lives hoping to reclaim them. "I don't remember signing up for the witness protection program," as Tess, a Steubenville adoptee dryly put it. For Marco, who arrived in Steubenville on July 5, 1959, possessing an Italian passport that read Marco SANTELLI, the search for his lost mother has been his ongoing cause. He possesses meager crumbs of knowledge about his life that began in a *brefotrofio* in Cagliari, the capital city of Sardinia. According to his redacted case file, Marco was breastfed by one of the institution's sixty hired wet nurses and never stepped outside its walls during his two and a half years there because no one had taught him how to walk. Confined to spending his days in a chair, Marco had "no materials to play with," the social worker reported, "but if he is given an object to occupy himself, like a pencil, colored paper, etc., the expression of his beautiful and luminous eyes lights up and becomes more vivid than ever. Child is considered a good and tranquil boy, but it has been reported that he never smiles."

The chain of connection that led me to stumble onto the orphan emigration program originates with Marco. Just before Cousin John was set to embark on his month-long solo bike ride in Italy, he and Marco spoke on the phone, catching up on many years of news. It was Marco who urged my cousin to join John Campitelli's adoption group and search for his past, although Marco sensed early on my cousin's hesitancy, and it was Marco who shared many of the stories that were passed along to me.

The social worker wrote an apt physical description of Marco, as I can now attest looking at his baby photo. She probably fashioned her case narrative knowing that its audience would be a Catholic agency in the United States, and that portions of her report would be passed along to prospective parents. But she was right, the boy did have "luminous brown eyes," luscious dark saucers with an imploring gaze that would have caused many an ovulating woman to sweep up that sad little toddler who never smiled.

As a child in America, Marco's longing to know about his past shared parallels with John Campitelli's, both boys having lived in a *brefotrofio* for their first two years. John left before his second birthday and Marco a few months after, and both experienced a deep abiding need to meet their birth mothers. They also had supportive adoptive parents whom they were close to; Marco's dad even served as the best man at his son's wedding. Yet still, this desire to discover the person who brought him into the world, and the hope to one day see her face, persisted. Marco always understood that the earliest words spoken to him were Italian and that he was adopted, but he didn't possess John's tools to aid his quest, unable to speak the language and unversed in the culture of Italy.

In Steubenville, even as a boy, Marco intuitively felt the need to fashion his own history. As Russell Campitelli shared with his son the story of Robinson Crusoe and John imagined himself as its protagonist stranded on an island, Marco's father bought him a series called Classic Comics that retold famous works in comic strip style. The boy seized upon the issue devoted to Shakespeare's *Julius Caesar*—an adventure story that took place in Italy!—and became so immersed in the tale that he decided to dress as a Roman soldier, putting together a haphazard hat,

a makeshift shield, and wielding a plastic gold sword that his parents had bought him at a circus. Running up and down the streets of his neighborhood, he became the hero of his own story, announcing his true Roman roots and a neighbor announcing him nuts. "What's wrong with you, you're not a Roman," Marco says, imitating the confused man. "He was Irish, he didn't understand." Marco jokes about most things concerning his past: "Listen, if you don't have a sense of humor, you're not getting through some of this."

Marco suffered malnutrition in the Cagliari institution (despite the social worker reporting he was well fed) and received ultraviolet treatments to compensate for his lack of sunlight. Cousin John's father was Marco's doctor and he worried that the malnutrition and vitamin deficiency might stunt the boy's growth. Dr. John predicted that Marco would reach only 5'2", but he grew to a notch short of 5'8". The early malnutrition may also be the root of digestive problems that still plague Marco today, and wreaked havoc on his body during childhood and adolescence. Marco vomited so often and unpredictably that his parents placed a bucket beside his bed.

A rigid and unforgiving school system only aggravated Marco's pain. Catholic parents in Steubenville, particularly if they had adopted through the Church's orphan program, were pretty much obligated to enroll their child in one of its Catholic schools. But classrooms were large, in Marco's case fifty-one children in his first grade, and the nuns strict enforcers of the rules. Tess remembers firm whacks to the back of heads in elementary school and Cousin John, the ruler to knuckle: "Boy those nuns, they had the eighteen-inch rulers, not the twelve-inch rulers, and they knew how to use them."

Marco refers to all his early teachers as "Sister Slaps-A-Lot,"

with no first name because the sister who slapped a lot changed each year. The nuns used a ping-pong paddle to punish Marco in the hallway and a ruler in the classroom. Later in the day, Sister Slaps-A-Lot would call home to report the bad behavior, and "then you'd get it again," Marco explains, as few parents believe a child's word against that of a nun.

The purpose of early childhood education, like at all religious schools, was to learn academic skills and moral teaching, that is, reading, writing, and arithmetic along with the distinctions between venial and mortal sins. The children attended mass every day and each Catholic school in Steubenville—and there were many in the City of Churches (my cousin remembers at least ten Catholic churches with an adjacent school)—employed diverse techniques in teaching right from wrong.

Tess, a small quiet girl terrified of the nuns, recalls being told that if you lied or made a poor confession during communion the priest would see a black spot on your tongue, like those old-fashioned soft pink taffies with black licorice centers stuffed into candy store jars, each awaiting an undeserved communion host. Marco learned the finer distinctions of achieving salvation. If a husband, the nuns told the class, was Catholic but his wife was Protestant, the husband would go to heaven, but the wife needed to convert or, well, you knew where she was going.

In the fourth grade Marco missed a lot of school, the combined effects of a traffic accident injury and his stomach problems. When the nuns failed Marco and forced him to repeat the grade, the boy reached his limit, fighting this bleak prospect until his parents agreed to put him in public school. Tess, too, reached her threshold at the end of the fourth grade and begged her parents to send her to public school. Both children would meet for the first time in seventh grade, when the elementary school children entered the town's junior high school.

Although Marco appreciated the absence of the ping-pong paddle, soon hormone-filled adolescence struck, a time when his bad moods erupted so quickly that his father nicknamed him "Stromboli." It was during this time, around the age of fifteen, that his desire to learn about his birth mother became even stronger. Marco's mother, wanting to help ease her son's sadness, took him to the local Catholic Charities that facilitated the adoptions for the Steubenville cluster.

Put your mother out of your mind, a nun told Marco, she died in childbirth, a tonal variation of the dirge heard by Italian birth mothers. The boy, like the mothers, accepted the explanation of the nun cloaked in black habit. But these words affected Marco in a way he hadn't anticipated when he went looking for answers. In the years to follow, his birthday, once marked by joyful celebration, cratered into periods of depression because Marco now held himself responsible for killing his mother. The teenager who was learning photography, a hobby that became a lifelong passion, saw the picture developing before him, one image emerging into light as the other faded into darkness.

High school brought out a wild streak, the beginning of a period of reckless behavior that sent Marco's mother to church every day to pray for him. The once painfully shy boy who couldn't assert himself to request a glass a water in a relative's house was emerging from an adolescence of bad acne and social isolation to becoming a handsome young man. For the first time Marco joined the popular crowd, but to stay in that crowd you had to please them—and bending yourself out of shape to please others can be an easily acquired trait of the adopted child, the threat of original abandonment never far from mind. He became the class clown, blurting out things that would get him in trouble. "I took risks, did drugs, drove like a maniac. People would ask to ride with me because they thought they

were going for some experimental drive. They heard I got the car off four wheels."

His mother, worried as ever, enrolled Marco in art classes. She was an art teacher who understood its therapeutic potential. Although Marco didn't abandon his reckless behavior he, sometimes to his astonishment, survived it. After graduating high school in 1976, Marco studied fine arts at Ohio State and graphic arts at the Pittsburgh Art Institute, the beginning steps to forging a life of his own. But as part of the cohort of adoptees who remain determined to find their roots, he never stopped looking for his birth mother or the Santellis of Sardinia.

With the approach of the new millennium, Marco was far more content than all those years before, now living in a larger city in Ohio, two hours from Steubenville, happily married and the father of four children. But even these gifts, his proudest achievements, didn't eliminate the part of him that felt he never fully belonged. He needed to learn about his birth mother and family in Sardinia and started searching the internet for help. Yahoo Groups, before the birth of social media, offered the largest collection of online forums and this is where he discovered John Campitelli's adoption group, and where he kept coming back for more.

One night a funny thing happened on his way to the forum. Tess, the girl from his junior high and high school, joined the discussion board, also seeking advice and an outlet for a shared feeling of isolation and longing for a biological homeland. Marco couldn't believe what he was reading. "Tess and I were in the chorus together senior year. I kept thinking, what a bad person I am that I didn't know she was adopted. She was sitting fifteen feet from me, she played the piano, she had a great voice, and here she is from Rome." Tess similarly remembers thinking, what, you were adopted from Italy? "Oh my God!"

It would take many years of digging for John Campitelli to piece together just how large the Steubenville cluster numbered but the early connection caught his interest. Tess faded from this group because she found its format, mostly a collection of people and email addresses, intimidating, returning years later when the group moved to Facebook, where she and Marco became friends. Marco stuck with the Yahoo group and when John Campitelli switched to Microsoft, he followed him there, too, itching for clues to his past. He thought he knew the name of the church in Sardinia where he was baptized. "I tried to leave a message. I could hear a priest in his Italian accent, 'You no-ah baptized here.' That was his response."

Despite the nun's infamous words when he was a teenager, something told Marco that his mother was alive, a persistent feeling that he couldn't ignore. He also started to navigate ancestry sites, another new offering of the millennium. Feeling lucky to possess his original Italian passport, Marco searched for people with the name Santelli, a quest that persisted for six years. One night he believed he had a breakthrough. A Joan Santelli appeared on one site and the two exchanged notes trying to determine if they might be related. Joan said that she was living in a retirement village in Palm Harbor, Florida, a residential community of about sixty thousand people. That's funny, Marco thought, his mother had moved from Ohio to Palm Harbor after his father died. Marco asked the name of the facility, and it turned out that Joan Santelli lived in the same apartment complex as Marco's mother.

After a childhood of nuns reaching for ping-pong paddles, in adulthood Marco explored alternative forms of spirituality. He abandoned weekly mass for daily meditation, found comfort in the healing hands and universal energy of Japanese

Reiki, and even sought card readers, despite not believing in them. His is a lifetime spent looking for signs to the mystery of his birth. And here he discovered the extraordinary coincidence of this internet stranger living in the same condominium complex in Florida as his Ohio-transplanted mother. Why was Joan Santelli navigating this ancestry site? What was she searching for anyway?

Marco decided to make a trip to Florida to meet Joan Santelli, and Joan happily agreed. He introduced her to his mother and the three went out to dinner. They all got along very well but sitting at that cloth-covered table no one could figure out how Marco and Joan might be related. Joan had no long-lost child or nephew for whom she was searching, as Marco secretly hoped. Like millions of Americans, she found ancestry sites a fun hobby to keep her company on long nights alone. Joan remembered an uncle who never left Italy and suggested that maybe he moved from Campania to Sardinia. But despite no obvious reward, the evening proved to be a warm one, and Marco and Joan stayed in touch, corresponding for about a year. After Joan learned that Marco's mother had died, she reached out again to offer her condolences. She suggested that Marco might want to join her at a Santelli family reunion to be held in Toronto, Canada that year, a gathering that promised many members of the clan.

The reunion would be taking place the same time as Marco's twentieth wedding anniversary, and in another coincidence, Marco and his wife had spent their honeymoon in Toronto. The stars were pointing the couple to make the trip north, and perhaps finally get some answers to a lifetime of questions. At a modest home in the city's Italian section, they met the reunion's host and patriarch, a short and kind older man born in the old country, who stored homemade wine in the basement and cultivated a fertile backyard garden. Marco remembers most the

espresso bar and how the gracious host whipped up cappuccino after cappuccino with a fancy machine. Everyone tried to figure out how Marco was related or whom he resembled, Marco with his full head of hair and the rest mostly bald.

"We had a blast," Marco said, a word that brought me back to my childhood days, when my Steubenville cousins came to New Jersey to visit and always described the great time we had together as a "blast," an unusual expression for someone on the east coast. We'd tease about each other's funny words and varying vowels, and only later did I discover how language gives Steubenville its third ingredient of renown, after Dean Martin and miscreant athletes: the small town is considered "the geographic ground zero of the US," the place closest to "standard" English.

The hope, however, for this pure-American speaking boy to find a connection to his mother tongue via a family reunion in Canada did not pan out. But there was a simple reason for this, one far too outlandish for trusting Americans to have anticipated. Like the eleven-year-old John Campitelli winding his way back to the Santa Maria Novella station with his hand-copied list of people named Davi, like the mothers who gave birth in front of a roomful of people but whose babies became *figli di ignoti,* Marco had been robbed of ever knowing his mother's name. The person assigned to his files might have chosen "Marco Santelli" as an antidote to the sins of his mother, renaming him a devout little *santo,* born on April 27, two days after the *festa di San Marco.* But in the reality of a person's life, this falsified document, the embossed passport which could bring a child into the United States, resulted four decades later in Marco traveling nearly three thousand miles, from Ohio to Florida to Toronto all in the vain effort of finding a family connection to a family that never existed.

- 22 -

One summer evening five members of the Steubenville cluster agreed to join me for a Zoom conversation. The manageable screen of faces allowed me an entry point into the lived experience of the dozens of adoptees who arrived from Italy into this tight-knit town. The group included: Cousin John, Marco, Tess, Mary, the youngest and among the last children sent to the United States in 1968, and another John who now lives in the city of Columbus, Ohio, whom I will call Columbus John to avoid even further confusion.

Mary was the firebrand among them, most vocal in calling out the harm inflicted by the absence of a support network for all these adopted children and parents. Columbus John joined our call late because he had to pick up his son from the airport, and after some typical audio and visual connection problems, finally appeared on our screens. The conversation was coming to an end, but he wanted to at least say hello to a group of people with whom he had never imagined such an unusual and intimate connection in his youth.

Columbus John, like Cousin John, had no idea where he was born until John Campitelli provided them with the paperwork. All three began life in the Turin Institute, but Columbus John

had not arrived as the kind of perfect healthy package of which the *brefotrofio* had prided itself. In the orphan program's files documenting his September 20, 1962 Alitalia flight, a hand-written note reads: "Child's nose had a bad sore, his right hand's palm was red, looked like a large boil, same hand's top portion had a mark. His legs were like rubber—cannot stand or put them together."

"I was sixteen months old," Columbus John told the group, "and my mom told me that I looked like I was six months old. The doctors told her that they didn't know if I was going to make it, I was that weak, I was not in good health. My mom worked her ass off to keep me alive along with the doctors."

Mary, who had lived for twenty-six months in a *brefotrofio* in the city of Biella in northern Italy, responded, "I wasn't healthy either when I came here. I had rickets and bone disease and I was Vitamin A deficient. They did not treat us well."

"In Sardinia, it wasn't any different," said Marco.

"Well, at least you had a pencil for a friend," Cousin John chimed in, enjoying ribbing his old pal about the social worker's description of Marco's eyes lighting up if given a pencil.

"Yeah, I had a fucking pencil."

As the adoptees shared what little information they knew about their early years in Italy and reminisced about growing up in Steubenville, the conversation felt in part like a support network, the kind Mary wished had existed in their youth, and in part like a reunion, even if some were meeting for the first time. They talked about their early schooling, attending mass every day, and De Carlos Pizza, "the center of the universe." Motivational words like "preach" were said when someone shared a painful realization. Mary addressed everyone as brother and sister, an acknowledgement of their peculiar lifelong bond. She also remained quiet for a good portion of the discussion,

preferring to listen, and became emotional rejoining later. "It's crazy," she said. "We've moved forward but there's this thing that digs deep in you and it's bothersome, it's bothersome."

Mary bears a double burden as she had been adopted together with her younger brother, also named John. Her parents had intended to adopt only the six-month-old but were persuaded to take his older sister ("I'm the two-for-one special," Mary explains.) But both children may have been too much for her adoptive mother. Mary, by her own account, was a rambunctious and challenging child. She detected at a young age that her parents had a troubled relationship and came to believe that her mother did not want to have children but had been persuaded by parish priests that a child could save the couple's marriage. Mary also became the family's sole survivor.

Tess, who remembers Mary's brother from their youth, later described him as an "open heart walking around on two legs, he was just that type of kind, sweet, loving person." This sensitive soul took his life when he was in college at the age of twenty-two.

"He hated the whole fact that he was adopted, he wanted nothing to do with it," Mary said, who still has difficulty talking about her brother thirty years after his death devastated their family. "There were other circumstances," Mary told me, her brother struggling with issues of his sexuality in high school and college, "but I think adoption really played heavy on that, and later after his suicide I learned that there are mental health issues in my biological family. I'm like, what do I do with this? What do I do with all these mental health issues? It scares me sometimes, even to this day."

As family stories were shared, the complex choice of the adopted child, whether or not to search for one's past, surfaced, and was summed up in a succinct exchange between Columbus John and Marco.

"I've always wondered if I've had any brothers or sisters," said Columbus John, "but I was very fortunate with the parents who adopted me, and it really didn't matter because they were my parents and they basically brought me back to health." He worried if he looked for his origins, "Would I be opening up a can of worms?"

"I'm a can opener," Marco retorted. "I'm an asshole, I'll open that damn can. I'm pretty stubborn, I seem nice on the outside."

Not to open a can of worms, or to be a can opener; some adopted children prefer to keep the lid shut, whereas others are unable to imagine life with one's beginnings sealed. Among the Steubenville group, Cousin John and Columbus John were squarely in the first group, Marco, Tess, and Mary in the second.

Cousin John explained that even though he's been to Italy five times in the last ten years, he has not had the urge to pursue his origins. He described his choice by invoking the famous words of baseball player Lou Gehrig announcing his retirement from the New York Yankees after being diagnosed with an incurable neuromuscular illness, amyotrophic lateral sclerosis, ALS, which took his life two years later. Gehrig, in one of the most gracious speeches in American sports history, told the packed crowd at Yankee Stadium that while they had been reading about his bad break, "I consider myself the luckiest man on the face of the earth."

Cousin John indeed was a lucky infant, leaving the Turin Institute in good health at nine months old and raised by loving supportive parents in an upper-middle-class home. His mother adored him, and I always envied the look of pride on her face when she saw or spoke about her son. Popular and athletic, the star quarterback of the high school football team, I thought, too, about genetic inheritance, his of an extrovert, in the random turn of fortune's wheel. A social worker's report about the Turin

Institute described the section for children between four and eight months old, probably the last place Cousin John lived before heading to America, where the babies, finally able to leave their cribs, had been placed in chairs on a veranda four times a day. She observed the innate human tendency to be attracted and give more attention to the "naturally vivacious" child. "The child who is the object of special attention on a nurse's part," the social worker wrote, "makes greater and more rapid development in his mental and physical process than the others. The less pretty children, the less adaptable, naughtier, more nervous types receive less attention and fall into a state of boredom and apathy; even when they are on the veranda their interest is very slight." Cousin John, I felt certain, looking at his Italian passport photo, a cherubic infant posed with a curled tuft of hair pomaded to stand high and dressed in what looks to be a baptismal gown, had caught some nurse's eye.

"I have a question," my cousin asked later in the conversation. "I don't have a need, a desire, it doesn't keep me up at night to find my birth mother. But, if she is still alive and she wanted to find me for the past fifty years, were there ways she could have done that?"

Impossible if surrendered anonymously, I assured him, and impossible even if recognized at birth, if the child doesn't also embark on the search. Absolute secrecy was the point of the orphan program—the reason why the Vatican's Monsignor Baldelli determined that children sent to America be surrendered anonymously, although the Church included some babies recognized at birth to meet the great demand of childless couples. Files of where the children had been sent remained under tight seal, kept even from the directors of the *brefotrofi*, and no information was ever revealed to a birth mother, despite her legal right under Italian law to know what had happened to her child.

Tess, another member of the can opener group, explained that from the moment she learned she was adopted she wanted to know "who I was." She uses this grammatical construction often. It is the phrase of a former high school English teacher, a reflection of Tess's belief that knowing who you are means starting on page one of the book of your life.

She began asking questions as a little girl. Her friends could name the Ohio hospitals where they had been born but when Tess asked her parents about hers, their response was always the same: "Oh, we were lucky, we got to pick you out." Around the age of eight, she intuited that their cryptic answer meant that she was adopted. One day she confronted them and her parents replied, yes, they adopted her and she had been born in Rome. That was all they ever told her. Throughout her youth Tess quietly held onto the possibility of learning about her past from this scrap of information, but she waited, fearful of hurting their feelings and causing a rift.

Tess returned to Steubenville in 1997 to clean out her family home. She was now the mother of two young children, nine and seven years old, who accompanied her during this difficult task. She approached with trepidation her favorite childhood spot, her mom's cedar chest, that magical rectangular box whose woody scent always enticed her, the place where she dug out shiny trinkets, gently unfolded her mother's billowing wedding dress, and imagined her own. When she opened the chest that day, to her astonishment her original passport and adoption papers lay inside. Her mother must have added these documents after Tess left home and curious eyes no longer peeked inside.

"You hear poetic descriptions of feeling an earthquake and that's what it felt like," Tess said about this moment of discovery. For the first time she held her Italian passport and

carefully fingered each page. "I felt my whole world had shifted because now I had a name and I knew who I was." Tess initially believed that she had stumbled upon her entire adoption file, but only the passport stating that she had been born Maria Luisa Santarella and some legal documents from Ohio were inside the chest.

"I hit a wall, I hit a huge wall, as anyone who is trying to do this on their own will. I found all of my information by a source that probably is just the other side of legal, to tell you the truth."

"Welcome to Steubenville," Marco responded.

Tess laughed and continued her story: "A friend of mine had spent a couple of college semesters in Italy. She stayed with a family in Rome, the father of that family worked in the Italian government, and she prevailed upon him to open my records to find out who I was."

Tess traveled to Italy with this friend, a colleague from work, to meet the family and the father in government who agreed to help. She fantasized for months about her first trip to Italy, weighing its many possibilities; the idea of meeting her birth mother both thrilled and terrified her. But she arrived to learn that her mother was no longer alive. Observing the glances exchanged between her friend and the family, she believes this former friend knew the truth before they left but didn't tell Tess, fearful the news would cause her to cancel their trip. Devastated, Tess wanted to go back home, immediately. But they urged her to stay and seek out her birth mother's family. The woman's name was Angela Santarella. She had recognized Tess at birth, the passport truly her own.

"I ended up going to this little town in Puglia where she was born and grew up, just to get a flavor for it, and while talking to the people there, I was introduced to her brother and my cousins, and they sent me back to Rome to meet her husband.

They welcomed me like I was the long-lost daughter. I just wish I could have met her." Angela was among the birth mothers who died young, suffering her second heart attack in her sleep at the age of fifty-eight. She also learned that Angela's husband, like her mother's relatives, never knew Tess existed.

"Here was the circumstance," Tess continued. "She was a young woman in Puglia, and she was engaged to be married and got pregnant with my brother and the guy bolted. So she had my brother and picked up to move to Rome and cut off all ties with her family, and about ten years later, she re-established ties with her family. I was born in that interim.

"The funny thing is my mom always used to say, you were supposed to have a brother. I took that to mean that they were going to adopt another child. She was having many sicknesses and didn't feel up to it. Well, when I found that out about my origins, when I found out who I really was, I have an older brother. We were both supposed to be adopted together and my mother backed out and adopted only me.

"My mother's widower called my brother to come over and meet me and he flatly refused. I harbor no animosity toward him. That had to have been horrible if his mother was trying to give him up when he was six years old, and the baby got to go, and he didn't.

"From what I understand, my mother kept me for the first six months, that I was actually with her for the first six months, so she not only recognized me, she was trying . . ." Tess said, her voice trailing. "I met her best friend who told me that my mother, Angela, often told her of a recurring nightmare, of people ripping a baby girl out of her arms, and her friend said, 'Now it makes sense.'

"So, I don't know if she gave me up because she just couldn't do all of this anymore, or I don't think she was ever intending to

be a mother, not of one, not of two. But it sounds to me like she did have some trauma giving me up. To tell you the truth, for a long time I still felt incomplete because I didn't get to meet her and talk to her, and find out how and why, but as the years pass, I feel like, I'm good, I'm good with it. At least I know where I came from, I know a little bit about her."

Tess stopped here, wanting to give other members of the Steubenville cluster time to share their stories. But Tess's narrative troubled me, many of its parts didn't seem to add up. After the adoptees exchanged their goodbyes and hopes to have another group chat, I texted Tess and we agreed to speak again soon.

- 23 -

Tess pieced together all of this, bits she'd taken and formed into a story about her birth mother from Angela's brother and sister-in-law in Puglia, her best friend in Rome, and her widower. "Her husband absolutely adored her, and he enfolded me like I was second Angela." Tess learned that she inherited her mother's petite stature and features: "Oh yeah, she's who she says she is," Angela's husband proclaimed upon meeting her. All created a portrait of an independent spirit, a young pregnant woman dumped by her fiancé who didn't want to live under the shameful stares of family and neighbors and moved to Rome.

"My assumption is that she put my brother and me up for adoption and my mom, because she had so many health problems at the time, thought she could only take one. Boy, I have to tell you, that took a long time for me to get past. I had some serious anger and resentment for my adoptive mother for doing that. Separating children, why would you do that, and then to take the cute baby? Ugh, I guess it is what it is, there's nothing I can to do change it. But I'm putting these pieces together because my birth mother had not told anyone about me, and she had not met the man she would eventually marry until long after I'd been adopted." Tess had never asked her adoptive mother any

questions about the brother she was supposed to have had, but rather imagined this scenario after her half-brother in Rome refused to meet her.

But if Angela had the courage to leave her family in Puglia to raise her child as a single mother in Rome, why would she decide to give up her son six years later with her newborn? Why did Tess think a little boy would be angry that he didn't get to go to America, that he'd want to leave his mother's side, to be sent to a strange country and placed in a stranger's house? If Tess's birth mother had signed the surrender papers, losing all of her rights, and her adoptive mother had changed her mind, why wouldn't her brother have been placed somewhere else in America, since orphan program siblings were also separated, sometimes ending up at different ends of the country. And most hauntingly, why did Angela tell her best friend about her recurring nightmare "of people ripping a baby girl" out of her arms?

Did Tess, unaware of the machinations of the orphan program, and deeply hurt by her half-brother's refusal to meet her, jump too hastily to conclusions about her birth mother's willingness to give up a child, or two? She had been spared the details of a program that was not all it had purported to be, starting with the word orphan. The pages and pages of correspondence between Monsignors Landi and Komora, the stories of daughters like Rosalba who refused at first to meet her half-sister Sara, reveal myriad possible scenarios of what had taken place with birth mothers and many complicated reasons for turning away from a newly discovered half-sibling. Tess admitted she, too, harbored doubts about a narrative that could only be woven from scraps.

"In the beginning, I assumed that she was putting both my brother and me up for adoption because she didn't want to be a mother anymore, or a single mom. It's the fifties in Italy, it

couldn't have been easy. But then when her best friend told me that story, I thought maybe there is more to this, maybe she felt like her hand was forced. Maybe it wasn't an actual recurring nightmare, but that's how she felt, that her baby girl was taken from her, which just breaks my heart. And I know where I was born, it's called the Assistenza Materna."

Those words set off more alarms. That was the institution run by Jolanda Torraca, the woman who described unwed mothers as choosing to surrender their children after "the first impulse of affection" because of "misery, frivolity, or irresponsibility." I read Torraca's description to Tess.

"My God. Wow. That plays into the movie stereotype of the woman who gives up her baby for adoption, that you hate being pregnant, that you never intended to be pregnant, and you say, 'take this thing.' If you have ever been pregnant, and they put that baby in your arms, that is all there is. All of a sudden, the rest of your life fades into the background, this is what it's all about. And when I think about what it had to take for any of these mothers to separate from their babies, it's just heartbreaking."

Tess's story brought to mind my conversation with Diana Miller, who in 1989, then known as Diana Smithson, attended with John Campitelli the eye-opening session run by Florence Fisher at the California adoption conference, which led them to co-found their first adoption group, CIAO. Diana also had spent her early months at the Assistenza Materna. I made a mental note to return to that interview as more than a year had passed since I had spoken with Diana, the details of her story now murky in my cluttered head. I suggested Tess reach out to Diana but sensed she didn't want to reopen this box. "A few years ago there was a movie about an Irish woman," Tess said, referring to the film *Philomena*, "and all of my friends kept saying, you have to see this, but I don't want the reality of what happened

and possibly still happens all over the world to women, I don't want to see that."

Tess also has never seen her redacted case file and without that information it's impossible to know if she was with her mother for those early months as she had hoped. She based this idea on notes her future adoptive mother had recorded from a conversation with Sister Claudia from Catholic Charities in Steubenville as the couple awaited Tess's arrival. Jotted on a slim rectangular slip of paper labeled, "Latest report on Tessy," its details included her weight at three months, height, observation of a slight rash, slight cold, and that she was under the constant supervision of a doctor. It also says she was being breastfed six times in twenty-four hours, which Tess interpreted, as any daughter would, that she had been in Angela's arms.

But the Assistenza Materna employed wet nurses too. Sister Claudia's information was the kind that would have been relayed from a social worker at a *brefotrofio* to Monsignor Landi's office in Rome to Monsignor Komora's office in New York City to Catholic Charities in Steubenville. Unless Angela had been living at the *brefotrofio* while someone took care of her six-year-old son, the reported milk would have come from a wet nurse. Tess's passport photo, an adorable baby in a too-big crocheted sweater and large starched cotton white bibb collar, shows her being held up by a woman wearing a wedding ring. Perhaps a worker from the Assistenza Materna or the National Catholic Welfare Conference. Tess admits, "For a little while I had fantasies that was Angela's hand."

Soon after speaking with Tess, I went back to my notes and listened again to my conversation with Diana Miller. As I heard myself asking how to spell the institute's name, I realized that Diana was the first person to mention the Assistenza Materna. Diana, who was anonymously surrendered as an infant, never

has been able to find her mother, the name on her birth certificate, Cinzia Buttironi, falsified. But Diana managed to obtain her redacted case file and learned that her birth mother had spent eight days with her at the Assistenza Materna. When her mother left, Diana was sent to the countryside to be breastfed by a wet nurse. A month later the wet nurse contracted influenza and brought Diana back to the institution severely malnourished.

Diana's case report states that her birth mother, "Approximately twenty-five years old was dating a police officer in the Rome area. She became pregnant, and when he found out, he fled the Rome area and went to Apulia." It was the reverse of Tess's story where the pregnant woman fled the hills of Puglia for a new life in Rome.

Then they met the policeman or the fireman—and we got the children. The words of orphan program supervisor Virginia Formichi rang in my head.

"Then, the interesting thing is," Diana said, pausing to locate the precise line. "They actually say that the woman was tranquil, passive, and rather superficial, and has a poor capacity for affection. And I thought, here's this young woman who is alone and probably doesn't know, probably scared to death, probably ready to give up her baby. Oh my gosh . . ."

Those flippant judgments that astounded Diana are consistent with the Assistenza Materna's superficial depiction of birth mothers that helped justify its work in taking children away from women. In yet another article published in the foreign ministry's pet magazine *Italiani nel Mon*do entitled "Little Emigration," which was sent to adoption agencies in the United States, the Assistenza Materna maintained: "Only when every effort has been made to keep mother and child united or when later that mother repents of her first impulse in having recognized the child and wishes to wipe out of her life even

the memory of her youthful indiscretion, then the Service of Affiliation and Adoption intervenes and logically seeks a resettlement of the child as far away as possible from the mother, since the child also has a right to a happier life than that which would be in store for him in any orphanage."

Diana said she met other adoptees from the Assistenza Materna and the same doctor's name and witness appears on their birth certificates: "Jolanda Torraca, she was with Assistenza Materna and she was like a delegate. It's like an assembly line. They had a plan, they knew who was executing what and how, and that's how they did it. There's no way that if it was all valid, that all of us would have the same doctors, the same witnesses. It's all very crazy."

Tess and most American adoptees, unlike John Campitelli, who learned through his own family and then by aiding others, couldn't have been aware of the assembly line nature of adoption delivery, moving from *brefotrofio* to office in Rome to New York City to the grateful members of the Steubenville Adoption Club. Once a woman signed the irrevocable surrender, whether or not she understood its implications, her fate and that of her child had been sealed. What took place next might even be described as a recurring nightmare of people ripping a baby girl out of a mother's arms.

In July of 1959, just four months after Tess arrived in the United States, this very issue of an Italian mother changing her mind caused a crisis for the Church. The woman's emotional public scene was one of two incidents that took place within a week at Rome's Ciampino airport. An impoverished Neapolitan widow and mother of eight children sought police intervention after she refused to relinquish her five-year-old girl and three-year-old boy to America. A few days later, a ten-year-old girl tearfully pleaded with airport personnel not to separate her

from her mother, while three unidentified people accompanying the girl tried to convince her to take her seat. The girl was the daughter of an unwed mother who twice before had refused to be sent to America. These incidents, widely reported in Italy, had been picked up by the *New York Times*, creating an international scandal about the black marketing of Italian children from which the Church narrowly escaped.

- 24 -

"By this time you may have heard about the public furor in Italy which has arisen over the orphan program," Monsignor Landi wrote from his office in Rome to his superior in New York City, Msgr. Edward Swanstrom. The monsignor, whom Pope John XXIII would make a bishop the following year, was the executive director of Catholic Relief Service—National Catholic Welfare Conference, its offices located on the forty-ninth floor of the Empire State Building. Landi composed his letter, dated July 17, 1959, the same day the *New York Times* article had appeared.

The *Times* reporter described how "Italians, proverbially fond of children, have been deeply impressed by these episodes." The newspaper story informed an international audience of what Italians had been talking about for months, in their homes, on the square, in the local bar, the whole country discussing the black marketing of babies.

The controversy had started in May when the current affairs magazine *La Settimana Incom illustrate* had written a feature story about the sale of Italian orphans to the United States. The Ministry of Foreign Affairs had blocked the departure of ninety orphans scheduled to arrive in America, checking to make sure all was in order. On the glossy pages of the magazine, the

Church had been spared indictment. The reporter mentioned only a shady unnamed "character" who was seeking the children of the *brefotrofi* to send to America.

The character was Peter Giambalvo, an Italian-American lawyer from Brooklyn, who after adopting a child in 1951 from a *brefotrofio* in Emilia Romagna, began facilitating adoptions for interested clients, Italian-American couples seeking a good fortune similar to his own. Having learned how the system worked through the Church program, he copied it. He was a vice-president of the Order Sons and Daughters of Italy in America, which long had requested babies from the orphan program, and through this organization he sent considerable amounts of physical and hospital equipment to institutions in Italy. He hung a plaque on his office door that read, "Chairman of the Committee of Italian Orphans and Migration."

The magazine reported the visit of this nefarious character to a *brefotrofio*: "The middleman came, took the children in the garden and also took the pictures of each child while they played with the gravel, without knowing that in that precise moment their destiny was sealed." Shortly after letters began pouring into the *brefotrofio*, from American priests attesting to the good character of potential adoptive couples, banks showing their deposits, police their good standing. Giambalvo knew how to play the game.

The magazine also reported that when this shady character couldn't find potential adoptees in the *brefotrofi*, he headed to the impoverished south of Italy paying poor women for their children.

Since the mid-fifties, Giambalvo had corresponded with Monsignors Landi and Komora and both men replied to his letters and took his calls, forwarding his requests to receive applications for prospective adoptive parents he represented to

the local Catholic agency that handled these forms. They may not have liked Giambalvo but they did not walk away from his requests—until now.

The magazine article was a public relations nightmare for the Church. At the time, Landi was on vacation in Brooklyn and orphan supervisor Virginia Formichi sent him a long letter explaining the circumstances, and that the Church, too, although not named, had a presence in the feature story: "The photographs are of our children, and no doubt you will recall that the group photo originally included yourself, Miss Rich [Formichi's predecessor], and Miss Petrucci [a social worker from the Vatican's POA]. The children mentioned in the last paragraph of the article, to my knowledge, have ab initio been processed by us." The article had concluded with a list of children whose documents would be reviewed to make sure no middlemen would profit from the adoptions.

"In essence," she continued, "the article seems to have been precipitated by Mr. Giambalvo's attempts to obtain passports for the rather large group of children whom he is processing. No doubt, however, this kind of negative publicity will reflect on our program as well."

In June, Landi's Naples representative informed him that the Province of Benevento was suspending all orphan emigration due "to the recent negative publicity concerning black market babies," a huge blow to the program since the Naples area provided a steady stream of illegitimate children.

And in July, Landi had to explain the *Times* story to his boss in New York, writing that it "further fanned the flames of public indignation and Communist calumny," as left-wing newspapers had included the Church among the group of black marketers. Monsignor Landi also informed Monsignor Komora at the Catholic Committee for Refugees that, "A series of articles

which have appeared in the Italian newspapers and magazines concerning black market activities in children have occasioned us real difficulty in our ongoing work in obtaining referrals of children; this is to make no mention of the inquiries which we have received concerning children already departed in past programs."

Landi asked Komora to send photographs of children arriving in New York after they were newly attired to help generate some good press, along with photos of the recent visit to the States by Monsignor Baldelli. "We are seeking to offset this negative publicity at various levels. We think it may be helpful to us in approaching provincial authorities, and most particularly, mother superiors at various institutions, if our program workers can carry with them a small album of photographs which can pictorially demonstrate something of the nature of our work."

In his letter to Monsignor Swanstrom, Landi provided background details for both airport incidents described in the *New York Times*. Regarding the initial one, the mother changing her mind about sending two of her children to America, Landi explained that Peter Giambalvo had arrived at the Rome airport with five children, but only had passports for three of them, the other two held by his secretary who had already left for the States. This discrepancy garnered the attention of the border police who then sought clearance from their Rome headquarters. While the matter was being sorted out, the mother, Landi explained, "appeared at the airport and demanded the return of her children in a very hysterical manner, stating that she was prepared to renounce the money which she was to have received from Giambalvo."

The second incident, which took place the following Tuesday, that of a ten-year-old girl who refused efforts to be seated on the plane, tearfully demanding to be returned to her

unwed mother, was a case handled by Monsignor Landi's office. Landi told his boss that twice this girl had been accompanied from Naples to Rome to board the flight to America, and twice she tearfully refused to leave her mother and was sent back to Naples.

According to Landi, her mother pleaded with orphan program social workers to send the girl to America, supposedly to a cousin, but they replied they would do so only if the child went "of its own free will." Apparently, the girl's fierce emotional response twice from being separated from her mother was not an expression in the eyes of these trained social workers of her true feelings. Or perhaps they thought the third time would be the charm. After leaving the facility in Rome where babies and children awaited their departure, arriving at the airport the girl once again "broke down, cried, and insisted on being returned to her mother." Landi's team, evidently recognizing that the sobbing child was not going "of its own free will," brought her back to Naples straightaway—although the article described three unidentified people who had accompanied her trying "futilely to convince her to take her seat on the plane." Monsignor Landi added, "We are still unable to find out how this incident came to the attention of the newspapers."

In response to the *New York Times*, Monsignor Landi "categorically denied today that any guardian or any institution in Italy had received 'a single lira' from his organization for the transfer of an orphan to the United States." Thus began the repositioning of the Church to separate from the actions of Peter Giambalvo. Landi's categorical denial of not paying an institution "a single lira" was *almost* true. The Church didn't need to pay the state *brefotrofi*, as the Italian government handled the upkeep of these children. Sending the illegitimate to America relieved the government of its social burden, and the mother

superior running day-to-day operations of her moral one. But in Rome, the Church did pay ample lira for the monthly maintenance of each child at Jolanda Torraca's private institute, the Assistenza Materna, because the director of the state-run *brefotrofio* had refused to cooperate with the Church program. Without Toracca's referrals, the pipeline to send illegitimate children from Rome to the United States would have been closed.

Approaching and paying poor women, like Giambalvo had done with the mother protesting at the airport, was a situation from which the Church had tried to extricate itself years before. In the early days of the war orphan program, widows and widowers were among those approached by local priests, as documentary filmmaker Basile Sallustio depicted in "My Brother, My Sister, Sold for a Fistful of Lire." The early program had caused so many headaches for the Church—mothers changing their minds, saying they were tricked and demanding their children back, as well as local Italian-American organizations and Catholic couples demanding to know what happened to the children they wished to adopt—that Monsignors Baldelli and Landi refocused their efforts to the anonymously surrendered children whose mothers would be untraceable.

As for the price of children, Peter Giambalvo, privately representing American couples, charged $750 for an Italian child, plus legal and transportation fees. The Church, which obtained special privileges in the reduction of transportation and consular expenses, charged couples $475, not including inland transportation costs. Giambalvo's fee was higher, for sure, but no further interest was due.

The attorney was causing the Church a major migraine but the priests had also been suffering from a nagging headache—the involvement in the late 1950s of a private nonsectarian agency, the International Social Service (ISS), competing

for the same children of the *brefotrofi*. The ISS, whose office in Rome was a branch of the Italian Red Cross, found its own potential adoptive couples and had working relationships with private adoption services like Spence-Chapin in New York City. (Spence-Chapin continues to attract couples who can afford to pay the high price of international adoption, which today can cost as much as $50,000.) Children of the *brefotrofi* sent to America and processed by ISS arrived wearing armbands marked "Red Cross."

The Church tried to insist that only Catholic Charities deal with prospective adoptive parents, but ISS refused, and the agency also allowed couples married in a civil ceremony to adopt an Italian Catholic child, a position geared to make the Church apoplectic. Monsignor Komora personally asked the ISS not to handle any Catholic cases, but again the organization refused, and tensions grew so high that a group of Catholic priests discussed bringing the very powerful Cardinal Francis Spellman, a close associate of Pope Pius XII, into the matter.

For the moment, however, both organizations shared one common problem—the urgent need to distance themselves from Giambalvo. The Church, ISS, and the private attorney all dipped into the same pool of children, but Giambalvo sometimes sweetened the deal, offering a present, like a television set, to a *brefotrofio* director, a little something to compete with the Church's moral authority and ISS's social clout. With all the press attention plus another a huge setback—the announcement that a Brooklyn District Attorney was investigating the existence of a black market for children in Italy—both the Church and ISS needed to work hard to cast the Sicilian-born lawyer as a merchant of children, like the character Alberto Sordi played in the film "The Last Judgment."

On both sides of the Atlantic the mood was frantic. Monsignor

Landi, his vacation hopelessly ruined, fired off several cables to Formichi in Rome, telling her to inform Monsignor Baldelli of the Giambalvo situation and to make sure the Vatican priest was included in the conversations. But she responded with more problems. Luciana Corvini, the director of the Italian Branch of ISS and Monsignor Landi's secular equivalent, had called Virginia Formichi to express her concerns about the negative publicity. "After discussion with her board members," Formichi wrote, Luciana Corvini "advised me that ISS planned to pay a reporter to write an article explaining the manner in which ISS processed children."

Formichi told Corvini that the Church agreed with this approach but before the article was published Monsignor Baldelli would need to review it. "Miss Corvini," Formichi continued, "thereafter advised me that ISS did not wish to have Msgr. Baldelli read the article indicating that they had some concern about recent negative propaganda attached to the POA, and therefore would prefer 'not to have anything to do with the POA.' Because I did not feel that we could therefore be included in the article, it was agreed that the article would be confined to the activity of ISS; I did agree to a statement in the article to the effect that ISS and NCWC are the only two agencies authorized by the Italian Government to undertake orphan placement in the US."

Formichi concluded her letter by informing Landi that *Newsweek* magazine was making inquiries at the various consulates about the numbers of visas that had been issued during the orphan program. "When it rains it pours," she wrote.

No doubt Monsignor Landi must have been furious about ISS's position toward the Vatican organization but there was little he could do. Both groups were formidable. While Landi, working on behest of the Vatican, knew all "the big shots," as

Corvini described in a letter to a New York colleague, Corvini had Italian aristocracy on her side, referring often to the Marchesa Origo, her principal board member, as well as the Contessa Rattazzi, formerly Susanna Agnelli, the sister of FIAT head Gianni Agnelli.

The Marchesa, Iris Origo, friend of the original "war orphan" adopter Martha Gellhorn, was also a writer, born Iris Margaret Cutting to a wealthy American diplomat and an Anglo-Irish mother. After her father's early death at the age of twenty-nine, her mother moved to Italy, dipping into the family fortune to buy the Villa Medici in Fiesole, where the young Iris grew up. She married Antonio Origo, the illegitimate son of Marchese Clemente Origo, but the union was a troubled one and both found consolations outside of it. Both the Marchesa and Luciana Corvini were particularly supportive of the Assistenza Materna, the Marchesa enthusiastic about possibly funding an institution of Jolanda Torraca's to help Italy's unfortunate illegitimate children.

Where Monsignor Landi's office was on prime Vatican real estate, the Via della Conciliazione, Luciana Corvini's office was on the fashionable Via Veneto. Where Landi's "big shots" could solve problems with the Italian government, Corvini served as a consultant to its foreign ministry, a fact that did not go unnoticed by an ISS director in America. "We believe that your capacity as a Director of the Italian Branch," she wrote, inciting Corvini's rage, "sometimes gets confused with your consultative capacity to the Foreign Office." When the New York district attorney conducting his black-market baby investigation wrote to ISS requesting all of its materials concerning Peter Giambalvo, a supervisor attached an abbreviated handwritten note for a colleague: "Here is our file on Mr. Giambalvo . . . This wd. leave only Luciana's letter of 3/23 as something wh.

THE PRICE OF CHILDREN

we know 'of our own knowledge'—*I question our sending this since it contains so much of the Italian Br in relation to the Italian Foreign Office."

With both Monsignor Landi and Luciana Corvini on the case, it was no surprise that the Italian government would single out Giambalvo as the sole villain of baby trafficking. Despite government ministries warning the Church for years that the orphan program did not comply with Italian law; despite the many juvenile court judges concerned about approving these adoptions; despite the protestations of provincial directors of the *brefotrofi*, some, like in Rome, antagonistically "opposed to the foreign adoption placement of children," or others, like the esteemed head in Turin, pleading "to be in a position to contest the argument of some of his colleagues that he places children with families about whom he has no information"; despite all of these red flags, the *New York Times* reported that July: "According to Government sources, only the International Red Cross and the National Catholic Welfare Conference, an organization of the members of the Roman Catholic hierarchy in the United States, are authorized to be instruments in the emigration of Italian orphans." The statement mimics the one Formichi had agreed to months earlier, the article which ISS had planned to pay a reporter to write.

To get a sense of the ways in which the Christian Democratic government accommodated the Church's orphan program, it's helpful to look back exactly one year earlier, in July 1958, to a letter from Monsignor Landi to Monsignor Komora.

> The Italian government is still raising legal questions about the orphan program. Until these are resolved they will not issue any more passports . . . Enclosed is a copy of the memorandum which

the Foreign Affairs Ministry sent to the Ministry of Justice and the reply of the latter. You will note that the reply of the Ministry of Justice is not very favorable to the suggested procedure of the Ministry of Foreign Affairs. For this reason we went to see the head of the Ministry of Justice himself, in the company of a representative of the Pontifical Relief Commission. We found the Minister very sympathetic to the orphan program and he promised to look into the matter himself, personally, and see if a more favorable reply could not be sent to the Ministry of Foreign Affairs.

At the time, the Minister of Justice was Guido Gonella, a former columnist for the Vatican newpaper, *L'Osservatore Romano.*

Once upon a time, before the media described the activities of the Sicilian-born (his birthplace often mentioned) Peter Giambalvo with headlines like, "Black Market in Italian Children" and "They Sell Italian Children"; before the New York district attorney's investigation led to a fifteen-count indictment against Giambalvo for illegally bringing 168 children into the United States; before all of this, Peter Giambalvo had been admired in Italy, the subject of a fawning article in the local newspaper of Cremona, a small town in Lombardy, about his wonderful work in bringing their poor and miserable children to the United States.

The article described the story of Giambalvo adopting his daughter in Italy, and how because of "the man he was" continued to find children for other grateful American couples. And how, "Adoption procedure, as usual, was put to hand by the Catholic Relief Services (National Catholic Welfare Conference) an American Catholic Association with a branch office in Rome and Head Office in New York. It works in strict cooperation with

the Pontifical Relief Committee . . . The organization handles the effective transfer of children from Italy to America and the transport is effected on normal services running regularly from Ciampino airport."

It was such a lovely tale until that great man became known as a merchant of children.

In 1961, when the New York district attorney's indictment of Giambalvo for illegally bringing Italian children to the United States finally went to court, the terrible press about selling children resumed in Italy and America, but this time focused solely on the attorney, photographed wearing a fedora and dark glasses, cigarette in hand. Newspapers proclaimed that with his arrest the black-market ring had been quashed. The Italian government announced its procedures had been changed so that only authorized social agencies could bring children to America. The foreign ministry released a statement saying that all Giambalvo's activities had occurred prior to the government's agreement with the Church and ISS, and that the procedure now in place protected Italian children.

"For the moment," Luciana Corvini wrote to her colleague in New York, "I would say that the declaration made by the Foreign Office to the press should be enough. Let us hope that our Parliament, which should be busy with other matters, will not start asking questions."

One of the social service agencies' knocks against Giambalvo was that he used the system of proxy adoption, which became popular in the 1950s, allowing American citizens to adopt in foreign courts by designating a proxy agent to represent them. (Giambalvo claimed that he worked mainly with the Order Sons of Italy and used the proxy only in a small number of cases.) Directors of the *brefotrofi* sometimes preferred this system,

both because it made the children's passage to America quicker, and because private attorneys were willing to share information about the adoptive homes where the children were placed, information legally necessary for a *brefotrofio* director who was supposed to serve as each child's official guardian, but which the Church refused to reveal.

Social welfare agencies, however, detested the proxy system, which was legal, but prevented the Church and ISS from conducting home studies of potential adoptive parents, opening avenues for abuse. A fair enough point, although leaving a child to linger in an institution for years didn't particularly benefit the child, and neither approach addressed the suspect mechanisms in which these children had been attained. Both the Church and ISS highlighted these home studies to illustrate the superiority of their programs and distinguish themselves from Giambalvo.

But how rigorous were these home studies and what measures did the local Catholic agencies use to assess couples? Applications from prospective Italian-American couples filed with a favorite Church agency, the Angel Guardian Home in Brooklyn, reveal the make-or-break factor the nun's sought for obtaining a child. Dozens of applications reviewed were tersely rejected, the reasons given nearly all the same:

"Civil marriage. No church ceremony."

"Lack of Catholicity."

"No church marriage."

"Extremely lax in their religious obligations."

"Home study completed. Lack of religion."

"For reason of lack of practical Catholicity."

A sixty-year-old husband, a candymaker with two years of education in Italy, and his fifty-three-year-old wife had their application approved, the home study box checked complete. But Sister Mary Augusta of the Angel Guardian Home rejected

another childless Italian-American couple, a thirty-four-year-old bricklayer and his twenty-eight-year-old wife. "Due to lack of practical Catholicity on their part, we cannot recommend an application for the possible adoption of an Italian War orphan." Dated in 1955, this rejection marked a decade since World War II had ended yet somehow Italian women still seemed to be producing war orphans.

Once the child arrived in America, the local Catholic agency assigned to the case had a year to determine if the placement was working before legal adoption. But by then a problematic home spelled disaster for an Italian child. If another family placement couldn't be found immediately, the child was sent to an American institution, as orphan program case notes describe:

"Placed in institution—family could not care for him. Now in institution. Has not forgotten sibling."

"Non-adjustment due to institutional life. Family could not cope with their problem. Both placed in institution."

"Family demanded too much of child, requested his removal—separated from younger brother. Placed in institution and doing well."

"Family returned child day after placement. Child confused. Placed in institution."

"Family requested removal of child after three weeks. Child placed in institution and adjusted well."

But these outlier cases, children of the *brefotrofi* hopelessly cast aside, now outsiders both in Italy and America, did not speak for the overall good work of the orphan program, of which the Church was so proud. The ever-practical Virginia Formichi would fight for its smooth operation and survival—even if that meant working with, of all people, Peter Giambalvo until he, too, had been cast aside. There is no better illustration of the overlap between the work of the Church and that merchant

of children than what Virginia Formichi herself described in a letter to Monsignor Landi during that infamous summer of 1959.

> I wonder if an effort couldn't be made by us State-side to cooperate with Mr. G. I believe that he has a three-fold purpose in his adoption work: (1) the welfare of the children placed, (2) the providing of service to his clients, (3) the earning of a living. None of these purposes are incompatible with his working through CCR [Catholic Committee for Refugees] although with reference to point #3 he would be limited to his fee for the actual adoption proceeding.

> From our point of view, I can see a number of benefits to be derived in collaboration with Mr. G. More and more frequently the social workers return to Rome indicating that the institutions referring children to us are similarly working with Mr. G., and since he is willing to comply with all the requirements of an Italian affiliation (name, address, referrals, etc. for prospective adoptive parents) we are decidedly at a disadvantage. Should he work out the passport situation he would have an open field, and I honestly don't believe that even that POA could deter him. Should he not work out the passport situation, his cooperation with us would obviate his need to proceed on the proxy adoption basis which he has always been so negatively viewed. All of this to make no mention of the advantages that would enure to the orphans if they are placed through qualified agencies. In conclusion, would you, if you think it advisable, speak with Monsignor Komora about the Giambalvo affair?

- 25 -

Tess and Cousin John and Marco, who arrived respectively in Steubenville in March, April, and July of 1959, had been aboard those normal service flights (Pan Am for Tess and Marco, KLM for Cousin John) running regularly from Ciampino airport while the black-market baby scandal in Italy had been brewing and unfolding. Yet the defense mounted by the Church and ISS, already crafted by the time of Marco's arrival, allowed the orphan program not only to survive but to thrive. A record number of babies arrived that year and a steady stream followed, allowing Columbus John to discover America in 1962, and Mary and her brother John in 1968.

Americans adopting children from abroad had become so popular that the government ended the emergency status of the various refugee relief acts, the legal mechanisms allowing children to enter the country throughout the fifties, replacing it with permanent legislation. In September 1961, the United States Congress passed a law, still in place today, that gives foreign children adopted by American couples the classification of an immigrant, one not subject to the country's strict quota system. These little immigrants are considered Americans from the get-go.

By 1963, even Peter Giambalvo was back in the orphan business, wounded, but still trying. Because the proxy adoption system was legal, cases targeting baby exporting rings were hard to convict, allowing him to escape the district attorney's charges against him and possible prison sentencing. Giambalvo now needed to be more creative in his endeavors, and in one case he partnered with a New York travel agency trying to find a way to bring children to America. The owner of the travel agency, pretending to be a prospective adoptive parent, wrote and called an ISS staff member for help in facilitating a passport, explaining that the *brefotrofio* director suggested he do so. When the caseworker discovered this man's impersonation of a potential adoptive parent, he replied that he was just trying to make things easier. The caseworker advised her boss: "You may want to inform the New York State Department of Social Welfare of the fact that Mr. Giambalvo is again active in intercountry adoption work in New York State, and also that in such work one finds the Garone Travel Agency active also." Attached to her memorandum was a list of an additional twelve cases that involved the attorney.

Mary and her brother John were among the last Italian children to enter America through the orphan program in 1968, as the number by then had declined precipitously. Adoption had become more popular in Italy and in 1967 a new law passed allowing younger couples to adopt. Social mores also were changing, lessening the stigma of illegitimacy, and with contraception and abortion soon becoming legal, the population of the *brefotrofi* kept shrinking until the institutions closed in the 1980s.

Today, for all those adopted children in America, the window to find their birth mothers inches further shut each year, the women deep into old age, their offspring approaching this stage

of life. Marco, still searching, has had little success. Yet the traits of the boy remain in the man, photography still a passion, stubbornness a defining feature. Marco digitally modifies photos, blurring and coloring images to create what looks to be part painting, part animated frame. In one, a photograph of a sculpture Marco bought on a vacation, he portrays a ghostly woman, deeply lined, her eyes sealed shut, hands praying. "It depicts my birth mother without any distinct facial features because she is hidden from me," he explained.

I remember Marco's optimism and enthusiasm when we first spoke back in 2017. He was getting ready to petition the courts in Cagliari with John Campitelli's help. He needed first to meet with the Italian Consul General in Detroit to assure her that he could handle the process ahead of him, that he could accept whatever he would learn. "She was the first Sardinian I ever talked to," he recounted with delight.

The years passed. I occasionally texted Marco but he had no news. One day the court informed him that no files or information about his birth mother could be located. He refused to accept this information as a final answer: "I am hardheaded, there must be a file."

Six months later Marco learned that a box in a corner of a room seemed to have turned up. With this new information in hand, John Campitelli petitioned the courts to reopen the case. They informed him that a court-appointed social worker would be sent to find Marco's birth mother. Then more months of silence until the spring of 2021, two weeks before Marco's birthday in April, still for him the cruelest month.

His screen lit up with a WhatsApp message from John Campitelli. Marco knew it had to be about his birth mother and was struck by the timing. But despite his earlier assurances to the Consul General, Marco wasn't prepared for the text he

would read. "They found your mother," John told him. "She is alive, but not only does she not want to give up her anonymity, she vehemently denies having a child on that date."

"Next year my birthday will be better," Marco tells me with trademark black humor, "I won't have the guilt of having killed my mother."

John Campitelli, too, was perplexed. In all his years of aiding adoptee searches, this type of scenario had happened only once or twice. John didn't speak to the social worker who reported this information but learned that she went to the woman's home and asked if she had given birth to a child on April 27, 1957, presenting the birth certificate with the woman's name on it. The woman responded that she never gave birth on that day, someone gave false generalities, that is, gave her name but it wasn't her. "How do you dispute that?" John asks. Marco was born in a private home, obligating the midwife to file a report. "If that woman gave the name of someone else, who is to tell? If that name is false, who could check?"

Could this possibly be true or was it a dodge by a frightened old woman who opened the door to an official person sent by the courts? John had once encountered a birth mother who denied the facts of a birth certificate presented to her. The woman, raped by a family member, had erased all memory of the trauma.

John suggested the woman take a DNA test but the court replied that there is no legal basis to ask for this information. In a paternity case a DNA sample could be requested but maternity cannot be challenged. The father can be anyone; the mother is always certain. Unless you are Marco, still trying to make sense of how he came into this world.

Marco now is left in the macabre position of needing to wait until the woman who may be his birth mother dies before he can

petition the court for information about her. He's made peace, more or less, with never being able to see or to touch the woman who brought him into the world, but still he holds out hope to one day meet a sibling, or an aunt or uncle, or a first cousin. As Marco and Tess, both members of the can opener school, sought out their birth mothers and were denied the chance to meet them, I asked each, after all they have been through, how they view the choices they made and think about their life as an adopted child today.

"I have the strongest urge at times," says Marco "to go and live in Sardinia where I belong. You know how some say you don't feel like you belong, I have always felt that—the 'I don't belong' part too. I was fortunate because my parents were awesome, they had large families, Lebanese, Syrian, Italian, but there's still that thing over here dragging. I want to know my family. I want to go to Sardinia. If I had the money and spoke Italian, I'd probably go tomorrow." One of Marco's four children has promised his father that one day he is going to have a place in Sardinia and he will take Marco there.

And Tess: "I feel like I've done as much as I can to establish my identity of who I was and who I was supposed to be, which is how I like to term it. I am who I am now, and everything that happened to me has shaped who I am. I know Mary talks a lot about a primal wound and I do still struggle with that every once in a while, that was a primal rejection, whether it was forced or whether it was voluntary. When you hold that baby, you can't imagine ever giving that baby up to strangers and it feels literally like a primal rejection, and I feel like I never really got over that. I have been a people pleaser all my life and I twist myself into pretzels to try to keep everyone around me happy and I don't want to make anybody mad.

"But I don't have the anger and confusion I used to have

around the subject, at least now I've made peace with what has happened. I'm still trying to figure out how to be in the world, at sixty-two I'm still trying to figure it out. But I feel I've made much more peace with it than I ever expected to. And I think that comes from just wanting to move on. I've wrestled with it long enough. When you look at adoption, it's almost barbaric because you're taking a baby and you're putting it into another situation and you're closing the door behind it and it can't find out what its health records are, what its family history is, what kind of people that it came from, it's artificially now in this new family. The mother has a right to her privacy, if she wants it, but don't I have a right to know who I am?"

Part Five
The Genealogist and the Priest

- 26 -

I am back at John Campitelli's apartment, measuring time. Three years have passed since I first sat in this living room. The floor space has doubled in size and the apartment addition is complete—and the family takes up every inch of it. Clothes and shoes and bags clutter a portion of the living room floor, remnants of their recent return from Greece. The vacation marked the family's first time back since John had introduced himself to me, sending a photo with the Parthenon behind him. When I looked at that picture again and noticed John was wearing a white T-shirt beneath a black polo and black jacket, creating the look of clerical garb, I realized that my first impression of him, the priest comparison, had primarily been formed by a trick of the eye.

The renovated space tells time's transformations. His daughters, fourteen and fifteen, no longer share a small bedroom, having grown from tweens to high school students. Jars of pastel-colored bath bombs replace the rabbit in his bathroom cage. The oldest, he says, mostly likes spending time with her boyfriend these days, her younger sister eager to start high school in the fall.

We settle into two large leather chairs; the couch and Hello

Kitty accent pillow have also disappeared. The air is silent, absent the cheerful buzz of my first visit, as Simona and the girls have gone to the mountains for the late summer weekend. Soon we weave back to John's childhood, resuming the conversation begun at lunch in the garden of a local restaurant, for no matter how old we are our childhoods always remain within our reach.

His is weightily documented. John hands me a huge three-ring black notebook spreading three inches wide. The book contains every document he has compiled in the search for his mother. "It's like *War and Peace*," I joke, gaging its heft. An apt title, I realize, as it rests in my hands, the sheaves of paper marking each painstaking step of interior struggle and path toward resolution to discover and visualize his hidden past.

"Yes, it was years and years of research. Trying to find your birth parents is not easy."

The book opens to a map of Italy centering on Turin. There is a page of photocopied postcards, a collage of the city's architectural treasures. There is an enlarged city map that marks the distance between Sant'Anna Hospital, the place of John's birth, to the *brefotrofio* where he would be raised for the next two years. There are hospital records that report his mother's temperature from the moment John was born, at 5:45 a.m. September 23rd, until she left the hospital on September 27th. There is a piece of paper that details the grams of breast milk she exported, as if he could bottle these meager drops of her love. There is the birth certificate that veils Francesca as a *donna che non consente di essere nominata*. There is the consent form that states the minor's parents abandoned him since birth and that their whereabouts are unknown.

There is the social worker's case report that extinguishes the truth of Francesca's suffering to meet the orphan program's ideology: "She had no interest in her little son, because born of

a father with whom she had never any affectionate ties, and she felt she had to abandon him out of consideration towards her own family. She intended to leave Turin and to return to her family in the South. Since that time nobody had ever inquired about little Piero, not even his maternal aunt who resides in Turin."

Another neatly constructed lie, as Francesca stayed in Turin during those two long years, continuing to return to the Institute's gates in the hopes of getting her son back until the mother superior finally told her, "Make peace, woman. Your child has been sent to America. He is with a good family." Words said while little Piero was right inside those gates, an image that still haunts John, the idea that he might have been playing on the grass before his mother's eyes while she was being banished from the grounds.

The fairy tale report continued with a section on Piero: "He is already able to remain seated in a small chair for a few hours; he likes being in the small chair, and he enjoys rocking himself in it . . . to increase the movement of the rocking he pushes more and more energetically with his feet . . . The sister in charge says that he is an easily led child, that the institutional environment does not bear too negatively on his development, nor does he seem frustrated by the absence of a maternal figure."

There are photographs John found of the woman assigned to accompany him on his international journey on April 23, 1965 (a TWA stenographer named Amores Santolini), two days after the toddler had been escorted from Turin to Rome. Santolini took dictation and answered calls for her sales supervisor boss when she wasn't being asked to comfort an orphan toddler and change diapers on the plane.

With each turned page the years pass. A letter from Barbara and Russell Campitelli dated September 25, 1990, begins "Dear

Dot," addressed to the woman from the local Catholic agency who helped arrange the adoptions of their four children. Twenty-seven years after John's birth, they ask for her help in finding information about their son's origins. The date of the letter corresponds to Barbara's sharp memory at the age of ninety. She had told me that John called them one Labor Day weekend when he was in his twenties asking their permission to search for his birth mom, the couple never knowing about his childhood endeavors. By the end of the month, they were composing this letter, affecting in how it illustrates Barbara and Russell's willingness to help, but with a slight, and natural, defensiveness of an adoptive parent, as well as containing information that reveals the seeds of the tragedy that would befall Paul and David seven years later.

We are writing because there comes a time when adoptees want to have information about their genetic histories. For our family that time has arrived and is beginning to be aggressively pursued.

First of all, we want you to know that John and Sara are very well-adjusted and happy people. Both have had successful school careers and are looking forward to bright futures. David and Paul, the identical twins have had difficulty in school from the first grade through high school which they never completed. For the past fifteen years, they both have been working in Florence at the Central Food Market and during the past three years they have become alcoholic. There is some feeling that they may have fetal alcohol syndrome because of their behavior over the years (Of course, this is something completely unknown in their younger days.)

When we adopted, no information was given to us. It worked out well for John and Sara who had no problems. But in the case of Paul

and David information might have helped us to understand them better and have expectations for them within their capacities. We are sending a letter to the institution in Turin, Italy, informing them that we give our utmost approval and support to our children in their search for the particulars of their backgrounds.

Their words made no difference to the authorities in Turin, but John intuited at an early age that he'd have to persevere using his wits. And the boy grew into a man who today has a much more effective instrument in his arsenal, one which he believes will solve the mystery of closed adoptions and anonymous surrenders.

In Flaubert's creation of one of literature's most famous adulteresses, whose moral transgressions and spendthrift ways lead to her suicide and family financial ruin, the author (whose prose led to his trial for obscenity), poked fun at the social and religious order of his day. Through two sparring characters, the pharmacist and the priest, the novelist cheekily voiced the clash between the nascent values of Enlightenment rationalism and Christian dogma. The pharmacist, supplier of the villagers' medicines, judges himself a "believer in progress," while the priest, keeper of their souls, deems, "We're born to suffer, as St Paul says." The pharmacist scours for news of all the latest scientific developments, while the priest sends Madame Bovary a copy of *The Errors of Voltaire*. Their quarrels continue to the book's conclusion when the two men are left to disagree over the poor dead body of Emma Bovary. Exhausting themselves, both nod off beside her coffin, and when they awaken the pharmacist spreads a little chlorine on the floor while the priest sprinkles some holy water around the room.

The novelist, born in 1821, might have imagined that two

hundred years later the discourse would have evolved at least a bit further, that perhaps we would be humble enough to acknowledge the limits of progress and humane enough to seek to ameliorate inevitable human suffering. Yet still the camps remain divided as ever, the innermost fabric of our lives, and our choices, determined by who holds the reins of political power.

In the land of adoption rights, amid the debate of whether to open the long-sealed records of the orphan program, today it is the genealogist who challenges the priest. While the priest insists that no link to the past can exist, the genealogist, avowing the Enlightenment belief in individual rights, seeks his identity lost at birth. The genealogist contests the priest's assertion of orphans offered in Christian fashion and instead places his faith in human progress, turning to science for answers when institutions refuse to cooperate.

"He'll never figure it out," Virginia Formichi responded to John Campitelli's quest to link adoptees to birth mothers. "Those documents are closed."

Yet he is figuring it out, slowly and painstakingly. Genealogy has turned secrecy on its head. The DNA testing services Ancestry and 23andMe have thirty-two million profiles between them, with Ancestry boasting one hundred million family trees. Genetic genealogists, who use DNA to find biological families, are making significant discoveries from these fast-growing databases. A study published in 2018 in the journal Science revealed that sixty percent of Americans of Northern European descent could be identified through genetic databases, whether or not they had taken a DNA test; its author predicted the number to soar to ninety percent in just a few years.

Inexpensive spit-in-a-vial kits undertaken in the privacy of one's own home are unlocking the secrets of closed adoptions,

and in the case of forced adoptions revealing appalling societal truths of women across the globe who had lost their babies because they violated religious and social conventions, were pawns of dictatorships, or seen as vessels giving birth to an inferior race. Over the past decades national governments or the Catholic Church in Ireland, England, Wales, Canada, Scotland, New Zealand, and Australia have offered apologies for the treatment of unwed mothers and forced adoptions.

Children conceived by sperm donors, too, are seeking answers or have been confronted with long-hidden family secrets, each new fact upending people's sense of who they are and what a blood tie means. One young man conceived by using a sperm donor discovered that he had thirty-two half siblings and questioned in an essay for the *New York Times Magazine* whether his mothers, focused on the family they were creating, ever considered "the implications of the huge, inadvertent social experiment they were joining." The Italian children from the orphan program face the uneasy truth of having been part of a religious and social vision that punished sinful mothers and pardoned irresponsible fathers, their offspring sent to foreign couples of proven Catholic faith.

John urges every adoptee who petitions the Italian courts to take a DNA test. The results rarely yield a birth mother or immediate relative. Most people find the closest relatives to be second cousins. It takes a highly skilled person to create a family tree leading to a birth parent from the matches testing services provide. The genetic genealogist must move backward in time, looking for a common ancestor like a great-grandparent, building connections from this distant information. But it is a puzzle that the boy who read Sherlock Holmes enjoys tackling in his middle age.

Once John receives the sequenced genome, he looks for the

centiMorgans, known as cMs, the units for measuring genetic linkage. "Perfect strangers take a test and through the centiMorgans, which is the genetic distance between two people, you can see how many matches they have across all twenty-three chromosomes," he explains. These services have developed a table to calculate family relationships, for example, 1,500 or 1,600 cM's signal a half-sibling, while full siblings share about 2,300. John has conducted successful searches for birth mothers from the genetic distance of third cousins, applying his investigative skills and knowledge of public records to link far-off families.

John believes that genetic advances will make Italy's law of anonymous surrender irrelevant in the twenty-first century, its secrecy obsolete. Like those nineteenth-century reformers who campaigned to close the system of the *ruota*, John argues that anonymous births have delegitimized the responsibility of father and mother to the child whom they have conceived, a position that differs from some of his fellow adoption rights advocates in Italy who sense the country still is not ready to abandon a law birthed in the Middle Ages, even if the number of anonymous surrenders today is very small.

Activists often are born of women and men who challenge the institutions and societal acquiescence that changed the course of their lives, seeking some form of personal resolution and hoping to help others. Ever since John's permanent return to Italy in 1999, he has used his computer (and later genetic tracing) skills not only to assist the growing network of Italian-American adoptees like himself, but the far larger group of Italian adoptees. They have been fighting to change the current law, which states that records must remain sealed for one hundred years. Although progress has been made with individual judges, some amenable to opening records once the adopted child has turned eighteen, still a piecemeal system

exists, with twenty-nine tribunals holding differing points of view. The advocates continue to press for a national law that can address the needs and scientific advances of twenty-first century life.

Despite the many decades that John has lived in Italy, at heart his vision of adoption rights is an American one. His ideas have been shaped and fortified by his university and young adult years in the States and the radical actions in the seventies of Florence Fisher, who helped create an adoption movement that heralded each child's right, once they turned eighteen, to have access to sealed birth records. John believes that this desire toward a deeper understanding of self and quest to heal a thrumming sense of loss, which propel many adopted children to seek their birth parents, is not an abdication of loyalty or love to adoptive parents, but a basic human response to the unresolved absence of the woman who brought her child into the world.

- 27 -

"No, no, I can't. My father will kill me, my brother will kill me," a nanny from the Turin *brefotrofio* named Feliciana remembers her friend telling her. What a beautiful boy, what a sad story, the nanny said, shaking her head as she recalled the conversation. When they met again the woman's eyes averted Feliciana's. Another crib added to the crowded institution. Comparably, an Irish woman looking back on her country's legacy of Magdalene Laundries and falsification of birth certificates to make adoptive parents appear to be biological ones, acts for which the government has since apologized, explained to the *New York Times*: "In Ireland you would be better off saying you murdered someone than to say you were single and pregnant in 1966 because they'd tell you that no one would have you as a woman. If you tried to keep the baby you were told you were selfish, that it was a stigma, didn't the baby have a right to have two parents?"

But this community wager never considered the loss that would always remain present for mother and child. Ambiguous loss is the term coined by social scientist Pauline Boss to describe the ghostly shadow cast by loss without closure. "How do I answer how many children I have when I gave one up for

adoption?" is a question she posed in her book of the same name, which explored the psychological and physical toll of unresolved loss on people's lives, a grief Boss argues that passes through generations.

The mother's sorrow of losing her living child. The shivering sensation of being told, as Francesca was, that her baby had left for America, the gates of the *brefotrofio* now forever closed; the grief for Lia Maria, with such vague notions of the vast country she feared her twins had died on September 11th; and for Tonia, who didn't even know what continent Sara lived on.

The child's sorrow of losing a living mother. The seedlings of this loss prodding an eleven-year-old John Campitelli to head to the Florence train station to telephone strangers in Turin named Davi. Its mature growth provoking a middle-aged Sara to travel to Puglia to sit across from the man whom she believes to be her birth father, the man who refuses to acknowledge her existence as part of his own. Its tangled offshoots spreading to the outdoor café in Turin where Rosalba rolled slender cigarette after cigarette recounting life as the second daughter, living in the shadow of her absent older sister Sara, the little girl trying to make sense of the rage flashing in her mother's eyes that felt like a thousand poison darts aimed at her.

One of life's more vexing labors is acquiring the dexterity necessary to navigate its labyrinth of many valid truths. Desires compete, chafing the fabric of our lives and others. Unresolvable questions inevitably arise, yet each person's needs remain worthy of the space of our imagination. Adoption lays bare this thorny reality.

The yearnings of the couple who have tried for years to conceive a child, who may have suffered miscarriage or still birth, who today may endeavor upon a range of hormonal

injections or surgical procedures that fail to produce a viable embryo, are profound and sorrow-filled. Sometimes society, however, privileges the needs of the adoptive parents by villainizing or tucking away the story of the birth mother. It's simpler to remove her from the picture, replaced by the more heroic narrative of rescuing an abandoned child: the adoptive parents selfless, the birth mother selfish. The mother might be viewed as a sum of her bad decisions or simply as a ghost, easier to erase than to imagine.

To place your own needs into the lacuna of her story is a subjectivity that I once experienced. At the time, two decades ago, our son was a toddler and the joy of raising him had transformed me from a woman who once considered not having children to one who was considering another. I was thinking about Cousin John's successful adoption and wondering whether such an arrangement could still be possible.

I had been thinking a lot about Cousin John for another reason. After the birth of our son, I discovered that I shared a strong genetic connection with his mother Betty. I had suffered a pregnancy illness that almost cost me my life, a severe form of preeclampsia called the HELLP syndrome, which stands for hemolysis, elevated liver enzymes, low platelet count. This meant that at thirty-four and one-half weeks pregnant, I woke up one morning with slimy clots of blood nestled along my gums; fingering them, tired and confused, I thought I had been eating grapes, and by evening was in a hospital operating room for an emergency C-section, a nurse asking if I wanted to see a priest. There was no choice but to operate, even if my blood wasn't clotting properly, to save me and my baby. My blood pressure was soaring, and my liver and kidneys were shutting down, all part of this syndrome.

After this life-changing incident, I learned that Betty also

had suffered from preeclampsia, her sister from the full-blown seizures of eclampsia, along with my aunt or our grandmother, Betty's story grew unclear. Betty was the one woman in our family cluster who couldn't carry a pregnancy to term because of the condition and after multiple miscarriages the couple decided to adopt. The phone conversation in which Betty shared her story was the closest I ever felt to my first cousin, a Midwestern woman thirty-five years my senior, recounting the sadness of her reproductive years. These were family secrets buried by time now being passed along to me, the latest carrier. Women by nature look to their mothers to illuminate the mysteries of childbearing like spring buds open to cloudless skies; never did I imagine inheriting a pregnancy illness from my father.

I considered getting pregnant again (even if my doctor's partner advised, "Whatever you do, don't ever get pregnant again"), but ambivalence pulsed as strongly as the urge. I already was an older mother, thirty-eight when our son was born, and not only did I fear for my life, despite specialists' assurances that they would be closely monitoring me, or a prospect of spending months away from our boy on hospital bedrest, I didn't want to risk another premature delivery, which is the only course available if preeclampsia develops. We'd been lucky once and I was aware of a range of problems prematurity can cause. Having grown up with a sibling with an intellectual disability, I lived with grief over his condition, along with the constant fighting and diminished lives his disability brought upon our entire family.

It was at this juncture that my husband and I flirted with the idea of adoption. My mind drifted to Southern Italy (not knowing my cousin had been adopted from Turin), imagining a baby who might share my dark hair and eyes, who came from a cultural heritage from which my family had been separated

nearly a century ago. A line of thinking and lack of questioning that mimicked the Italian-American couples from the fifties and sixties whose applications for adoption I would one day read in the archives of the orphan program.

I entertained this fantasy long enough to have mentioned it to a therapist I was seeing (the couples I later read about in the files had sought the guidance of priests) and she encouraged me to pursue the idea. Her words must have broken the spell because I remember saying aloud, Italy is no longer a poor country. Italians don't give up their babies for foreign adoption.

My thoughts then shifted to Central America, another possibility for a dark-haired girl with vague cultural similarities, but ultimately, we decided not to pursue this course. My husband and I came to understand that the shape of our family, a triangle not a square, was one that fit us best. I'd like to believe that if we had pursued this idea, I would have begun to think about the birth mother and considered an open adoption, in which the files are voluntarily made available to each person involved.

I'd like to believe that I would have learned the social workers' maxim that adoption is about finding parents for children, rather than children for parents. A maxim I'd one day read in the files of the International Social Service agency during the orphan program: an assistant director relayed her concerns about a social worker's remark that "Mrs. T. [Jolanda Torraca] would like to give us babies."

"You know how strongly I had felt from the beginning of the enlarged programme," she wrote, "that we should not put ourselves in a position of seeming to be looking about in Europe for children for American parents such as was done by American agencies in the years following the war. . . . I think it is very important that we all continue to bear in mind that the major focus must be to find parents for children for whom

suitable plans cannot be made in their own country rather than children for parents."

A worthy goal, yet the circular logic of this adoption maxim leads to its own tautological challenges, as Natalia Ginzburg pointed out in her last book, *Serena Cruz or the Meaning of True Justice.*

> *Give a family to a child and not a child to a family.* Obviously. However, when a child is adopted, his destiny is at once linked to the destiny of those who adopt him. If they love him and are happy with him, then the child is happy with them too. Well-being, in its universal and actual sense, meaning harmony and mutual understanding, cannot help but be mutual. Once the adoption takes place, the child and the family become one unit. So if one really thinks about it, that seemingly very obvious sentence makes no sense at all.

I'd like to believe that I could have tolerated the ambiguity of including the birth mother in the family narrative, of facing the findings of research, as Pauline Boss noted, that the birth mother is kept psychologically present both by the adopted child and the adoptive mother. But not having considered adoption's complicated dimensions, this drifting balloon had been filled solely with the breath of my own desire.

Looking back on that time, I wonder how much of my thinking had been influenced by the small cuts of social opprobrium that sliced through the comments of acquaintances, draining a sense of what made sense for us. "Just the one?" was a question asked so many times I wanted to scream. Or being told stories of an adult's selfish behavior with the tagline, well, he was an only child. Or standing at a child's birthday party making small talk with a mother I knew from the playground. A cake of sculpturesque splendor had just been sliced, and as I put

forkfuls of gooey icing into my mouth, she rubbed her free hand on her belly as if it were Aladdin's lamp. Her bump was still small, and she wanted to tell me that she was pregnant again. "My husband says that now we will be a family." Her words sickened me more than all the sugar I'd consumed that afternoon. No one had informed me until that moment that four was the magic number that defined a family.

Family needs are fierce and can lead to fierce thinking. Margaret Moorman gave up her baby for adoption as a teenager in the sixties and in 1998 published a wrenching memoir about the experience, *Waiting to Forget*, which shatters the notion of adoption as a woman's easy alternative to an unintended pregnancy. She captured the selective gaze that can affect couples seeking to adopt, citing an article called "Baby Hunt," in which a magazine editor shared her strategies for finding a child: "We buy a guide to colleges and choose places with the best adoption laws and strongest anti-abortion sentiment. That means Bible Belt States, where religion or economics would favor a girl carrying to term—ironic for a pro-choice couple." Remarked Moorman: "I thought of a friend of mine who said, 'Adoption would be a feminist issue if the feminists weren't doing the adopting.'"

At the height of Florence Fisher's renown in the adoption movement, a magazine editor assigned Moorman to write a story about the group she founded, the Adoptees' Liberty Movement Association. Sitting in Fisher's office, Moorman learned about the registry ALMA had created for adoptees and birth families hoping to find each other, leafed through photographs documenting successful searches, and listened to Fisher tell the story of her adoption and difficult hunt for her biological parents. Fisher then paused and pointed to the rows and rows of tall file cabinets that filled the room.

"You know what's in those files?" Fisher asked. "Pain. *Pain.* That's what's in those files."

My husband and I have just finished watching "True Mothers," a 2020 film by Naomi Kawase, based on the novel by Mizuki Tsujimura. It's a beautiful film, the director conveying with delicate touch the oppressive weight of natural yet competing desires. I email a Japanese friend to tell her how the film moved me and she responds that the original title translates as "Morning is Coming." You could consider morning as the future, she writes from Tokyo, the idea that there is no night without morning. A title too abstract, I think, for an American audience.

The film depicts a thoughtful and loving couple, who after much emotional and physical distress from failing to conceive decide to adopt. They come across a nonprofit adoption agency called Baby Baton, whose director informs a roomful of couples seeking the same path, "Baby Baton is not a place where parents find their children. It's a place where children find their parents." The adoption maxim, crossing continents and time, resonates with the husband, who suffers from azoospermia, the condition of having no sperm in the semen, and he suggests to his wife that they might be worthy parents for a child who is looking for them.

When the joyful day to receive the baby arrives, Baby Baton's director asks the couple if they would like to meet the birth mother. With trepidation they agree and are brought to the room where a teenaged mother waits. She bows, sobs in sorrow, and clutches the hands of the adoptive mother, passing along a letter that she has written to her son.

Flashbacks tell her story. She is a naïve diligent school-girl who had experienced her first love before getting her first

period, discovering the pregnancy too late for any option but to give birth. Her parents, mortified by what has happened and what the neighbors will think, direct every decision, never asking how she is doing or what she would like to do. Despite the parents' careful plans to reboot their daughter's life, they can no longer make her fit into the dimensions they have drawn—a quick return to school after she has been made to disappear, rigorous study for a competitive high school entrance exam. Their girl can no longer perform for them, she has been broken. She leaves the family home, a once-promising life reduced to peddling a bicycle to deliver newspapers.

The possibility of some kind of emotional resolution is held in the response of the adoptive mother. She will encounter this damaged girl who threatens her family's stability. Yet she comes to understand her son must know that he has two mothers, both true mothers, the one who raises him and the one who gave birth to him.

Kawase's nuanced treatment of adoption's perilous emotional terrain, her choice of details, the adoptive mother singing lyrics of devotion to her son as he brushes his teeth, the same song his birth mother once whispered as he stirred in her belly, is heart-breaking to watch, each mother's valid truth laid bare, the trans-forming love of raising him, the cruelty of relinquishing him to strangers. As the credits rolled, my husband and I, emotionally spent, sat in silence. He turned to me and said, maybe adoption should be thought of more like a transplant. A heart transplant, we considered, but recognized the trouble with this metaphor as the heart comes from a living woman.

- 28 -

"I am a Catholic," the surrender form began. Words reminding her who she was and how far she had fallen. "I sign the present document of my own free will without any compulsion or coercion." Did she hold pen to paper with shaking hands? Could she comprehend the pages of legalese before her? Was her signature any choice at all, or the response to centuries' worth of stimuli—sermons, liturgy, icons, hymns—a call to her faith, family, ancestresses? Imagine a favorite symphony that you could never recollect on your own, but once the music plays you are humming the opening of the next movement in the silence of the orchestral pause. The chords have been registered into the depths of your soul. Who composes the music that determines the most intimate decisions of a woman's life, whose voices are ultimately heard?

In Enrique Vila-Matas's novel *The Illogic of Kassel*, a narrator resembling the Spanish author recalls his last visit "to the wonderful city of Turin in northern Italy. I'd been struck by how contained and elegant that place was—actually a French city, due to the long shadow of the House of Savoy. Etched in my memory was the serenity of its daily life, which one sensed

as a dangerous creator of unexpected absurdities." Vila-Matas continues: "The great Italo Calvino, Turinese by adoption, saw in this perfect, geometric city an invitation to logic. 'Turin is a city that entices a writer toward vigor, linearity, style,' he wrote. 'It invites logic, and through logic opens the way toward madness.'"

These descriptions came to mind as I looked back on the two long decades of the orphan program and the importance of this logical city, cultivated by the tree-lined design of Napoleonic rule, to its success, supplying one-third of all the babies to America. Madness and absurdities had coursed through the veins of the entire country during this fervent time—nuns in Bergamo leading young mothers to mourn at fake graves, Milanese social workers shuffling babies to the lakes of Cannobio far away from the pesky interference of birth mothers, Trans World Airline stenographers recruited in Rome as escorts for toddlers on endless piston engine flights. Yet Turin, "industrious and rational Turin," to borrow again from Calvino, delivered the product best.

Verdant grounds and the warble of birdsong outside the institute, nannies cloistered and disinfected by infrared shower within; babies whose temperatures and feces were inspected daily, toddlers made to sit idly for hours in chairs rocking with unbridled ferocity ("he enjoys rocking himself," as the social worker wrote of John Campitelli's toddler years, and "to increase the movement of the rocking he pushes more and more energetically with his feet"). After being selected for America, the children were shepherded to Genoa for medical examinations and visas, later placed on economical overnight trains to Rome where they would meet other children, arriving from the connected arteries of *brefotrofi* in the north, south, east, and west. Together they spent their last night in Italy at a convent

run by friars, which charged the Church for the rooms. The next day the orphan program staff cleaned up the kids and handed medication to the adult escorts to give to the children for the long flight ahead, followed by their first night in New York at the louche Chelsea Hotel where they roomed near adults who probably had their own stash of drugs the night before. All those crazy logistics, all those lies, all to take babies out of the arms of unwed mothers. The logic of illogic.

It would be convenient to believe that the orphan program, along with the tens of thousands of anonymously surrendered children who remained in Italy during that time, was an aberration, a frantic response to the shifting social landscape that emerged from the ashes of World War II. And that we, twenty-first century people, know better. The orphan program, however, never was an aberration but a refinement of the turning medieval Italian invention of the *ruota* combined with a modern American one, the Wright brothers flying machine. An updated version of an ancient idea: abandonment as antidote to female sin, institutional life, and up, up, and away, as the old TWA slogan went. Without doubt, adoption improved the life once destined for illegitimate children, rescued from the bleakness of the institution, or being farmed to a wet nurse in the countryside as in the old days, but the moral penalty and emotional suffering a woman had to endure, as well as the child's loss, now a societal orphan, remained.

So perhaps madness existed, too, in the confidence of modern women, a rosy glow now pallid and sagged, that freedoms secured would be everlasting. The circle continues, and its perfect symbol, the wheel, is back. The *ruota*, transformed into the *culla per la vita*, cradle for life, has been installed in about fifty places throughout Italy. When this project began in 2006,

WIRED Magazine described how a "high-tech cradle for found-lings" had been resurrected from its medieval forebear.

The cradles are the handiwork of the group Movement for Life, whose website tells its own version of history, that the *ruota* saved, not ended through starvation and disease, the lives of children for multiple centuries. The group, touting its new *ruota*, changed the language of "abandoned" to "entrusted," which critics charged was not about helping infants since no one was using these boxes, but part of the movement's true agenda to end the right to legal abortion in Italy. A cradle for life sat empty in Genoa for fourteen years. The first baby to be abandoned (um, entrusted) into the mechanism was in 2021; the group cooed over the life saved.

On Easter Day in 2023, a mother anonymously surrendered her newborn to Milan's *culla per la vita*, near where the ancient *ruota* once stood. The mother included a letter written in her baby's voice (her chosen name for him referenced Aeneas, the mythical hero of Troy): "Hi, my name is Enea. I was born in the hospital because my mom wanted to be sure everything was ok and to be together as much as possible." This Italian Easter story, which quickly spread throughout the country, fit not only the Vatican message of the "culture of life," but Prime Minister Giorgia Meloni's call for "*Dio, patria, e famiglia*," a motto with its roots, like her hard-right party the Brothers of Italy, in the country's Fascist past.

The twenty-first century desperate mother can now push a button that opens a metal flap releasing a small crib and setting off an alarm to notify social workers on twenty-four-hour call. Once the mother places her baby inside, a weight-triggered sensor sounds another signal notifying an ambulance and acti-vating a warming device. As in the turn of the ancient wheel, the baby she has nurtured inside her womb, whom she has brought

into this world through great pain and suffering, will disappear moments after her hands have secured the tiny body inside the rectangular box, buried forever from her reach. Technology upgraded the physical environment, but can you reboot the cognitive sensations of that irrevocable act? If the wounds of anonymous surrender do not abate through the centuries, but intensify with a modern self-awareness, then these boxes seem more medieval torture machine, refreshed by an industrious and rational design, than form of salvation, their re-creation the kind of logic that opens the way toward madness.

And the wheel kept on turning. The year 2016 marked its maiden voyage to the New World, more than a half-century after the children of the *brefotrofi* had their paths charted by the Vatican and the American Catholic Church. An Indiana resident named Monica Kelsey, herself an abandoned infant, introduced the idea to America without knowing its medieval Italian roots. She saw this type of device in Cape Town, South Africa, three years prior, where she had been invited to give an abstinence talk at a church. Deciding to bring a version to the United States, she named them "safe haven baby boxes." Etched onto each unit's interior hatch is the motto SAVING BABIES ONE BOX AT A TIME.

These boxes, like the cradles for life, are temperature controlled, automatically lock once the baby has been surrendered, and an alarm system, like the ancient bell, alerts a fireman to arrive and take the infant to a social service agency. On a website promoting safe haven baby boxes, a prominent picture of a girl in a sweatshirt, her face hidden by a dark hoodie as if she were a criminal, clandestinely deposits her baby into the slot. Today, about one hundred and fifty safe haven baby boxes exist in America—and the number keeps growing, which is to be expected after a Catholic majority of Supreme Court justices decided to set the moral boundaries of a woman's life.

In the fall of 2022, as women were still in those early months of dazed disbelief over the decision to overturn *Roe v. Wade*, a local Ohio television reporter stood in front of one of the state's eight installed safe haven baby boxes in the city of Troy. Her plaintive expression belied her breezy demeanor and the cheery chartreuse dress that she had chosen that morning for the camera. The reporter's concern did not stem from a sadness at the idea that a mother would dispose of a newborn in such a fashion. In fact, quite the opposite: It arose over a strong trepidation that mothers were being *prevented* from abandoning their newborns after a citizen's complaint to the state health department charged that the box failed to comply with necessary codes.

Dispatched to this site by a station owned and operated by the conservative Sinclair Broadcast Group, the reporter defended, like a modern-day Aeneas, the city of Troy's right to have a baby box: "It is *so* easy to use. All parents have to do is come in, open this lever here and place the baby inside an environment that is temperature-controlled, and there's air flowing. Now once this lever over here is pulled, 911 is immediately dialed, and law enforcement comes here to this location to pick up the child and take it to the area hospital."

The desperate and once criminal act to abandon a child has been turned into a good thing as the anti-abortion movement races to install safe haven baby boxes across the country. The Ohio Department of Health green-lit the Troy baby box a mere three days after the Supreme Court overturned *Roe* with its *Dobbs v. Jackson Women's Health Organization* decision. Print and broadcast media spread the word of the public abandonment of a baby like celebratory national birth announcements: "A Kentucky infant last week became the first in the state to be left at a 'baby box' under a new state law

permitting the anonymous drop-off of newborns," the *New York Post* declared in February 2023, the story also reported by CNN, CBS, and, of course, Fox News. A Minnesota-based attorney named Greg Luce, who founded the Adoptee Rights Law Center, told me, "There is no one to stop them. There really is no one to stop them," repeating his words in disbelief over what he has witnessed. Controlling the debate by declaring that a baby could die without the presence of one of these "newborn safety devices," the right is readying for a future where fire station baby boxes are as common as hose and ladder.

This is the *ruota*'s most astonishing turn—that it has been brought into the lives of all American women. In Justice Samuel Alito's opinion to overturn *Roe*, he cited certain "modern" developments that obviate the need for abortion. The judge included on his list "that States have increasingly adopted 'safe haven' laws, which generally allow women to drop off babies anonymously." In either an aggressively America-first worldview or an Orwellian "war is peace, ignorance is strength" turn of phrase, Justice Alito did not acknowledge, or was unaware of, the roots of anonymous surrender planted in thirteenth-century Italy. Rather, he credited this "modern" development to the country's first "safe haven" law, also known as the "Baby Moses" law, passed in Texas in 1999 and signed by Governor George W. Bush.

The idea behind safe haven laws was to stop maternal infanticide, the extraordinarily rare, headline-grabbing story of a newborn found in a garbage can. The movement quickly gained steam after the Texas law passed and by the next decade safe havens would become law in all fifty states. Legislators approved them rapidly, often with bipartisan support and little inquiry into the long-term consequences of anonymous abandonment

on birth mothers and their children, and in all likelihood without an understanding of how anonymous surrender had been used historically to control the reproductive behavior of women. In several states, Planned Parenthood and NOW added a collaborative voice, joining their usual adversaries.

One of the few people back then to question this near-unanimous fervor was Carol Sanger, a Columbia University law professor specializing in reproductive rights. Her journey to understand what was happening in state legislatures began, of all places, on a New Jersey Transit train. Looking out the window, she encountered a billboard emblazoned with the words NO SHAME. NO BLAME. NO NAMES, accompanied by an 800-hotline number. The billboard startled the legal scholar, long attentive to how law regulates mothers' decisions to separate from their children. Had she just, in a passing glance, witnessed the state of New Jersey urging women to abandon their babies? The traumatic act of anonymous surrender reduced to a catchy slogan?

But by then the safe haven train had already left the station, with seemingly everyone on board. Acts of public abandonment, however, were not a particularly pressing social issue—in 1998, the year before the Texas law passed, a study by the U.S. Department of Health and Human Services found that of nearly four million live births, 105 babies had been abandoned in public places, with thirty-three found dead.

Each was a tragedy, but maternal filicide falls low on the register of reasons for infant death. Far more pressing and less sensational causes—low birth weight, preterm birth, and pregnancy-related disease complications—do not receive as much enthusiastic attention from impassioned legislators. (Nor has the death of children from gun violence, along with its profound psychological toll, forever etched into public consciousness after the Columbine school shooting massacre

in 1999, the same year the Baby Moses law passed in Texas.) And because safe haven laws exist on the premise of anonymity, they can feed a culture of shame and concealment, one that can create a destructive spiral leading women to forgo counseling and maternal care, the primary ways to address infant mortality.

"The need for anonymous abandonment in 2006 puzzles and disturbs," Sanger wrote in a prescient *Columbia Law Review* article published that year. "After all, subsistence levels in the United States are satisfactory, contraception is generally available, and abortion is legal. Single motherhood is less stigmatized, and the institutions of adoption and foster care are well established. How is it then that against a menu of medical, social, and legal alternatives, concealed pregnancy and infanticide have made such a comeback?"

The legislative zeal, especially on the part of Republicans, suggested that something else was happening. What may have begun as a media-induced frenzy over a handful of reported cases of infanticide soon became a shrewd mechanism for the anti-abortion movement to recast the debate by linking the act of infanticide to the decision to have an abortion. Emphasizing the urgent need for safe havens helped paint a dark portrait of a country in moral decline, where madwomen emerge from the attic and Medea crosses the border to the United States. Monstrous mothers—mothers, that is, who kill, or callously abandon, their infants—exhibit a depravity not far on this warped continuum from another type of woman, the one who ends her pregnancy. It's a line of thinking that has culminated today in the concept of "fetal personhood" as the movement pushes for a total ban on abortion.

Sanger's article not only saw behind the laws but predicted their inevitable outcome: "By connecting," she concluded, "infant life to unborn life and infanticide to abortion, Safe

Haven laws work subtly to promote the political goal of the culture of life: the reversal of *Roe v. Wade*." Safe haven laws both framed abortion as murder and offered a "moral" alternative to abortion: Women stripped of choice could perform the selfless act of giving up their child for adoption. The phrase "culture of life" became part of the Republican vernacular after Pope John Paul II used it in his 1995 encyclical.

Adoption is the new front line in the ongoing battle for women's bodily autonomy, and the anti-abortion movement is using adopted children as its political football. The only moral solution to an unwanted pregnancy, this thinking asserts, is for women to do the right thing: carry the baby to term and relinquish the child for adoption. The handmaiden of this argument is Amy Coney Barrett, who was educated and who later taught at Notre Dame Law School, which helped develop the Catholic conservative legal thinking in the anti-abortion movement. She stunned pro-choice advocates during oral arguments for *Dobbs* in December 2021 when she asked why, if a woman can have an abortion at twenty-three weeks, the state cannot require her to carry the baby for fifteen or sixteen more weeks and then terminate parental rights at the conclusion. "Why didn't you address safe haven laws and why don't they matter?" Barrett suggested that because safe haven laws allow women to terminate parental rights as early as forty-eight hours after birth, they eliminate the need for abortion through the act of anonymous surrender that provides a route to adoption.

Most women hadn't anticipated, in the game of chess over *Roe*, that a member of America's highest court would justify forcing a woman to carry to term with the blithe notion that she can always abandon her baby to a box at the local fire station. Modern day safe haven laws, the medieval law of anonymous surrender, one and the same: Carry your baby for nine months,

press a bell for the nearest fireman, and go back to work. The Made in Italy label took on an entirely new significance as the Supreme Court stamped it onto the fabric of America.

Wheels and circles bring me back to where I began, the early days of my research when I hoped to meet two women intimately connected to the orphan program, Barbara Campitelli, then ninety, and Virginia Formichi, ninety-one, both residing in the San Francisco Bay area. I would only speak to Virginia Formichi on the phone, but Barbara, who lived outside the city on the way to Silicon Valley, generously greeted me. Although beginning to struggle with extreme old age, confined mostly to her apartment as she had given up driving a couple years before, still she looked stylish that day, wearing black leggings and an off-white shawl with a sparkle of silver threads woven into the knit, moving more lithely than she had expected. Classical music played in the background and sections of a clementine awaited me on a plate. "Good for vitamin C," Barbara said, encouraging me to eat the snack.

But besides this pleasant occasion to meet John and Sara's mother, what I recall most about that trip was my arrival, a sun-soaked day in late January of 2018. I leaned out the taxicab window and tilted my face toward the sky, savoring a much-needed reprieve from a gray New York winter. The ride from the airport had gone smoothly until we entered downtown where traffic halted to a stop. As the driver pumped his brakes and the cab hiccupped forward, I tried not to grow fidgety. Two main streets, Market and Mission, were closed, the cab driver explained apologetically, because of a huge protest march.

I perked up. Hungry and weary from the long flight, a good protest might provide some needed adrenaline. My husband had spent his early boyhood years in San Francisco (coincidentally,

his family home was one block from where Virginia Formichi had grown up), and I never tire of his stories about the city at the heart of sixties counterculture, of joining his parents in anti-war marches, of picnicking during Be-ins in Golden Gate Park. I decided to hop from the cab and roll my suitcase the rest of the way, eager to see what discontent San Franciscans were proclaiming.

"By the way," I asked, paying the driver, and reminding him to pop open the trunk, "what are the marchers protesting?"

"Abortion."

Not quite what I was expecting. I had just arrived as the annual March for Life, which brought fifty thousand people to San Francisco that day, was coming to an end. Dropping off my bag in the hotel lobby, I headed to Market Street where groups of students wearing T-shirts with the names of their Catholic high schools walked with parents, nuns in habits, and priests in cassocks.

Red and yellow balloons sailed in the air with the words "Life" and "We will rise up and end abortion." Everyone looked positively ebullient at the end of the long marching day, carrying banners proclaiming, "We are the pro-life generation" and "We are praying to end abortion in this country." I found all this very strange, my coastal ears more in tune with the drum of pro-choice chants like, "Not the church, not the state, women must decide their fate" and "Keep your rosaries off my ovaries." Or aphoristic posts on Instagram: "If you're against abortion, don't have one." It was as if the marchers had gathered in America's Midwest, made a bad turn left and landed on the streets of San Francisco.

Someone lifted high a gold-framed portrait of the Virgin Mary holding the baby Jesus, blue sky and heavenly clouds behind her, melding with the afternoon's perfect weather, while

others clutched plastic statues of the Madonna and held cruci-
fixes draped in rosaries. Curious, I continued to tag along, but
began to feel more and more unsteady, my dislocation warping
into a kind of vertigo. It wasn't just the visceral realization that
the hard-earned gains of reproductive freedom were eroding as
fast as our shorelines, but the feeling of watching time collapse
before me.

After all, I had come to San Francisco to research a time, not
so long ago, when the Vatican dictated the terms of women's
sexuality, shaping policy by the mighty sword of heavenly
retribution. With knowledge of this sorry past sharpening my
vision, I stood on streets that afternoon watching marchers pray
to return to a time when powerful institutions controlled the
most intimate aspects of women's lives. Their zealous desire
to set these moral boundaries reminded me that the fear and
hatred of women's sexuality in Western culture still ferments
like a yeast in the collective conscious, always readying to rise.
Whether the fourth-century Bishop of Milan praising virgin
martyrs from the pulpit or twenty-first century black-robed
justices dictating opinions from the bench, such is the inescap-
able plight of women.

The marchers began to disperse at the Embarcadero on the
city's waterfront and I headed in the same direction, badly in
need of caffeine. Inside the Ferry Building, I found a favorite
coffee shop, downed an espresso, and walked to the adjacent
piers. Some student marchers had gathered there, girls teasing
boys, boys teasing girls, each enjoying a playful dance domi-
nated by the boys' bluffs of bravado. They looked so young and
naïve; life appeared as expansive as the Bay Bridge spanning the
translucent water before them.

Observing their interactions, I felt both protective and
angry, wondering how they would navigate the inevitable hurts

and disappointments ahead, and distressed by their (or their parents') certitude to limit the dimensions of other people's lives. What if one of these girls found herself forced into a bad situation or forced to pay for a moment's bad decision, the type that's been made, and will continue to be made, for countless times in human history? She could have to make the life-changing decision to surrender her child for adoption.

The new zealotry on the landscape begets more disturbing thoughts. Will its fervor bring back the stigma of unwed motherhood, girls hiding behind hoodies, reputations ruined in the seconds of a social media post? Will those left with no recourse be forced to undergo illegal operations in filthy rooms, the threat of imprisonment shadowing them along with anyone who tries to assist? Will those who dispense this justice believe it an appropriate punishment for woman's sin?

A wave of protectiveness washed over my anger: after all, they were children ill prepared for what they would end up doing to each other. How can we expect them, like any of us, to escape human nature? The same patterns and dynamics repeat, each shift forward matched by an inevitable one back, believers in scientific progress clashing with keepers of the faith. Flaubert's sage depiction of the human condition in the nineteenth century might explain why his imaginings of the twentieth century proved so prescient: "It will be utilitarian, militaristic, American, and Catholic, very Catholic."

The powerful will continue to prey upon the vulnerable, the poor always suffering most, and venerable institutions will silence others to protect their own. New verses will emerge for intractably old ideas. Here's one: women are not autonomous beings but childbearing vessels with no natural right to make life's most intimate decisions.

On San Francisco's packed streets and airy piers, icons of the

Virgin Mary and insouciant girls framed the picture of femininity. Image, time, place meld, the warmth of the January California sun turns to the cold slap of a Milanese March. I am back at the Basilica di Sant'Ambrogio following teachers leading a group of students whose gait is as carefree as their peers on the pier. They head from the side aisle of the church to steps leading to the sarcophagus of the bishop who seventeen centuries earlier preached the tale of the virgin martyr Agnes to girls their age. If prayers were being offered, I wanted to add one, too, that all these girls might have a choice and a voice, unlike so many who have lived before them, unlike the women now their grandmothers' and great-grandmothers' ages. May the stories of those Italian women who have been silenced by history shine some light on the dangerous path ahead.

Notes

Chapter 1:

10 **over two hundred thousand:** This number of abandoned children is cited by Jolanda Torraca, director of Rome's Opera Assistenza Materna, in an article published in *Italiani nel Mondo*, September 25, 1958. The magazine, closely tied to Italy's Office of Foreign Affairs, was published twice a month and sent to consulates and Italian representatives abroad. I interviewed a woman in a high administrative position at a *brefotrofio* during this era who believed the number was significantly higher than Torraca's figure.

14 **now shuttered *brefotrofio*:** Greek origin of *brefotrofio* from the Museo degli Innocenti in Florence.

14 **Roman Catholic Church repackaged:** The workings of the orphan program are found in the archives of the National Catholic Welfare Conference (NCWC), housed at the Center for Migration Studies (CMS) in New York City, as well as in the papers of the International Social Service-American Branch (ISS), held at the University of Minnesota's Social Welfare History Archives (SWHA).

15 **my cousin (Case #21048)**: Letter from Monsignor Andrew P. Landi to Monsignor Emil N. Komora, February 19, 1959, CMS archives, NCWC papers.

15 **obtained visas in America due to a special clause**: The Displaced Persons Commission Sixth Semiannual Report to the President and Congress, August 1, 1951, (Washington: United States Government Printing Office, 1952).

Chapter 4:

36 **"The need is not that of a child for a parent"**: Interview with Florence Fisher, *New York Times*, July 25, 1972.

36 **Fisher has been credited for helping to spark**: E. Wayne Carp, *Family Matters: Secrecy and Disclosure in the History of Adoption* (Cambridge: Harvard University Press, 1998), pp. 143–144. Carp's book offers an excellent overview of American adoption in the twentieth century.

39 **relevant INS yearbooks**: Annual report of the Immigration and Naturalization Service, Vols. for 1944–1977 issued by: US Dept. of Justice, Immigration and Naturalization Service, Washington, DC.

Chapter 5:

43 **an American law firm polished the legal mechanism**: Gerard C. Durr, of the law firm Gallagher & Durr in New York City, was the primary attorney working with Monsignors Landi and Komora during the years of the orphan program, CMS archives, NCWC papers.

43 **Registrar of Births was charged with**: Mary Rose Norris doctoral dissertation, "Adoption of Children from Overseas: A Study of the Process Involved in the Intercountry Adoption Placement of 145 Children Conducted Under the Auspices of the Catholic Committee for Refugees—National Catholic Welfare Conference," (Washington: The Catholic University of America), 1967, p. 66.

43 **contemporary version of those medieval scribes**: For a discussion of false surnames given to abandoned children of unwed mothers throughout Italian history, see David I. Kertzer, *Sacrificed for Honor: Italian Infant Abandonment and the Politics of Reproductive Control* (Boston: Beacon Press, 1993), pp. 119–122.

45 **The newspaper welcomed the opportunity to publish**: "*Dalla California cercando la madre*," *La Repubblica*, July 5, 1991.

Chapter 7:

55 **"The really comic side"**: Rémi Fournier Lanzoni, *Comedy Italian Style: The Golden Age of Italian Film Comedies* (New York: Continuum, 2009), pp. 106–107.

55 **remained in Italy's penal code until 1981**: Eva Cantarella, "Homicides of Honor: The Development of Italian Adultery Law over Two Millennia," from *The Family in Italy from Antiquity to the Present*, ed. Richard P. Saller and David I. Kertzer (New Haven: Yale University Press, 1991), p. 244.

68 **I am a Catholic:** Surrender form for mothers, 1958, CMS archives, NCWC papers.

Chapter 8:

71 **spy on the bedroom behavior**: Kertzer, *Sacrificed for Honor*, see Chapter Three, "Policing Women," pp. 38–70.

71 **Bologna's "Hospital of the Little Bastards"**: ibid., p. 40.

71 **A headline for a newspaper photo**: unnamed American newspaper dated August 6, 1951, CMS archives, NCWC papers.

72 **legally entered the United States**: The Displaced Persons Commission Sixth Semiannual Report to the President and Congress, p. 23.

72 **defined a "war orphan"**: Rachel Rains Winslow, *The Best Possible Immigrants: International Adoption and the American Family* (Philadelphia: University of Pennsylvania Press, 2017), p. 44. Winslow provides a comprehensive overview of Congressional actions and postwar American adoption practices.

73 **"take their places in good Catholic families"**: National Catholic Welfare conference Fourteenth Annual Report, October 1, 1949, to September 30, 1950, The Catholic Committee for Refugees, p. 24, CMS archives, NCWC papers.

73 **"lobbied for this amendment"**: Monsignor Edward E. Swanstrom of the National Catholic Welfare Conference filed briefs to support the extension of the Refugee Relief Act of 1953. The Refugee Relief Act, in addition to aiding adult refugees from Europe, enabled four thousand "orphan" children to enter the United States for the purpose of adoption. See, Rev. Aloysius

J. Wycislo, "The Refugee and the United States Legislation," *The Catholic Lawyer*, Volume 4, Spring 1958, pp. 148–149; and "Catholic Aid Is Sought for 130,000 Refugees Under New Relief Act, *The Catholic Telegraph-Register*, August 14, 1953.

73 **new definition of orphan permanent**: Winslow, *The Best Possible Immigrants*, p. 7.

Chapter 9:

75 ***ADSIS CHRISTE EORVMQVE***: translation found in online book, *Roma*, Pasquale "detto Lino" Antocicco.

75 **connecting the secular city to the sacrosanct:** Terry Kirk's "Framing St. Peter's: Urban Planning in Fascist Rome," (The Art Bulletin, Vol. 88, No. 4, December 2006, pp. 756–776) explores the Via della Conciliazione's physical embodiment of the relationship between the Catholic Church and the Italian State.

76 **in the odd historical position**: on Pope Pius XII's silence during the Holocaust, David I. Kertzer, *The Pope At War: The Secret History of Pius XII, Mussolini, and Hitler* (New York: Random House, 2022); and on unwittingly and knowingly helping Nazi war criminals escape from Italy, Gerald Steinacher's *Nazis on the Run: How Hitler's Henchmen Fled Justice* (Oxford: Oxford University Press, 2011).

76 ***Chi vota Comunismo***: Sign in Sicily, 1955, photographer Nino Migliori, from the exhibit "NeoRealismo: The New Image in Italy, 1932–1960," New York University Grey Art Gallery, fall 2018.

77 **Monsignor Ferdinando Baldelli was the person**: Sister M. Pascalina Lehnert, *His Humble Servant: Sister M. Pascalina's Memoirs of Her Years of Service to Eugenio Pacelli, Pope Pius XII*, translated by Susan Johnson, (South Bend Indiana: St. Augustine's Press, 2014), p. 101.

77 **Pius XII placed Baldelli in charge**: Steinacher, *Nazis on the Run*, p. 102.

77 **money for the PCA directly into the Vatican bank**: ibid., pp. 105–106.

77 **Federico Fioretti was a spy**: Philippe Sands, *The Ratline: Love, Lies and Justice on the trail of a Nazi fugitive* (London: Weidenfeld & Nicolson, 2020), p. 249.

77 **American Catholic Church also greatly helped**: Steinacher, *Nazis on the Run*, pp. 107–110.

78 **"breath-taking in its size"**: Paul Ginsborg, *A History of Contemporary Italy: Society and Politics 1943–1988*, (New York: Palgrave Macmillan, 2003), p. 115.

78 **Landi first arrived in Italy in 1944**: *Diocese of Immigrants: The Brooklyn Catholic Experience 1853–2003* (Strausborg: Éditions du Signe, 2004), p. 103.

78 **Landi, along with three other American priests**: Eileen Egan, *Catholic Relief Services: The Beginning Years* (New York: Catholic Relief Services, 1988), p. 109.

79 **NCWC received its own financial rewards**: Letter from Msgr.

Komora to Msgr. Landi explaining the $475 figure for processing orphans was agreed upon at a meeting with Msgr. Edward Swanstrom, November 7, 1957, CMS archives, NCWC papers.

79 **like so many of those fiery young workers**: Ginsborg, *A History of Contemporary Italy*, p. 15.

79 **as couples preferred to adopt girls**: Norris, doctoral dissertation, p. 137.

80 **"Evil is being spread"**: "Mother Witnesses Canonizing of Girl," *New York Times*, June 25, 1950.

Chapter 10:

81 **The Pope's spiritual weapon**: Nicholas Perry and Loreto Echeverría, *Under the Heel of Mary*, (London; New York: Routledge, 1988), p. 242. The chapter "The Fervent Fifties" provides an overview of the ways in which Pius XII used the figure of Mary in his postwar anti-Communist crusade.

81 **"a virginal maternity, incomparably superior"**: "Address to Midwives on the Nature of their Profession," October 29, 1951, Papal Encyclicals Online.

81 **not "fully proved" theory of evolution**: "Humani Generis," August 12, 1950.

81 **as far back as the sixth century**: Marina Warner, *Alone of All Her Sex: The Myth and the Cult of the Virgin Mary*, (New York: Vintage Books, 1983), p. 105.

82 **"reign over our intelligence"**: Perry and Echeverría, *Under the Heel of Mary*, p. 242.

82 **"four established dogmas"**: Warner, *Alone of All Her Sex*, p. 19.

83 **"to embrace a fully developed ascetic philosophy"**: ibid., p. 48.

83 **"And it was in this shift"**: ibid., p. 49.

83 **the Pope announced before a crowd**: "Assumption Rite is Seen by 500,000," *New York Times*, November 1, 1950.

83 **For only the second time in Church history**: "Pope Affirms Dogma of Assumption of Mary to Heaven 'Body and Soul,'" *New York Times*, November 2, 1950.

84 **the Pope believed that her Divine pleasure**: "Says Pope Viewed 'Miracle of Sun,'" *The Tablet*, October 20, 1951.

84 **"It is not our task to formulate deductions"**: *Il prodigio di Fatima*, in *L'Osservatore Romano*, November 17, 1951.

85 **gathered in St. Peter's Square to witness**: "Mother Witnesses Canonizing of Girl," *New York Times*, June 25, 1950.

85 **Maria Goretti, born in 1890**: Details of her life and murder are described in Pietro Di Donato's biography of her assailant Alessandro Serenelli, *The Penitent* (New York: Hawthorn Books, 1962); Kathleen Z. Young analyzes Goretti's canonization in "The Imperishable Virginity of Saint Maria Goretti," from *Violence Against Women: The Bloody Footprints*, edited

by Pauline B. Bart and Eileen Geil Moran (Newbury Park, California: Sage Publications, 1993), pp. 105–113.

86 **"I remember sitting in the cafeteria"**: Caryl Rivers, *Aphrodite at Mid-Century: Growing Up Female and Catholic in Postwar America* (New York: Doubleday, 1973), pp. 150–151.

87 **"If a girl wouldn't play ball"**: Edoardo Albinati, *The Catholic School*, translated by Antony Shugaar, (New York: Farrar, Strauss and Giroux, 2019), p. 1247.

87 **"They laughed up their sleeves"**: Annie Ernaux, *The Years*, translated by Alison L. Strayer, (New York: Seven Stories Press, 2017), p. 37.

87 **"shame lay in wait at every turn"**: ibid., p. 68.

87 **"Between the freedom of Bardot"**: ibid., p. 69.

87 **"that a constant flow of chidren"**: Letter from Msgr. Landi to Msgr. Komora, October 3, 1951, CMS archives, NCWC papers.

88 **"We are completely without C-14 forms"**: Letter from Msgr. Landi to Msgr. Komora, December 1957, CMS archives, NCWC papers.

Chapter 11:

90 **"This was too terrible"**: Martha Gellhorn, "Little Boy Found," *The Saturday Evening Post*, April 15, 1950.

91 **According to her biographer**: Caroline Moorehead,

Gellhorn: A Twentieth-Century Life, (New York: Henry Holt and Company, 2003), p. 274.

91 **Gellhorn had decided at the age of forty**: ibid., p. 269.

91 **Gellhorn had moved to Paris**: ibid., see pp. 35–61.

92 **"I can do very well without marriage"**: "Hemingway," documentary film by Ken Burns and Lynn Novick.

92 **After the first few years of raising Sandy**: Moorehead, *Gellhorn*, pp. 307–308.

92 **even added a clause to her will**: ibid., p. 376.

93 **"to a collapse into conditions which must resemble"**: Norman Lewis, *Naples 44: A World War II Diary of Occupied Italy* (New York: Carroll & Graf Publishers, 2005), p. 43.

93 **commissioned a study that confirmed**: Winlsow, *The Best Possible Immigrants*, p. 46.

94 **fielding questions from a dozen of these children**: Letter from Msgr. Landi to Msgr. Komora, June 6, 1951, CMS archives, NCWC papers.

94 **"displaced orphans"**: Letter from Msgr. Komora to Msgr. Landi, June 27, 1951, CMS archives, NCWC papers.

95 **"If anything should happen"**: Letter from Msgr. Landi to Msgr. Swanstrom, January 15, 1952, CMS archives, NCWC papers.

95 **"wretchedly dirty"**: Interagency Orphan Program meeting, February 20, 1952, CMS archives, NCWC papers.

95 **"had to be refurbished"**: Letter from Msgr. Swanstrom to Msgr. Landi, June 12, 1951, CMS archives, NCWC papers.

95 **the monsignor insisted that the staff**: Msgr. Land first proposed to Msgr. Komora on December 9, 1955, to return the clothing his staff had purchased. As the orphan program continued to grow, on December 2, 1958, Msgr. Komora wrote to the Barr shipping company to pick up four boxes of old clothing from the Hotel Chelsea for shipment to Rome, CMS archives, NCWC papers.

96 **"the accusation of 'stealing Italian children'"**: Letter from Msgr. Landi to Fr. Aloysius Wycislo of War Relief Services, NCWC, November 17, 1951, CMS archives, NCWC papers.

96 **"*Una vita serena e felice*"**: Letter from Msgr. Landi to Msgr. Swanstrom, February 1, 1952, includes article from *Caritas*, published by the Pontifical Relief Commission, CMS archives, NCWC papers.

97 **more than four hundred "Italian refugee children"**: NCWC press release, November 10, 1952, CMS archives, NCWC papers.

97 **"much confusion, intentional and unintentional"**: Letter from F. Robert Melina, supervisor of orphan emigration, to Msgr. Komora, October 16, 1953, CMS archives, NCWC papers.

97 **suggests the exchange of money**: "My Brother, My Sister,

Sold for a Fistful of Lire," 1998, original title, "Mon frère, ma soeur, vendus pour quelques lires," directed by Basile Sallustio.

99 **"Three children have already been sent back"**: Letter from Fr. Wycislo to Msgr. Landi, June 16, 1952, CMS archives, NCWC papers.

99 **"I have lost my peace"**: Compilation of family letters from the Fall of 1952 sent to Msgr. Landi's office, CMS archives, NCWC papers.

100 **"these children were accepted in good faith"**: Letter from Msgr. Komora to Msgr. Landi, July 8, 1953, CMS archives, NCWC papers.

101 a **"superhuman" effort**: Letter from Msgr. Landi to Msgr. Swanstrom, August 7, 1952, CMS archives, NCWC papers.

101 **That following January**: "Minutes of the meeting of the Interministerial Commission for the Emigration of Italian War Orphans," held at the Pontifical Relief Commission, Rome, January 9, 1953, CMS archives, NCWC papers.

Chapter 12:

104 **"absolutely opposed to Italian law"**: "Memorandum of the Meeting of the POA on Monday, February 1st, 1954, at 5:30 p.m.," on the emigration of minors to the United States. The disagreements between different government ministries on the legality of the orphan program would continue for years, CMS archives, NCWC papers.

107 **"to talk with the Presidents of Institutions"**: "Orphan Program Summary," Winter, 1955 CMS archives, NCWC papers.

107 **"Italian legislation does not strictly speaking provide"**: "Orphan Program Summary," October 1955 CMS archives, NCWC papers.

107 "**RE: PLACEMENT OF ILLEGITIMATE CHILDREN,**" Letter from Pasquale Saponaro, president of the provincial administration of Benevento to Msgr. Landi's office, February 19, 1960, CMS archives, NCWC papers.

108 **filed a detailed report about her work**: Msgr. Landi sent the June 1957 report, translated into English, to Msgr. Komora in a letter dated July 4, 1957. Landi explained: "One of our orphan social workers who was lent to us by the Pontifical Relief Commission prepared a report of her activities with our agency at the request of Monsignor Baldelli." CMS archives, NCWC papers.

109 **Social workers griped**: Orphan Program summary, in which social workers detail political divisions in northern Italian regions about the orphan program, Spring 1957, CMS archives, NCWC papers.

Chapter 13:

110 **"the children are for the most part unaccompanied"**: Letter from Msgr. Landi to Fr. Wycislo, March 15, 1952, CMS archives, NCWC papers.

110 **Airlines pitched in**: Orphan Program Reports, July 1954 and Winter 1958, CMS archives, NCWC papers.

111 **rented a top-floor suite at the Chelsea Hotel**: Norris dissertation, p. 109, footnote.

111 **staffed by three women**: ibid., p. 148.

111 **prescribed a mild medication**: ibid., p. 151.

111 **Be at the hotel by 5:00 p.m**: Letter from Catholic Charities caseworker Regina A. Gallagher to an adoptive couple, June 2, 1965.

111 **"No vacuum cleaners, no rules, no shame"**: "How Leonard Cohen Met Janis Joplin," *Rolling Stone*, November 14, 2016.

112 **"I've had eighteen straight whiskies"**: "The Chelsea Hotel, 'Kooky But Nice,' Turns 100," *New York Times*, November 21, 1983.

112 **prostitutes and pimps hung out**: "Where the Walls Still Talk," *Vanity Fair*, October 8, 2013.

112 **Warhol filmed "Chelsea Girls"**: ibid.

112 **naked woman stepping**: ibid.

112 **Janis Joplin, whom Leonard Cohen met**: "How Leonard Cohen Met Janis Joplin," *Rolling Stone*, November 14, 2016.

112 **"opportunity for rest and reassurance"**: Norris dissertation, p. 109.

112 **Landi had spent his prime boyhood years in an orphanage**: *Diocese of Immigrants: The Brooklyn Catholic Experience 1853–2003*, p. 103.

112 **His parents, immigrants from Southern Italy**: 1910 U.S. Census Records, accessed from Ancestry.com.

113 **Andrea's next home was an orphanage**: Egan, *Catholic Relief Services*, p. 122.

114 **"The future looks bright"**: Orphan Program summary, December 1955 CMS archives, NCWC papers.

114 **Monsignor Landi died in 1999**: Congressional Record, Volume 145, 1999.

114 **"They were offered to us"**: "My Brother, My Sister, Sold for a Fistful of Lire," documentary by Basile Sallustio.

114 **Msgr. Landi has employed a priest**: Letter from Mgsr. Komora to Robert Melina, attaching memorandum of conference "regarding the Italian situation," July 21, 1954, CMS archives, NCWC papers.

115 **Formichi worked at Via della Conciliazione, 4 until 1962**: "Interview with Virginia J. Formichi," 640 Heritage Foundation, 2017.

Chapter 14:

121 **The folksy ballad, which is not autobiographical**: "Italy Heritage" website.

127 "**undesirable interference on the part of their mothers**": Social worker report, *Istituto Protezione Assistenza Infanzia*, Milano—Viale Piceno, 60, Fall 1961, CMS archives, NCWC papers.

Chapter 15:

130 **The twins were far from the Twin Towers**: "Mamma Mia!" feature story about the twins' search and reunion, *Times Leader*, June 3, 2015.

Chapter 16:

135 **Doctor of Virginity**: Karen Armstrong, *The Gospel According to Women* (New York: Anchor Books, 1986), p. 27.

135 **formed the triumvirate**: Warner, *Alone of All Her Sex*, p. 55.

136 "**pledged to another lover!**": Jacobus de Voragine, *The Golden Legend: Readings on the Saints*, Volume 1, translated by William Granger Ryan (Princeton: Princeton University Press, 1995). The tale of St. Agnes is told on pp. 101–104.

136 **Centuries of retelling added**: Armstrong, *The Gospel According to Women*, p. 154.

137 "**tainted with evil**": ibid., p. 36.

137 "**Consequently it is in the West alone**": ibid., p. 2.

137 "**In truth, virginity gives souls**": *Sacra Virginitas*, Encyclical of Pope Pius XII on consecrated virginity (point 28), Rome, March 25, 1954.

139 **message of the "culture of life"**: *Evangelium Vitae,* Encyclical of Pope John Paul II on the Value and Inviolability of Human Life, March 25, 1995.

140 **"more to social than to medical needs"**: Kertzer, *Sacrificed for Honor,* p. 44.

141 **until the wheels finally closed**: ibid., p. 159.

141 **Milan had the astonishingly high rate**: ibid., pp. 24, 78.

141 **death rate more than double**: Kertzer, *Sacrificed for Honor,* p. 139.

141 **"Here babies come to die"**: David I. Kertzer, *Amalia's Tale: An Impoverished Peasant Woman, an Ambitious Attorney, and a Fight for Justice* (New York: Houghton Mifflin Company, 2008), pp. 12–13.

141 **foundational logic of the *ruota***: Kertzer, *Sacrificed for Honor,* p. 154.

142 **Nineteenth-century reformers challenged**: ibid., pp. 161–162.

142 **"disturbance of family peace"**: ibid., p. 70.

142 **ban on the search for paternity**: ibid., p. 70.

Chapter 17:

148 **a court in Florence upheld a European Court decision**:

"Una Mamma Ritrovata," *Corriere della Sera*, December 24, 2014.

Chapter 18:

154 **crying babies were not picked up**: Social worker report for *Istituto Protezione Assistenza Infanzia*, Torino, Corso Giovanni Lanza, October 1, 1961, CMS archives, NCWC papers.

154 **"given the great regimentation"**: Social worker report for *Istituto Provinciale Per L'Assitenza All'Infanzia*, Via Nicolini 14, Chieti, October 1961, CMS archives, NCWC papers.

155 **policy requiring unwed mothers**: Kertzer, *Sacrificed for Honor*, p. 131.

155 **But the director of Milan's *brefotrofio***: ibid., p. 132

155 **One hundred years later**: Social worker report, *Istituto Protezione Assistenza Infanzia*, Milano, Fall 1961, CMS archives, NCWC papers.

Chapter 19:

165 **"Anton Chekhov once observed"**: Vivian Gornick, "Put on the Diamonds," *Harper's Magazine*, October 2021.

169 **"a place, a history and a name"**: *The Museo degli Innocenti*, (Florence: Mandragara, 2016), opening statement from Alessandra Maggi, president of the Istituto degli Innocenti.

169 *finestra ferrata*: ibid., p. 80.

169 **statues of Mary and Joseph**: ibid., p. 39.

171 **unofficial publication of the Office of Foreign Affairs**: Letter from Luciana Corvini, director ISS-Italian Branch to Susan T. Pettiss, assistant director ISS-American Branch, November 15, 1957, referencing the Foreign Office ties, SWHA, ISS papers.

171 **"a considerable influx of disinherited"**: Letter from Msgr. Landi to Msgr. Komora, October 24, 1958, including translated copy of Jolanda Torraca article, "Difficulties in Regard to Italian Orphans in the USA," *Italiani nel Mondo*, September 25, 1958, CMS archives, NCWC papers.

172 **"misery, frivolity or irresponsibility"**: Torraca, ibid.

172 **state *brefotrofio* in Rome had refused**: Orphan Program Summary, December 1955, and letter from Msgr. Landi to Msgr. Komora: "as you know, the Director of the [Rome] Brefatrofy is opposed to the foreign adoption placement of children," March 26, 1959, CMS archives, NCWC papers.

172 **reimbursed the institution**: Letter from Msgr. Landi to Msgr. Komora, August 29, 1956, CMS archives, NCWC papers.

Chapter 20:

177 **a pronounced shift from earlier in the century**: Barbara Melosh, *Strangers and Kin: The American Way of Adoption* (Cambridge: Harvard University Press, 2002), p. 110.

177 **embracing popularized versions of Freudian theory**: ibid., p. 110.

178 **pool of available domestic babies**: Carp, *Family Matters*, p. 29.

178 **"the only agency in Italy"**: Information letter to parents, Spring 1959, CMS archives, NCWC papers.

179 **"a man with a talent for"**: "Popular Brooklyn Priest, Monsignor Andrew P. Landi, Is Ambassador of American Catholics to Italy's Needy," *The Texas Catholic*, June 13, 1959.

179 **"handy Andy Landi"**: ibid.

182 **lengthy caption on its front page**: "Six Happy People," *Steubenville Herald-Star*, March 25, 1957.

182 **formed an "Adoption Club"**: "Sister Mary Louis Bestowed Honors on 25th Year in Catholic Nun Order," *Steubenville Herald-Star*, May 11, 1959.

182 **My cousin arrived**: Children's Manifest lists Gianfranco Aragno, case number 21048, KLM flight 12992, April 16, 1959, CMS archives, NCWC papers.

182 **"Who could ask for anything more?"**: "The Social Notebook," *Steubenville Herald-Star*, April 18, 1959.

185 **"This is the funniest thing ever"**: "Roll Red Roll," documentary film by Nancy Schwartzman, 2018. Schwartzman further details the "first rape case ever to go viral in the United States" in *Roll Red Roll: Rape, Power, and Football in the American Heartland*, Nancy Schwartzman with Nora Zelevansky (New York: Hachette Books, 2022).

185 **"City of Churches"**: Nick Tosches, *Dino: Living High in the Dirty Business of Dreams* (Delta: New York, 1992), p. 43.

185 **little city bootlegged illegal liquor**: ibid., p. 47.

185 **Cosmo Quattrone who ran a gambling joint**: ibid., p. 61.

185 **stationed a man in a cubbyhole**: ibid., p. 62.

186 **"sin as an industry"**: ibid., p. 43.

186 **key to the city**: ibid., p. 227.

Chapter 21:

189 **"that they were committing crimes"**: Kertzer, *Sacrificed for Honor*, p. 165.

189 **"no materials to play with"**: Catholic Relief Service-NCWC social worker report, February 14, 1959, filed with Diocese of Steubenville, Ohio, Office of Family Services and Social Concerns (Catholic Charities).

197 **"geographic ground zero"**: Michael Tomasky, "A little bit more on accents, America this time," *The Guardian*, US edition, Michael Tomasky's blog, June 2, 2010.

Chapter 22:

199 **"Child's nose had a bad sore"**: Children's Manifest, September 20, 1962, CMS archives, NCWC papers.

202 **"naturally vivacious" child**: Social worker report, *Istituto Protezione Assistenza Infanzia*, Torino, Corso Giovanni Lanza, October 1, 1961, CMS, NCWC papers.

Chapter 23:

211 **sent to the countryside to be breastfed**: Case report filed by Ilda Valloni, Catholic Relief Service-NCWC social worker.

211 **"Only when every effort"**: Letter from Corvini to Pettiss, including translation of "Little Emigration" from *Italiani nel Mondo*, November 15, 1957, SWHA, ISS papers.

213 **creating an international scandal**: "Italians Stirred by U.S. Adoptions," *New York Times*, July 17, 1959.

Chapter 24:

214 **public furor in Italy**: Letter from Msgr. Landi to Msgr. Swanstrom, July 17, 1959, CMS archives, NCWC papers.

214 **"Italians, proverbially fond of children"**: "Italians Stirred by U.S. Adoptions," *New York Times*, July 17, 1959.

214 *La Settimana Incom*: Letter Virginia Formichi to Msgr. Landi, in which Formichi includes magazine article, May 5, 1959, CMS archives, NCWC papers.

214 **Ministry of Foreign Affairs had blocked**: ibid.

215 **began facilitating adoptions**: Letter from Msgr. Landi to

Msgr. Komora, December 22, 1956, attaching a translated copy of a feature story on Peter Giambalvo from a local newspaper from Cremona. The article, which ran on August 22, 1956, had come to the attention of a NCWC social worker, CMS archives, NCWC papers.

215 **sent considerable amounts of physical and hospital equipment:** Letter from Ernest A. Mitler to Susan Pettiss, March 30, 1959. Mitler was a former New York district attorney who had worked undercover in black market baby operations and interviewed Giambalvo, SWHA, ISS papers.

215 **visit of this nefarious character:** "In Italia si vendono i bambini per mille dollari," *La Settimana Incom illustrata,* May 1959.

215 **Giambalvo had corresponded:** Letter from Peter Giambalvo to Msgr. Komora requesting help processing paperwork for children at the Cremona *brefotrofio* waiting for adoptive placement in America, October 18, 1955, CMS archives, NCWC papers.

216 **"photographs are of our children":** Letter from Virginia Formichi to Msgr. Landi, May 5, 1959, CMS archives, NCWC papers.

216 **"negative publicity concerning black market babies":** Letter from Msgr. Landi to Msgr. Komora, June 1, 1959, CMS archives, NCWC papers.

216 **"further fanned the flames":** Msgr. Landi to Msgr. Swanstrom, July 17, 1959, CMS archives, NCWC papers.

217 **"concerning black market activities in children"**: Letter from Msgr. Landi to Msgr. Komora, July 13, 1959, CMS archives, NCWC papers.

217 **"seeking to offset this negative publicity"**: ibid.

217 **"appeared at the airport and demanded"**: Msgr. Landi to Msgr. Swanstrom, July 17, 1959, CMS archives, NCWC papers.

218 **"broke down, cried, and insisted on"**: ibid.

218 **"had received 'a single lira'"**: "Italians Stirred by U.S. Adoptions," *New York Times*, July 17, 1959.

219 **charged $750 for an Italian child**: Letter from Susan Pettiss to Luciana Corvini, enclosing New York newspaper articles in which Kings County District Attorney Edward S. Silver cites Giambalvo's fee, May 25, 1961, SWHA, ISS papers.

220 **private adoption services like Spence-Chapin**: Letter from Luciana Corvini to Susan Pettiss asking Pettiss to forward copies of "Little Emigration" to Helen B. Montgomery, executive director of The Spence-Chapin Adoption Service, November 15, 1957, SWHA, ISS papers.

220 **bringing the very powerful Cardinal Francis Spellman**: Letter from Msgr. Komora to Msgr. Landi in which he discusses what to do about the problem of the ISS "expanding its operation in Italy," January 11, 1961.

220 **investigating the existence of a black market**: Letter from Edward S. Silver, Office of the District Attorney Kings

County to William T. Kirk, General Director ISS asking for any files that refer to Peter Giambalvo, June 15, 1959, SWHA, ISS papers.

221 **fired off several cable to Formichi**: Radiogram from Landi to Formichi with message, "Suggest Cooperate with ISS Regarding News Article Provided POA Concurs," May 11, 1959, CMS archives, NCWC papers.

221 **"ISS planned to pay a reporter to write an article"**: Letter from Virginia Formichi to Msgr. Landi, May 1959, CMS archives, NCWC papers.

221 **'not to have anything to do with the POA'**: ibid.

221 **knew all "the big shots"**: Letter from Corvini to Pettiss, March 23, 1959, SWHA, ISS papers.

222 **"We believe that your capacity"**: Letter from Corvini to Pettiss, July 25, 1961, SWHA, ISS papers.

223 **"Here is our file on Mr. Giambalvo"**: Handwritten note from Emile T. Strauss, ISS-American Branch supervisor, to William Kirk, June 16, 1959, SWHA, ISS papers.

223 **"to be in a position to contest"**: Letter Msgr. Landi to Msgr. Komora, March 4, 1960, CMS archives, NCWC papers.

223 **"are authorized to be instruments"**: "Italians Stirred by U.S. Adoptions," *New York Times*, July 17, 1959.

223 **"The Italian government is still raising"**: Letter Msgr.

Landi to Msgr. Komora, July 25, 1958, CMS archives, NCWC papers.

224 **"Black Market in Italian Children"**: Letter from Corvini to Pettiss citing headlines in Italian newspapers and magazines, May 29, 1961, SWHA, ISS papers.

224 **"They Sell Italian Children"**: ibid.

224 **"Adoption procedure, as usual"**: Cremona newspaper story, August 22, 1956, CMS archives, NCWC papers.

225 **New York district attorney's indictment**: "Lawyer Accused in Child Adoptions," *New York Times,* May 25, 1961.

225 **"Let us hope that our Parliament"**: Letter from Corvini to Pettiss, May 29, 1961, SWHA, ISS papers.

225 **Giambalvo claimed:** Letter from Ernest A. Mitler to Susan Pettiss, March 30, 1959.

226 **Dozens of applications reviewed**: Applications sent to the Angel Guardian Home in Brooklyn from 1950 to 1956, CMS archives, NCWC papers.

227 **"Placed in institution"**: Compiled records of children's placement when adoptive home placement did not work out, Spring 1959, CMS archives, NCWC papers.

228 **"to cooperate with Mr. G."**: Letter from Formichi to Msgr. Landi, May 5, 1959, CMS archives, NCWC papers.

Chapter 25:

229 **not subject to the country's strict quota system**: Letter from Pettiss to Corvini: "What a joy to be able to start a letter by saying 'Now that permanent legislation has passed,'" September 25, 1961, SWHA, ISS papers.

230 **escape the district attorney's charges**: "Orphan-Sale Indictment Killed," *New York Times*, June 2, 1962.

230 **"Mr. Giambalvo is again active"**: Letter from social worker Maria A. Modica to Corvini, February 19, 1963, SWHA, ISS papers.

Chapter 26:

241 **"believer in progress"**: Gustave Flaubert, *Madame Bovary*, translated by Margaret Mauldon, (Oxford: Oxford University Press, 2004), p. 154.

241 **"We're born to suffer"**: ibid., p. 100.

241 **the pharmacist spreads a little chlorine**: ibid., p. 297.

242 **the number to soar**: "Your DNA, Identified by the DNA of Others," *New York Times*, October 12, 2018.

243 **"huge, inadvertent social experiment"**: "All My Siblings," *New York Times Magazine*, June 30, 2019.

Chapter 27:

246 **"In Ireland you would be better off saying"**: "Irish Leader

Apologizes for Adoptions That 'Robbed Children' of Their Identity," *New York Times*, May 30, 2018.

246 **"How do I answer"**: Pauline Boss, *Ambiguous Loss: Learning to Live with Unresolved Grief*, (Cambridge: Harvard University Press, 1999), p. 20.

250 **"rather than children for parents"**: Letter from Dicy Dodds, Assistant International Director ISS, to Susan Pettiss, January 18, 1957, SWHA, ISS papers.

251 *"not a child to a family"*: Natalia Ginzburg, excerpt included in *A Place to Live and other selected essays of Natalia Ginzburg*, chosen and translated by Lynne Sharon Schwartz, (New York: Seven Stories Press, 2003), p. 228.

251 **birth mother is kept psychologically present**: Boss, *Ambiguous Loss*, p. 35.

252 **"'Adoption would be a feminist issue'"**: Margaret Moorman, *Waiting to Forget* (New York: W. W. Norton, 1996), p. 162.

253 **"You know what's in those files?"**: ibid., p. 17.

Chapter 28:

256 **"a dangerous creator of unexpected absurdities"**: Enrique Vila-Matas, *The Illogic of Kassel* (New York: New Directions, 2014), p. 182.

256 **"'through logic opens the way toward madness.'"**: ibid., p. 182.

256 **"industrious and rational Turin"**: *Italo Calvino: Letters, 1941–1985*, selected by Michael Wood, translated by Martin McLaughlin, (Princeton: Princeton University Press, 2013), p. 377.

258 **"high-tech cradle for foundlings"**: "Baby Drop Box Gets a Tech Upgrade," *Wired* magazine, January 3, 2006.

258 **first baby to be abandoned**: "'Cradle for Life' Receives its First Newborn in Genoa," *Aleteia*, September 5, 2021.

258 **On Easter Day in 2023**: "Aeneas abandoned at Mangiagalli," *Corriere della Sera,* April 10, 2023.

259 **The year 2016 marked its maiden voyage**: "The Baby-Box Lady of America," *The New Yorker*, December 18, 2021.

260 **local Ohio television reporter stood**: "Ohio Department of Health Launches Investigation into Troy Fire Department Baby Box," Bryn Caswell, September 14, 2022.

260 **Station owned and operated by**: dayton247now.com/ station.

260 **"A Kentucky infant last week"**: "First infant surrendered anonymously at Kentucky 'baby box,'" *New York Post*, February 12, 2023.

261 **also reported by CNN, CBS, and, of course, Fox News:** "Kentucky sees its 1st infant anonymously surrendered at a fire station 'baby box,'" www.cnn.com/2023/02/12/us/ kentucky-baby-box-infant-surrendered/index.html February

12, 2023; www.cbsnews.com/news/baby-box-1st-infant-in-kentucky-surrendered-anonymously; February 12, 2023; foxnews.com/us/first-infant-anonymously-dropped-off-kentucky-baby-box-surrender-location, February 13, 2023.

261 **"States have increasingly adopted 'safe haven' laws"**: *Dobbs v. Jackson Women's Health Organization*, 597 U.S. (2022), p. 33.

261 **"Baby Moses" law, passed in Texas in 1999:** "Infant Safe Haven Laws," www.childwelfare.gov.

262 **One of the few people back then:** Carol Sanger, "Infant Safe Haven Laws: Legislating in the Culture of Life," *Columbia Law Review*, May 2006, Vol. 106, No 4, pp. 753–829.

262 **study by the U.S. Department of Health and Human Services**: ibid., p. 763.

263 **"The need for anonymous abandonment in 2006"**: ibid., p. 758.

264 **"work subtly to promote the political goal of the culture of life"**: ibid., p. 753.

264 **develop the Catholic conservative legal:** Fintan O'Toole, "The Irish Lesson," *The New York Review of Books*, August 18, 2022.

264 **"safe haven laws and why don't they matter?"**: Oral arguments, *Dobbs v. Jackson Women's Health Organization*, December 1, 2021, p. 57.

268 **"utilitarian, militaristic, American and Catholic, very Catholic"**: Julian Barnes, "Flaubert at Two Hundred," *London Review of Books*, December 16, 2021.

Selected Bibliography

Albinati, Edoardo. *The Catholic School*, translated by Antony Shugaar. New York: Farrar, Strauss and Giroux, 2019.

Armstrong, Karen. *The Gospel According to Women*. New York: Anchor Books, 1986.

Atwood, Margaret. *The Handmaid's Tale*, New York: Anchor Books, 1998, introduction copyright, 2017.

Bakewell, Sarah. *At the Existentialist Café*. New York: Other Press, 2016.

Bellochio Brambilla, Cesare. *Nascere senza venire alla luce.* Milano: FrancoAngeli, 2010.

Baio Dossi, Emanuela and Edoardo Bressan. *The City of Stelline*, Milan: Fondazione Stelline, 2015.

Barthes, Roland. *Mythologies.* Selected and translated from the French by Annette Lavers. New York: Hill and Wang, 1984.

Bart, Pauline B. and Eileen Geil Moran. *Violence Against Women: The Bloody Footprints*. Newbury Park, California: Sage Publications, 1993.

Boss, Pauline. *Ambiguous Loss: Learning to Live with Unresolved Grief.* Cambridge: Harvard University Press, 1999.

Bowlby, John. *Attachment*. New York: Basic Books, 1982.

Calvino, Italo. *Italo Calvino: Letters, 1941–1985*, selected by

Michael Wood, translated by Martin McLaughlin. Princeton: Princeton University Press, 2013.

Carp, E. Wayne. *Family Matters: Secrecy and Disclosure in the History of Adoption.* Cambridge: Harvard University Press, 1998.

Cooney, John. *The American Pope: The Life and Times of Francis Cardinal Spellman.* New York: Times Books, 1984.

Di Donato, Pietro. *The Penitent.* New York: Hawthorn Books, 1962.

Diocese of Brooklyn (ed.). *Diocese of Immigrants: The Brooklyn Catholic Experience, 1853–2003.* Strasbourg: Èdition du Signe, 2004.

Egan, Eileen. *Catholic Relief Services: The Beginning Years.* New York: Catholic Relief Services, 1988.

Ernaux, Annie. *The Years.* Translated by Alison L. Strayer. New York: Seven Stories Press, 2017.

Fessler, Ann. *The Girls Who Went Away.* New York: Penguin, 2006.

Filipponi, Stefano, Eleonara Mazzocchi, and Ludovica Sebregondi, eds. *Il Museo degli Innocenti.* Florence: Mandragora, 2016.

Fisher, Florence Ladden. *The Search for Anna Fisher.* New York: A. Fields Books, 1973.

Flaubert, Gustave. *Madame Bovary*, translated by Margaret Mauldon. Oxford: Oxford University Press, 2004.

Fournier Lanzoni, Rémi. *Comedy Italian Style: The Golden Age of Italian Film Comedies.* New York: Continuum, 2009.

Ginsborg, Paul. *A History of Contemporary Italy: Society and Politics 1943–1988.* New York: Palgrave Macmillan, 2003.

Ginzburg, Natalia. *A Place to Live and other selected essays of Natalia Ginzburg*, chosen and translated by Lynne Sharon Schwartz. New York: Seven Stories Press, 2003.

Ginzburg, Natalia. *All Our Yesterdays.* New York: Little Brown, 1989.

Gundle, Stephen. *Death and the Dolce Vita: The Dark Side of Rome in the 1950s*. Edinburgh: Canongate, 2011.

Jacobus de Voragine. *The Golden Legend: Readings on the Saints*, Volume 1, translated by William Granger Ryan. Princeton: Princeton University Press, 1995.

Kertzer, David I. *Amalia's Tale: An Impoverished Peasant Woman, an Ambitious Attorney, and a Fight for Justice*. New York: Houghton Mifflin Company, 2008.

—. *Sacrificed for Honor: Italian Infant Abandonment and the Politics of Reproductive Control*. Boston: Beacon Press, 1993.

—. *The Pope At War: The Secret History of Pius XII, Mussolini, and Hitler*. New York: Random House, 2022.

Lewis, Norman. *Naples 44: A World War II Diary of Occupied Italy*. New York: Carroll & Graf Publishers, 2005.

Malaparte, Curzio. *The Skin*. Translated by David Moore, introduction by Rachel Kushner. New York: New York Review Books, 2013.

Melosh, Barbara. *Strangers and Kin: The American Way of Adoption*. Cambridge: Harvard University Press, 2002.

Merleau-Ponty, Maurice. *The Essential Writings of Merleau-Ponty*, ed. Alden L. Fisher. New York: Harcourt, Brace & World, 1969.

Milotte, Mike. *Banished Babies: The secret history of Ireland's baby export business*, second edition. Dublin: New Island, 2011.

Moorehead, Caroline. *Gellhorn: A Twentieth-Century Life*. New York: Henry Holt and Company, 2003.

—. *Iris Origo: Marchesa of Val d'Orcia*. Boston: David R. Godine, 2002.

Moorman, Margaret. *Waiting to Forget*. New York: W. W. Norton, 1996.

Origo, Iris. *A Chill in the Air*, introduction by Lucy Hughes-Hallett. New York: New York Review Books, 2017.

—. *War in Val D'Orcia*, introduction by Virginia Nicholson. New York: New York Review Books, 2017.

Perry, Nicholas and Loreto Echeverría. *Under the Heel of Mary*, London; New York: Routledge, 1988.

Progoff, Ira. *Jung, Synchronicity and Human Destiny: C. G. Jung's Theory of Meaningful Coincidence.* New York: Julian Press, 1973.

Rivers, Caryl. *Aphrodite at Mid-Century: Growing Up Female and Catholic in Postwar America.* New York: Doubleday, 1973.

Saller, Richard P., and David I. Kertzer, eds. *The Family in Italy from Antiquity to the Present.* New Haven: Yale University Press, 1991.

Sands, Philippe. *The Ratline: Love, Lies and Justice on the trail of a Nazi fugitive.* London: Weidenfeld & Nicolson, 2020.

Sixsmith, Martin. *The Lost Child of Philomena Lee: A Mother, Her Son, and a Fifty-Year Search.* London: Macmillan, 2009.

Solinger, Rickie. *Beggars and Choosers: How the Politics of Choice Shapes Adoption, Abortion, and Welfare in the United States.* New York: Hill and Wang, 2001.

Solnit, Rebecca. *The Faraway Nearby.* New York: Penguin Books, 2013.

Steinacher, Gerald. *Nazis on the Run: How Hitler's Henchmen Fled Justice.* Oxford: Oxford University Press, 2011.

Tosches, Nick. *Dino: Living High in the Dirty Business of Dreams.* Delta: New York, 1992.

Ventresca, Robert A. *From Fascism to Democracy: Culture and Politics in the Italian Election of 1948.* Toronto: University of Toronto Press, 2004.

Vila-Matas, Enrique. *The Illogic of Kassel.* New York: New Directions, 2014.

Warner, Marina. *Alone of All Her Sex: The Myth and the Cult of the Virgin Mary.* New York: Vintage Books, 1983.

Warner, Marina. *Six Myths of Our Time: Little Angels, Little Monsters, Beautiful Beasts, and More.* New York: Vintage Books, 1994.

Winslow, Rachel Rains. *The Best Possible Immigrants: International Adoption and the American Family.* Philadelphia: University of Pennsylvania Press, 2017.

Van Der Kolk, Bessel. *The Body Keeps the Score: Brain, Mind, and Body in the Healing of Trauma.* New York: Penguin, 2014.

Van Steen, Gonda. *Adoption, Memory, and Cold War Greece: Kid pro quo?* Ann Arbor: University of Michigan Press, 2019.

Acknowledgments

I am extraordinarily grateful to all of the people who trusted me to tell their stories and helped me to understand the importance of questioning the stories we've been told. Foremost, to John Campitelli, without whom this book would not have been possible. John generously shared the details of his life and decades of painstaking research, pointed the way to critical archives, and introduced me to others who became a part of this book. My deepest thanks to him, and to his wife, Simona Dominque Pedrinazzi, who graciously accepted all the tugs on John's time. Also, to John's sister, Sara, who added her artist's sense of detail to reconstruct their childhood years in Florence. Their late mother, Barbara Battersby Campitelli, was equally generous. A special thanks to my cousin John Mantica, whose chance phone call in 2017 started this project; to the fellow members of the Steubenville gang who generously shared their time and thoughts with me; and to Diana Miller who began seeking answers with John Campitelli decades ago.

Along the way, many people offered invaluable ideas and research help, answered detailed questions over email, met over coffee or on Zoom, and even screened hard-to-get films for my personal viewing. Thank you: Stefano Albertini, Mary

Brown, Marta Casonato, David Kertzer, Joseph Sciorra, Gerald Steinacher, Anthony Tamburri, and Francesco Valdilongo. The translation skills and cultural insights of the marvelous Angela Ingrascì were simply invaluable.

Taking a work from a manuscript to the world is an act that requires great gifts and I am a lucky and grateful recipient of many. A huge thanks to David Steinberger, who provided a home for this work, and whose visionary ideas shine a needed light in the land of book publishing; and to Mara Anastas and the entire team at Open Road Media for their amazing help and support. Giuseppe Strazzeri, editorial director at Longanesi, had the courage to first publish this work in Italy and offered invaluable ideas and guidance.

I will always be grateful for the support and friendship of my agent, Susan Ramer, whose dedication to this project has been extraordinary. The wonderful Vicki Satlow expanded my world by introducing this book to a European audience before its American publication.

I had the great fortune of working with extraordinary journalists who believed in this book: Michael Tomasky of *The New Republic* and the fantastic team at CBS News "60 Minutes," Bill Whitaker, Heather Abbott, LaCrai Mitchell Scott, and the marvelous Sabina Castelfranco, whose support never wavered.

Thank you to old friends, and to new ones whom I was lucky to meet during the course of my research. In Italy, Elena dal Pra, who showed me the joys of the *ringhiera* and offered countless acts of generosity; Lonnie Holders and Giacomo Biraghi, who introduced me to the wonderful community of Bergamo; Paolo Rondo-Brovetto, my decades-long guide to Italian culture, who generously traveled from Austria to Milan when he knew I was in town; and Wallis Wilde-Menozzi, my confidant in Parma, whom I turn to for sage counsel.

ACKNOWLEDGMENTS

On the other side of the Atlantic, my thanks to Jan Carr, Joanna Clapps-Herman, Adam Cohen, Joe De Plasco, Edi Giunta, Renée Khatami, Susan McConaughy, and John Maggio. Liz Strout, I'll always be grateful for your insights and empathy, and for bringing the light of laughter into sometimes dark places. Jennifer Brown and Vincent Santoro, Susan Jacobson and David Moskovitz, and Ruth Pastine and Gary Lang, my heartfelt thanks for decades of friendship and conversation that make things right.

My brother, Bob Laurino, coincidentally working as a prosecutor on a project that intersected with my own, was a constant source of encouragement and advice. My son Michael, my favorite literary companion, shared his ideas, wit, and wisdom (which never cease to amaze me) and lent his astute editorial eye (which saved me). And finally, to my husband Tony, who since that chance phone call years ago, has accompanied me on every page of this book with love, humor, patience and unwavering support, as he does on every page of our lives.

About the Author

Maria Laurino is the author of the national bestselling memoir *Were You Always an Italian?*, an exploration of how stereotypes and class prejudice influenced Italian American identity; the memoir *Old World Daughter, New World Mother*, a meditation on contemporary feminism; and *The Italian Americans*, a companion book to the PBS documentary. A former staff writer for the *Village Voice*, Laurino's work has appeared in numerous publications including the *New York Times*, *Washington Post*, the *New Republic*, and *Salon*; her essays have been widely anthologized including in the *Norton Reader*.

INTEGRATED MEDIA